D0763847

Robert

Lehman

Lectures

on Contemporary Art

Dia Art Foundation, New York
No. 3

Robert

Lehman

Lectures

on Contemporary Art

EDITED BY LYNNE COOKE AND KAREN KELLY

WITH BETTINA FUNCKE

© 2004 Dia Art Foundation, New York

All rights reserved. No part of this book may
be reproduced in any form without permission
in writing from the publisher and author(s).

Printed in the United States of America
by Capitol Offset Company, Concord, New Hampshire
First printing 2004
ISBN 0-944521-77-0

Library of Congress Cataloging-in-Publication Data
Robert Lehman lectures on contemporary art. Vol. 3 /edited by Lynne Cooke and Karen Kelly.
 p. cm. -- (Robert Lehman lectures on contemporary art ; v.3) (Dia Art Foundation,
New York ; no. 3)
 ISBN 0-944521-77-0
 1. Art, Modern--20th century. 2. Art, Modern--21st century. I. Cooke, Lynne. II. Kelly,
Karen J., 1964- III. Dia Art Foundation. IV. Series. V. Dia Center for the Arts, New York
(Series) ; no. 3.
 N6490.R5483 2004
 709'.04--dc22
 2003068828

A version of "The Myth of the West" by Peter Wollen was published in his *Paris
Manhattan: Writings on Art* (Verso, 2004).

A German translation of "Beyond the Peter Pan Complex: Warhol's Shadows" by Victor
I. Stoichita was published in *SchattenRisse: Silhouetten und Cutouts* (Hatje Cantz, 2001).

Dia Art Foundation
535 West 22nd Street
New York, New York 10011
www.diaart.org
www.diabooks.org

Distributed by
Distributed Art Publishers, Inc.
155 Sixth Avenue, 2nd floor
New York, New York 10013
212 627 1999 fax 212 627 9484

Edited by Lynne Cooke and Karen Kelly, with Bettina Funcke
Proofreading and copyediting by Diana Stoll, Richard Gallin, Libby Hruska,
and Barbara Schröder
Research assistance by Simon Baier
Designed by Laura Fields
Cover image by Bill Jacobson Studio, New York

Contents

Preface

Since 1992, Dia has presented the Robert Lehman Lectures on Contemporary Art. The lecture series, an example of Dia's longstanding commitment to critical and intellectual discourse, was founded with a generous grant from the Robert Lehman Foundation, Inc., and has showcased a distinguished array of scholars, critics, art and cultural historians, and artists. While the exhibition program at 548 West 22nd Street has offered a fertile, groundbreaking arena for inquiry and discussion, this series of publications promises to extend and broaden the debate.

This third volume brings together eight lectures, which were presented from 1998 through 2000, on seven exhibitions in Dia's program. We would like to thank the authors for their insightful and inspired contributions and for their time in preparing the essays for publication. Additionally, the participation from the artists represented here and their galleries is gratefully acknowledged. Dia's staff has been dedicated to the success of this series, which was carefully conceived and organized by curator Lynne Cooke and coordinated over the last few years by Armelle Pradalier. Patrick Heilman and Sarah Thompson were also particularly supportive in organizing these events. This book has been realized through the collaboration of Karen Kelly and Bettina Funcke, who assiduously managed the editorial process, and Laura Fields, whose thoughtful design has brought this material into a clear and elegant form.

We look forward both to continuing this incomparable lecture series and publishing many future volumes of essays.

Michael Govan, Director

Introduction

LYNNE COOKE

These lectures and the exhibitions of works on which they were based took place at Dia Art Foundation's exhibition facility located on West 22nd Street in Manhattan's Chelsea neighborhood. The first of the shows addressed in these lectures—now essays—opened in September 1998. Since then, Dia has undergone a number of major changes, not least the temporary closure of this exhibition program in January 2004 and the opening in May 2003 of Dia:Beacon, a museum designed to present its collection to the public, sited on the banks of the Hudson River in upstate New York. Prior to the opening of the museum, works from this collection of mostly large-scale works from the 1960s and 1970s had occasionally been exhibited in Chelsea: in September 1998, for example, Joseph Beuys's *Drawings after the Codices Madrid* were installed together with a group of his sculptures known as Fonds. Such exhibitions were interspersed with others, which included both commissions to artists from the same generation as those with works in Dia's collection and commissions to a younger group; respectively representing these dual aspects of the program were invitations extended to Robert Irwin and Douglas Gordon. Interwoven with these two strands is a third: From time to time, major artworks from the 1960s and 1970s—works whose genesis and spirit betray affinities with pieces already in the collection—have been borrowed for temporary presentation. Notable in this regard is the 1995–96 exhibition of Gerhard Richter's masterwork *Atlas* (circa 1964 and ongoing).

As need has required and opportunity has permitted, catalogues and/or books have been published in concert with exhibitions at Dia in Chelsea. Thus, for example, "Double Vision," comprising new video projections by Douglas Gordon and Stan Douglas,

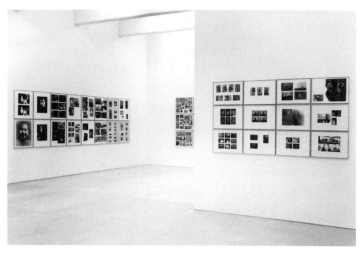

Gerhard Richter, *Atlas*, c. 1964–, installed at Dia's Chelsea exhibition facility, 1995–96

generated texts by critics Neville Wakefield and Sianne Ngai with
Nancy Shaw. The essays in the Lehman Lecture series' anthologies,
in contrast, arise out of a different set of considerations. They are
designed to encourage debate on each exhibition as it debuts; since
the talks are held during the course of the exhibition, respondents
may generate the terms of a future debate. The heteroglot voices
of scholars, critics, artists, cultural theorists, and poets who have
lectured reflect the multidisciplinary, multifocal discourse that
contextualizes contemporary art today.

The format of Dia's Chelsea program is simple. Each exhibition
is monographic—devoted to the work of a single artist. Each lasts
for the duration of a year, and each occupies one floor of the former
warehouse, now exhibition facility. Determined in large part by the
institution's idiosyncratic history, the program's deliberately narrow
focus is periodically challenged by an exhibition that for some
particular reason—structural, thematic, or conceptual—brings
together works by two artists. "Double Vision" was one such;
". . . the nearest faraway place . . . ," an exploration of the myth of
the West in the work of Bruce Nauman and Rodney Graham, was
another. A third, "Time Traced," counterpointed works relating to

the camera obscura by Rodney Graham and Vera Lutter.

The works discussed that were created by the four artists who matured in the 1960s—Andy Warhol, Joseph Beuys, Gerhard Richter, and Robert Irwin—are large, even environmental in scale, and are imbued with an epic sweep, characteristics

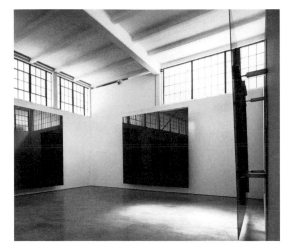

Gerhard Richter, *Six Gray Mirrors*, 2003, installation view at Dia:Beacon

exceptional in the oeuvres of Warhol, Beuys, and Richter. The projects by these three grew out of a singular set of circumstances. Comprising 102 elements, *Shadows* (1978–79) has no parallel in Warhol's oeuvre. It resulted from a commission from Heiner Friedrich, one of Dia's founders, who happened to see Warhol embarking upon what would probably otherwise have been a relatively modest series. Spurred by an abiding dream of environmental works, Friedrich persuaded him to vastly expand his endeavor, in short, to make what the canny Pop artist finally deemed a wrap-around piece that functions as decor as well as an environmental artwork. In the late 1960s, Richter decided to bring together into a formalized archive photographs that he had either taken himself or collected for more than a decade. He would update the archive as required. Although this unique work has been exhibited on a number of occasions over the past three decades, its showing in Chelsea in 1995–96 marked its first presentation in North America. Contained within the sprawling magnum opus are various sketches for projects, some of which were never realized, others of which probably never were intended to be. Several depict rooms dominated by huge paintings, as if to physically encompass a spectator within

their expansive bounds in an unprecedented way. With hindsight, they can be seen as distant progenitors of *Six Gray Mirrors* (2003), Richter's response to an invitation from Dia in 2002 to address a specific gallery at the heart of its forthcoming museum in Beacon. In the 1970s, Beuys created a number of multiples as part of an ambitious search for a wider audience. One of these, a limited-edition book, was based on a hundred drawings he executed in response to the rediscovery of Leonardo's manuscripts. Beuys subsequently determined that this cache of drawings should remain as a "block." With painstaking research, Pamela Kort has here deciphered the formation and structure of the source material from which this rare compendium—manuscript, multiple, and suite—was generated.

Of this group, only Irwin contributed a site-specific installation to the Chelsea program. His careful attention to the dimensions and proportions, light sources, and material conditions of the gallery were prerequisite to a heightened and clarified perceptual apprehension of the place and space. A consecutive two-part project, consisting of *Prologue: x18³* and *Excursus: Homage to the Square³*, was designed to take advantage of the naturally changing light conditions over its extended duration, a full calendar year. In fact, *Excursus: Homage to the Square³* remained on view for almost two years largely due to "popular demand"—that is, in response to the desires of a constantly returning audience. Critical to the success of this piece, though not hitherto discussed in print, was its social character, here brilliantly articulated by Jonathan Crary. It is this quality, this sociality, that sets it apart from much of the large-scale works executed by Irwin's peers, artists such as Donald Judd, Carl Andre, and Dan Flavin, key examples of which are now at Beacon on long-term view. While these artists, too, deemed the space engaged by their works integral to them, their art is nonetheless premised on a notion of the viewer as a lone or solitary individual spectator. Unlike his peers, Irwin has long been interested in commissions for works in the public arena. His experience, garnered from projects such as the redesign of the Miami International Airport and the definition of the architectural brief for a new

museum of contemporary art for Los Angeles, together with his professional relationships with Dia's staff, established during the realization of *Excursus: Homage to the Square³*, made the veteran Light and Space artist an ideal candidate to lead the design team in planning the transformation of the Nabisco Company's printing facility in Beacon into an art museum. Certain aspects of Dia:Beacon's final design (which he designates a work in his oeuvre) reflects Irwin's close attention to natural light and issues of circulation and orientation as well as his assignment of a signal role to the threshold; his treatment of these aspects was doubtless inflected by his previous projects—not least *Excursus: Homage to the Square³*. If, as instanced in the works of Richter and Irwin, the commissioning of works for Dia:Beacon resulted in the invention of new artistic forms, other works have entered the collection in recent years after a preliminary showing in Chelsea. These include Hanne Darboven's *Kulturgeschichte 1880–1983* (1980–83), which was on view in 1996–97, and the new work Nauman made for Dia, *Mapping the Studio I (Fat Chance John Cage)* (2001), which had its debut in Chelsea in early 2002. A fuller appreciation of those achievements and of other works in the permanent collection has been made possible by the concurrent contributions of a younger generation. Their works provoke reappraisals and reinterpretations critical to the ongoing vitality of the increasingly canonical 1960s precedents.

Though it does not engage every exhibition that took place within the three-year period from 1998 to 2000, this compilation of texts does more than provide an opportunity to reconsider Dia's singular exhibition program vis-à-vis its collection. The model of the artist and the role assigned to the artwork, exemplified by the projects under review, betray revealing affinities and allegiances—or the converse. Whether fortuitous, circumstantial, or somehow predetermined, parallels and discrepancies emerge among them that invite conjecture.

Few artists in the past half century have more relentlessly probed and pursued, scrutinized and shaped—literally and metaphorically—a model for an artistic practice than Nauman. Influenced as much by Wittgenstein's rigorous investigatory mode as by Beckett's

austere reductive texts for theater and radio, Nauman has sought
to impart form, structure, significance, and a moral undergirding
to a practice rooted in his daily activities, both those particular to a
studio situation and those stemming from his activities as a rancher
who breeds quarter horses. Since the late 1970s, ranching has played
a dual role in Nauman's life: it is at once an avocation and the source
for many of his recent artworks. Capitalizing on the fact that for
Rodney Graham, as for Nauman, the archetypal figure of the cow-
boy has provided a fertile point of departure from which to examine
models of artistic praxis, the exhibition ". . . the nearest faraway
place . . ." juxtaposed select works by each artist. Not surprisingly,
their approaches differ greatly. Deadpan and straight shot, Nauman,
typically for his generation, begins with the actualities, the quiddities
of the literal, phenomenal world from which he draws unprecedented
and often uncanny consequences. Graham, equally characteristically,
works from representation, from a mediated reality that carries him
ineluctably toward the elusive, the oblique, and the refracted. In
their distinctive ways, each pays tribute to a maxim, which Nauman
articulated long ago: "The true artist helps the world by revealing
mystic truths" (1967). This maxim prompts the question whether
revelation signifies a form of disclosure or one of exposure.

In a recent roundtable discussion, Jeff Wall argued, "People we
used to look to as artists—those who had unusual abilities and the
unusual intuitions that seem to be somehow connected with these
abilities—are not looked to as much anymore. Artists today work
as 'creative directors,'" he contends, for they typically employ
"skilled artisans to make things according to their specifications."
As a result, "other abilities have come to the fore, one of the most
important of which is the ability to sense meanings in the wider
culture and to contemplate the evolution and significance of those
meanings and the products that express them."[1] The dual types
Wall limns well characterize the positions Nauman and Graham
adopt vis-à-vis the myth of the West.

Like Nauman, Irwin is emblematic of Wall's first category. For
some four decades, his work has been acclaimed for its highly original
reworking of an abiding concern in Western art: the problem of

perception. While the subject of his art is perceptual experience itself, his renown is based on the affective as much as the conceptually and experientially challenging means by which his work produces "a heightened awareness of the operation of our own perceptual faculties," to borrow Crary's succinct formulation.[2] Warhol, in contrast, not only fits Wall's second model, that of the contemporary artist, but he in large part generated and defined it. On this count alone, his work remains hugely influential, even though issues that it foregrounds relating to the role and impact of the media, to questions of representation, to the blurring of distinctions between high and low art make up only a fraction of those presently deemed timely or topical.

As Wall goes on to argue, what is now required by the creative act is "to find a means, a form, or a format to make those meanings available": by his reckoning "the form and the technique are usually drawn from the original's production process—a film (or a moment in a film), an architectural trope, a social situation of some kind." The result is that meaning now arises out of the discursive relation between the first and second appearance of things. As evidence, he offers the example of a Warhol Disaster painting: "the first as some mass-cultural event, like a news photo of a car accident, and the second as that photo as a painting."[3] The works by Stan Douglas and Douglas Gordon discussed in these pages clearly adhere to this second modus operandi. Yet Wall's schema cannot be parsed by reference to generation alone, as was made evident in "Time Traced" (1999–2000), the exhibition of works by Rodney Graham and the younger German artist Vera Lutter. Variously employing or referencing the antiquated technology of the camera obscura, both artists created bodies of work that closely align them with Wall's chronologically earlier model: "those who had unusual abilities and the unusual intuitions that seem somehow connected with these abilities." But, as Jan Tumlir's searching study here evinces, and Graham's very different contribution to ". . . the nearest faraway place . . ." attests, Graham's elusive chameleon-like practice can neither be exclusively categorized nor predicted.

A compelling case for considering the oeuvre of Thomas Schütte as a contrarian conflation—or perversion—of these diametrically opposed schema is offered by Boris Groys. For him, whenever Schütte "speaks about his own work, he stresses the point that his methods of fabrication are traditional and do not relate to or rely on contemporary technology. Schütte does not appropriate. He is an author-creator." Nonetheless, according to Groys's provocative reading, he is simultaneously a self-appropriator: "The obvious discontinuities and gaps in his artistic production suggest the repudiation of the traditional notions of artistic identity or creative subjectivity." Thus Groys concludes that "Schütte is able to demonstrate the fate of artistic subjectivity in modernity precisely because he does *not* reject the traditional role of the artist as creator, as many other artists do. Schütte consciously takes on this traditional role, and, at the same time, he presents the collections of his own works as a kind of *Kunstkammer* consisting of disparate, disconnected series of objects and images." Ultimately, then, "the whole world of the creative personal and romantic imagination is shown by Schütte as debris of the past, which we cannot understand or reconstruct but can only collect."[4]

When invited to lecture on the Nauman and Graham exhibition ". . . the nearest faraway place . . .," Peter Wollen, in his inimical, independent fashion, forswore an engagement with recent incarnations of the enduring archetype of the myth of the West in favor of a study of its roots and lineage. Beginning with landscape painting, he then turned to cinema before concluding his study with a discussion of Jackson Pollock, whose conflicted legacy haunts, albeit elliptically, the work of both younger artists. Wollen's enthralling text is indicative of the license—the creative freedom and the speculative pleasures—presupposed in participating in this lecture series, not least in its indifference to the responsibility or burden—the supportive excursus—required when writing for a catalogue accompanying an exhibition. Similarly, Victor Stoichita chose to focus on a Self-Portrait, which Warhol based on a photographic negative of the same year as *Shadows*, because he considered the debate around that multipaneled mise-en-scène already exhausted.

This tack evolved into a fascinating study of the myth of the artist lodged at the center of Warhol's imaginary. The recurrence and overlapping of themes or tropes from one essay to another in this anthology highlights certain constants in current discourse, constants endemic to the predicament facing anyone working today: what is the model of the artist, and what is the identity of the artwork presupposed in his or her practice? While few artists have foregrounded this problematic with Nauman's persistence and inventiveness, few have been as obsessed by it as Warhol. In consequence, Nauman and Warhol (together with Robert Smithson) have shaped much of what has followed to date.

Notes

1 Jeff Wall, in "Pop After Pop: A Roundtable," *Artforum* 43, no. 2 (October 2004), p. 167.

2 Jonathan Crary, "Robert Irwin and the Condition of Twilight," in this book, p. 65.

3 Wall, p. 168.

4 Boris Groys, "The Case of Thomas Schütte," in this book, p. 141.

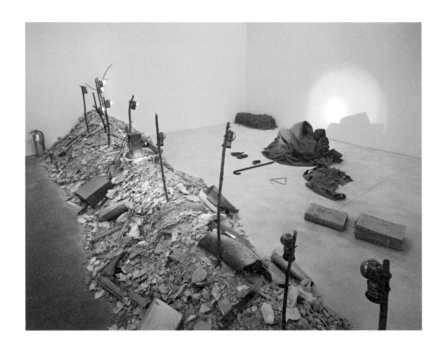

Aus Berlin: Neues vom Kojoten (*From Berlin: News from the Coyote*), 1979

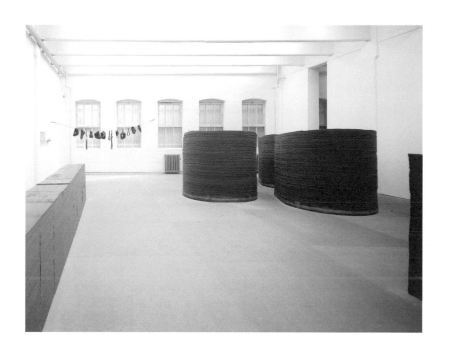

Fond IV/4, 1979; *Brasilienfond (Brazilian Fond)*, 1979; and *Möbiuswerfer*, 1983

ROBERT IRWIN
"Part I: *Prologue: x18³*"
April 12–June 14, 1998

"Part II: *Excursus: Homage to the Square[3]*"
September 13, 1998—June 18, 2000

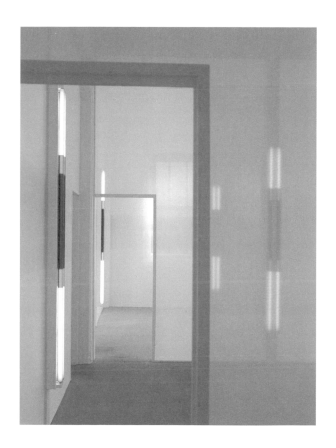

ANDY WARHOL

Shadows, 1978–79
December 4, 1998–June 13, 1999

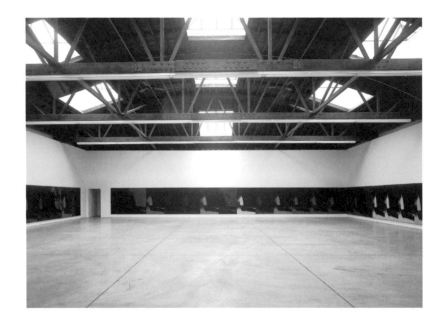

left is right and right is wrong and left is wrong and right is right, 1999

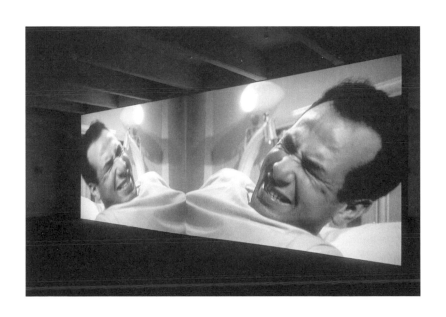

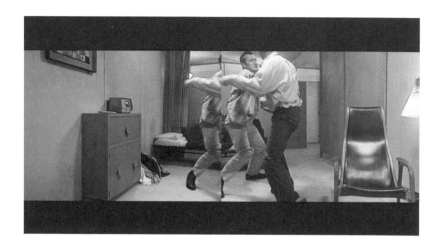

Win, Place, or Show, 1998

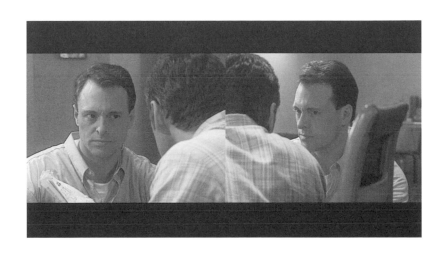

THOMAS SCHÜTTE
"Scenewright"
September 24, 1998–January 18, 1999

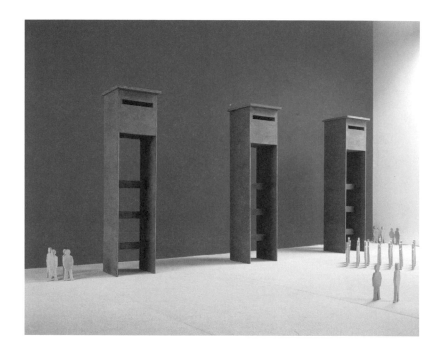

Piazza Due, 1986

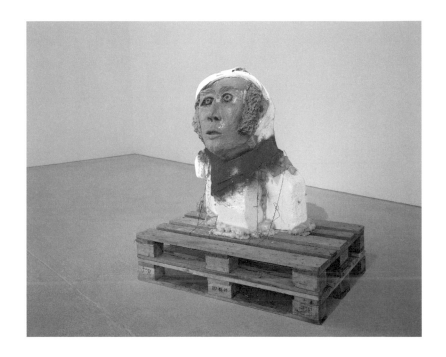

Alain Colas, 1989

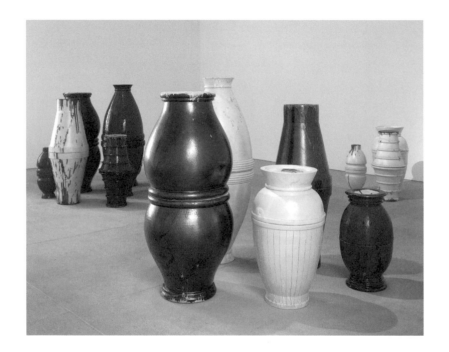

Ohne Titel (Urnen) (*Untitled* [*Urns*]), 1999

Thomas Schütte, working in his studio on Steel Women in preparation for "In Media Res"

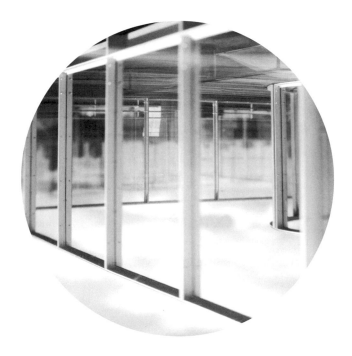

Photograph taken from inside Rodney Graham's *Camera Obscura Mobile*, 1996, installed on Dia's rooftop

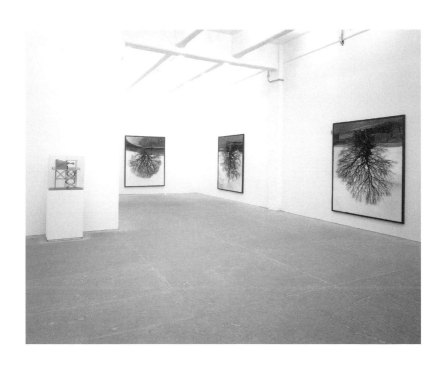

Millennial Project for an Urban Plaza, 1986, and *Welsh Oaks,* 1998

RODNEY GRAHAM AND BRUCE NAUMAN
". . . the nearest faraway place . . ."
May 10, 2000–June 18, 2001

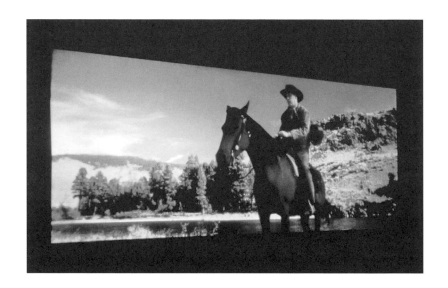

Rodney Graham, *How I Became a Ramblin' Man*, 1999

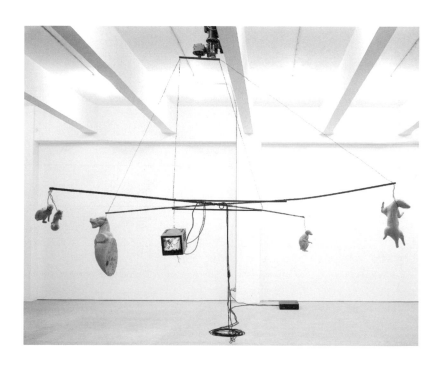

Bruce Nauman, *Hanging Carousel (George Skins a Fox)*, 1988

Leonardo da Vinci, Marcel Duchamp, and Joseph Beuys

PAMELA KORT

Early in the summer of 1974, Joseph Beuys began to work on what was to become one of the most autobiographic multiples he was ever to make: *Zeichnungen zu den beiden 1965 wiederentdeckten Skizzenbücher "Codices Madrid" von Leonardo da Vinci* (*Drawings after the Two "Codices Madrid" Sketchbooks by Leonardo da Vinci That Were Rediscovered in 1965*). Over the course of the next five months, Beuys gathered together some two hundred drawings in connection with this object. Sometime early in 1975, Götz Adriani (director of the Kunsthalle Tübingen) and Roland Hanssel (director of Manus Presse, Stuttgart) met with Beuys to choose one hundred of the drawings to reproduce in the multiple and an additional six to be printed as granolithographs to insert into various special editions. After he had finalized the order of the drawings within the multiple, Beuys signed, dated, and annotated the versos.[1]

In 1979 Dia Art Foundation purchased ninety-six of these and more recently published a scholarly book about them.[2] Its appendix uncovers the particulars of Beuys's inscriptions. These both enable a partial reconstruction of the sequence of the drawings' making and provide important clues about concerns central to his construction of the multiple. For example, the inscriptions "Napoli," "Capri," and

Joseph Beuys, from *Drawings after the Codices Madrid of Leonardo da Vinci*, 1974

"Vieste Gargano" show that he began to work on the sheets when he went to Italy between June 20 and 30, 1974.[3] Beuys continued to make drawings for the multiple while involved with various installations of *The secret block for a secret person in Ireland* later that year in Dublin and Belfast, as these city names, too, are written on the versos of the sheets. Finally, Beuys noted the words "Seven Palms/Kenia" on the backs of others, which reveals that he was still working on it during Christmas 1974, when he traveled with his family to Diani Beach, Kenya, to visit the photographer Charles Wilp. The appendix also discloses that not all of the one hundred drawings used for the multiple were made in 1974. Five remained undated, and Beuys ascribed 1964 to three and 1958 to a fourth. The multiple keeps these facts secret; its sheets are neither signed nor dated. Compelling and mysterious, their open-endedness stands in sharp contrast to Adriani's art-historical afterword, where one reads, "The drawings for this book were all produced in the autumn of 1974." "Where form and style are concerned," Leonardo's *Codices* and Beuys's drawings "stimulated" by them had little in common, Adriani concluded, and they could only be compared in terms of a "profoundly spiritual empathy felt by a contemporary artist for the unique work of Leonardo."[4] While this is undoubtedly true, a close study of Beuys's activities in 1974 reveals that his preoccupation with the work of James Joyce and Marcel Duchamp informed his work on the multiple just as much if not more than that of Leonardo.

The Science of *La Gioconda*

Characteristic of Beuys's aesthetic is his interest in expanding on various *termini*—be they written, verbal, or visual. This was certainly one reason why he plunged so enthusiastically into making a commissioned multiple whose departure point was McGraw-Hill's 1974 publication of *The Madrid Codices of Leonardo da Vinci* in a five-volume luxury facsimile edition. The work not only rekindled Beuys's long-standing fascination with Leonardo's ability to unify art and science but also caused him to reflect on the origins of his own artistry. Later, he would discuss his initial sketches for the multiple:

I made the first drawings in Italy, where I traveled, immediately after receiving the commission. I took paper with me straight away and then I also linked up with my experiences [in Italy] during the war. . . . [In the drawings] water and cliffs also appear, water and cliffs that somewhat eerily blend into one another and thereby take on form.[5]

Joseph Beuys, from *Drawings after the Codices Madrid of Leonardo da Vinci*, 1974

Beuys had decided to become an artist about 1943, while serving as a radio operator and Stuka pilot during World War II.[6] During this time, he was often sent on training missions to the southern Italian towns of Foggia, Manfredonia, Monte Gargano, and Valle Malbasso. His deep identification with both the region and its inhabitants yielded some of his earliest work, including many of his Mittelmeer-Zeichnungen (Mediterranean Drawings). While working on the drawings for the multiple in Italy in 1974, Beuys revisited some of these rural communities in connection with the exhibition "Tracce in Italia—Spuren in Italien" ("Traces in Italy"), 1978–79, which he was working on with the gallerist Lucio Amelio. Some of these "traces," particularly those associated with rocky landscapes and streams, found their way into his *Codices Madrid* drawings. The commission undoubtedly caused him to reminisce about another aspect of his biography, also indelibly associated with Italy: his early interest in Leonardo. Between 1958 and 1959, Beuys brought to paper his first set of drawings inspired by the Renaissance artist. Made for and reproduced in Eva Wurmbach's thesis *Die Landschaften in den Hintergründen der Gemälde Leonardos* (*The Landscapes in the Backgrounds of Paintings by Leonardo*), 1959, the eleven sketches share certain features with his later drawings for the *Codices Madrid*. Though authored by Wurmbach, the manuscript evokes ideas and linguistic formulations intrinsic to the art of Joseph Beuys.

Interestingly, Beuys met Eva Wurmbach, his future wife, in 1958 when she was a student at the Kunstakademie Düsseldorf —an event that coincides with his engagement with Leonardo and perhaps is quietly commemorated in the *Codices Madrid* drawing dated 1958. The connection between Beuys's preoccupation with the ideas of Leonardo in the years 1958 and 1974 is explicitly referenced in the multiple. In 1974, Eva Beuys-Wurmbach reprinted her thesis,[7] and, tellingly, it is this text—instead of the actual source of the quotation, Leonardo's *Codices Madrid* —that Adriani cites in his footnote for the epigraph that began his afterword:

Joseph Beuys, from *Drawings after the Codices Madrid of Leonardo da Vinci*, 1974

> And the water that you see streaming down from high places, and which constitutes the beginning of every river's course, behaves in exactly the same way as blood flowing upwards from below and rippling down from crevices in the brow. And so its coursing forms a circuit, constantly coherent, moving incessantly to and fro.[8]

If Beuys's *Codices* drawings have an identifying trait, then it is this fluidity that Beuys-Wurmbach describes: their lines pulse with life; their forms are embryonic; a circulatory energy is evident but not depicted. Written on several of the drawings in the multiple, the words "Transformation," "Bewegung" (movement), "Verwandlung" (metamorphosis), and "Weiterentwicklung" (advancement) under-score this condition. Beuys's concept that the act of drawing is a kind of distillatory process is also conveyed by the assorted beakers and vessels that appear on several of the work's faces. Later, in 1979, Beuys discussed his interest in these processes: "I use the idea of the transformer so often in my drawings. It contains a transforming stimulus—the transformation of concepts, the transformation of real events, transformation of social institutions, transformation

of nature, transformation of technology, transformation of the
human circulatory system."[9]

 This consequential passage, which serves as the header of
Adriani's text, appears in the section of the Beuys-Wurmbach
manuscript devoted to the landscapes in Leonardo's *Mona Lisa*
(1503–06). Beuys's version of the *Mona Lisa*, reproduced analogically,
reduces the subject to a vessel resting on a pedestal formed by her
hands. His interest in the *Mona Lisa* can be traced back to as early
as 1957: to a collage entitled *Mona Lisa Fluxus*. Seven years after
making this work, Beuys entered this statement under the year
1950 in his *Lebenslauf/Werklauf* (*Life Course/Work Course*), 1964:
"Kranenburg Haus van der Grinten 'Giocondologie.'" An analysis
of his entry yields that Kranenburg refers to a town in the Niederrhein
—an area in which Beuys took root as an artist and fledgling scientist,
the town in which his first patrons, the van der Grinten brothers,
lived, the place from which Beuys could really launch his art.
Though 1950 marks the year that Beuys met the van der Grinten
brothers, it was not until 1953 that he had his first exhibition in
their house. "Giocondologie," referring to *La Gioconda*, an alternate
title for Leonardo's *Mona Lisa*, might be roughly translated as "the
teaching or science of *La Gioconda*."[10]

 The attendant associations—fertile
landscape; safe, nurturing refuge; femi-
nine energies; and beakers—evoke the
actuality of the imperceptible forces
upheld by both Leonardo and Beuys:
For Leonardo, "force is a spiritual
power, an invisible energy . . . trans-
muter of various forms. . . . It grows
slowly from small beginnings, to
terrible and marvelous energy and
by compression of itself, compels all
things."[11] The lines that swirl around
the vessel that embodies Beuys's Mona
Lisa in the 1958–59 sketch suggest that
he viewed the *Mona Lisa* in precisely

Joseph Beuys, sketch for Leonardo's
La Gioconda or *Mona Lisa*, 1958–59

Joseph Beuys, *Mona Lisa Fluxus*, 1957

such terms, namely as an emblem of demiurgic and transmutative power. Several of Beuys's *Codices Madrid* drawings also seem to be informed by this particular understanding of Leonardo's painting, perhaps recalled by Beuys's examination of Leonardo's ten landscape studies in the second of his *Codices Madrid* notebooks. Reviewing the McGraw-Hill facsimile edition of them in 1974, the art historian Kenneth Clark described these particular drawings as "exquisitely delicate, and entirely naturalistic, which show that the landscape background of the *Mona Lisa* (probably painted at about the same time) was a construction of art."[12]

The word "Giocondologie" in the *Lebenslauf/Werklauf* combined with his sketches from 1958–59 and the *Codices Madrid* sketches make evident Beuys's understanding of Leonardo's notion of *disegno* as a science of lines. Yet Beuys refused to buy into Leonardo's definition of painting as a science capable of achieving mathematical certainty. Instead, in 1958, he professed his conclusion that because "in the development of occidental thought the concepts of art and science stood at diametrical opposites . . . expanded concepts had to be formed."[13] For Beuys, this seems to have entailed reconsidering, in 1958, the significance of James Joyce's writing to the evolution of his own work.

An Avatar in Ireland?[14]

Beuys included his *Lebenslauf/Werklauf*—which was expanded in the following years without altering its original entries—in almost

every catalogue published during his lifetime, a choice that indicates the importance he accorded to what may be termed his first manifesto. Its enduring significance for him is also attested by his decision to use it in 1973 as the basis for the first monograph to appear about him, one which was translated into English and has gone into a total of four printings to date.[15] Beuys, in fact, made three entries under the year 1950. While the one referencing "Giocondologie" demonstrates his fascination with Leonardo, another discloses his interest in Joyce: "Beuys liest im 'Haus Wylermeer' Finnegans Wake" (Beuys reads in the "House Wylermeer" Finnegan's Wake). Haus Wylermeer is a linguistic play on the Villa Wylerberg. A country home designed by Expressionist architect Otto Bartning, Villa Wylerberg was occupied at the time by Alice Schuster, who was attempting to translate Joyce's *Finnegan's Wake* into German. Beuys's renaming of the house proposes that *Berg*, or "mountain," be changed to *Meer*, which bears the more feminine connotation "sea." Although it is not known whether he actually read the book in this villa, the entry—written in 1964—and an agenda notation made the following year—listing its correct name and address— reveal this was the latest year in which Beuys would have known about Schuster's interest in Joyce.[16] Beuys's library contains two original editions of *Finnegan's Wake*, the 1939 Faber and Faber edition and the American edition by Viking Press, also 1939. The numerous handwritten notes within the latter book disclose that Beuys read it closely.[17]

The date 1958, which appears on the verso side of the *Codices Madrid* drawing Dia 80.492, also marks the year that Beuys began to work on six sketchbooks inspired by Joyce's *Ulysses*. Two drawings from this sketchbook particularly attest to his simultaneous preoccupation with Leonardo. One merely includes the word "Leonardo" in its composition; the words on the second sheet—"2 Ofenplatten, Tuben in . . . wie Lionardo . . . " (2 oven plates, tubes, in . . . like Lionardo . . .)—call to mind a kind of laboratory.[18] A 1961 *Lebenslauf/Werklauf* entry reads: "Beuys verlängert im Auftrag von James Joyce den 'Ulysses' um 2 weitere Kapitel" (Beuys extends "Ulysses" by 2 chapters at the request of James Joyce).[19] As may be

A view in Beuys's home, Drakeplatz 4, Düsseldorf, c. 1963

recalled, the semantic dimensions of the word *verlängert* (extends) underlies Beuys's procedure, which manifests itself as a process of persistence and transformation. When asked if he meant by this 1961 entry that he wanted to create a world parallel to the novel, Beuys stated:

Yes, there's a parallel there and I related my work to Joyce's because I thought that these things that change the universe were something we ought to become conscious of. . . . The important thing here is that the forms you make embody something that is along similar lines, but these don't necessarily have to be forms you make by drawing. They might be forms you create using a completely different method, and, what's most important, they have to be linguistic forms, too.[20]

In 1961 Beuys made a poster dominated by the single word "Joyce." Nine years later, in 1970, he incorporated a photograph of this object into an early version of *Arena—where would I have got if I had been intelligent!*, shown that year at the exhibition "Strategy Get Arts" in Edinburgh. His public acknowledgment of Joyce's significance reached its summit in 1974. Just ten weeks before Beuys began working on his drawings for the *Codices Madrid*, he opened an exhibition at the Oxford Museum of Modern Art that featured 362 single-sheet drawings made between 1936 and 1972. The title of that group of drawings, *The secret block for a secret person in Ireland*, pays respect to Joyce. Beuys moved at least two 1958 drawings from his *Ulysses* sketchbooks—both titled *Warm Time Machine*—into *The secret block* sometime before the Oxford exhibition opened.[21] Five years later, he transferred two of the drawings used in the *Codices Madrid* multiple—*Hasenfrau* (*Hare Woman*) and *Bein* (*Leg*)—into *The secret block* prior to handing over the remaining ninety-six to Ronald Feldman, who

then sold them to Dia. The three groups of drawings are thus deeply intertwined.

These maneuvers must be considered within the context of the final entry for 1950 that Beuys entered into his *Lebenslauf/Werklauf*: "Kleve Künstlerbund 'Profil Nachfolger'" (Kleve artists' society "Profile Successor"). The passage cites the ancient Celtic enclave and Beuys's alleged birthplace—the town of Kleve, Germany—as the site of an artistic successor. There was indeed an artists' society—Klever Künstlerbund—with which Beuys began to affiliate himself in 1946, but the word *Nachfolger* (successor) was not part of its name. The organization that he joined was reactivated in 1947 as Niederrheinischer Künstlerbund Kleve after a group originally founded in 1936, the Künstlergilde Profil.[22] The transposition of the group's name into "Profil Nachfolger"—accentuated by his quotation marks—may be simply an allusion to the Niederrheinischer Künstlerbund as the "successor" to the Künstlergilde Profil. The entire phrase, "Kleve Künstlerbund 'Profil Nachfolger,'" however, suggests Beuys's interest in designating himself as a "successor" in a lineage of persons deeply intertwined with the cultural-historical inheritance of Kleve. These include several members of the Künstlerbund, who had been crucial to fostering his own artistry, as well as the township's older fathers. In 1974, ten years after Beuys wrote this phrase, he made a multiple, *Testament*, that bears out his identification particularly with this later group. In this "testament," Beuys named himself as the son of Lohengrin, born in the earldom of Kleve, who bequeaths *The secret block to the secret person in Ireland*, namely James Joyce. Together then, the three 1950 entries in Beuys's *Lebenslauf/Werklauf* suggest his preoccupation with delineating himself as Leonardo's and Joyce's heir, descended from a legacy of individuals particular to Kleve.

Arguing with a Growing-Louder Silence

If this was indeed Beuys's objective, then he must certainly have realized that to accomplish it he would have to challenge and eventually usurp the aesthetic authority of Marcel Duchamp, whose work was rediscovered in the late 1950s in German-speaking Europe.

Marcel Duchamp, 1965; photo: Ugo Mulas

It was featured in the groundbreaking exhibition "DADA: Dokumente einer Bewegung" ("DADA: Documents of a Movement") shown in 1958 at the Kunstverein für die Rheinlande und Westfalen and later in Frankfurt and Amsterdam. The following year, in 1959, Robert Lebel published the first Duchamp monograph, which was translated into German in 1962. Lebel was not only a Duchamp expert but also a Leonardo scholar; in 1952 he had published *Léonard de Vinci, ou La fin de l'humilité*. Beuys would have found Lebel's assessment interesting: "Among all contemporary artists it is Marcel Duchamp who evokes Leonardo most irresistibly, even in his refusal to be simply a great painter."[23] Beuys, who also had come to deplore painting, probably realized that Duchamp was far more than just preoccupied with Leonardo's ideas. As critics increasingly recognized, Duchamp attempted to behave as Leonardo's descendant. Like the Renaissance painter, Duchamp was aloof and secretive, left major works unfinished, shared an interest in puns, cultivated an androgynous personality, and stressed the intellectual dimensions of art.[24]

It was not until 1960 that Duchamp had his first one-person exhibition in a European museum, "Dokumentation über Marcel Duchamp," at the Kunstgewerbemuseum in Zurich. The catalogue contained the first German translation of Duchamp's notes for *The Bride Stripped Bare by Her Bachelors, Even (The Large Glass),* 1915–23, which were enclosed in the multiple *The Green Box* (1934). Three years later, the Pasadena Art Museum mounted the earliest Duchamp retrospective, an event that attracted attention from the German press; and in 1964 a large traveling exhibition, "Marcel

Duchamp, même," opened in Milan at the Galleria Schwarz. It consisted of fourteen multiples of Duchamp's most significant readymades, reconstructed using illustrations from his *From or by Marcel Duchamp or Rrose Sélavy (The Box in a Valise)* (1935–41). The exhibition would travel to Bern, London, the Hague, Eindhoven, and Hannover.

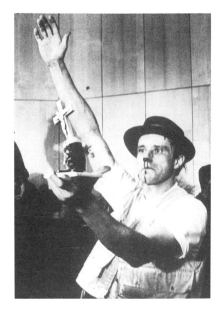

Joseph Beuys, *Kukei, akopee—Nein!,* at the Festival der neuen Kunst, Technische Hochschule Aachen, 1964

Whether galvanized by the growing aura around Duchamp or because the moment had arrived, Beuys went public in 1964, after a long period of withdrawn artistic activity. That June, he joined the international art scene, showing several drawings and sculptures at Documenta 3. A little more than three weeks later, on July 20, 1964, he took part in the Festival der neuen Kunst at the Technische Hochschule Aachen, for whose program booklet he drafted his first version of the *Lebenslauf/Werklauf*. These activities resulted in his first public interview, published that same year in two installments in the art magazine *Kunst*.[25]

Angered by the proceedings on stage in Aachen, the audience became disorderly; Beuys was even punched in the face. The now well-known photograph in which Beuys stands with one arm upraised, the other holding aloft an object with a crucifix while blood drips from his nose marks the beginning of Beuys's cultivation of an image of himself as a stalwart proselytizer. Such an engaged, if utopianist, stance was at radical odds with Duchamp's exit from the art world and alleged indifference to politics. Later that year, Beuys presented his first action that reached a large general audience. That work, *Das Schweigen von Marcel Duchamp wird überbewertet* (*The Silence of Marcel Duchamp Is Overrated*) took

place in the studio of a television station and was broadcast live by ZDF, Germany's national public television broadcaster. Performed with Bazon Brock and Wolf Vostell, the action was collectively informed by a debate among Fluxus artists about affiliating themselves with Duchamp under the rubric Neodada.[26] The most celebrated of Duchamp's Dadaist works was none other than *L.H.O.O.Q.*, his rectified readymade of Leonardo's *Mona Lisa* originally made, coincidentally or not, in 1919, the year that marked the four-hundredth anniversary of Leonardo's death.

The title of Beuys's action—*Das Schweigen von Marcel Duchamp wird überbewertet*—conveys his opposition to the widespread embrace of Duchamp's indifferent stance toward art. Duchamp, in fact, proclaimed in a 1960 radio broadcast that "silence is the best thing that man can produce."[27] Whether Beuys knew about the broadcast or not is irrelevant: by 1964 Duchamp's silence had become legendary. Because of this, Beuys's decision in 1964 to step firmly into the art world's public arena might be understood as one means to challenge the older artist's hegemony.[28] A year later, Beuys wrote a notice in his agenda that leaves no doubt about his wish to usurp Duchamp's position: "On the 12th of May 1963 Marcel Duchamp plunged into a sword." Beuys was born on May 12, while 1963 was the year of his first public action.[29]

Although Beuys objected to Duchamp's silence, he regarded him as one of the most "extraordinarily interesting artists."[30] In fact, he even went so far as to say: "My interest from that time [1964] on was to interpret Duchamp differently and to attempt to expand upon him."[31] The sheer number of multiples Beuys made between 1965 and 1986—more than 600—indicates the most obvious manner in which he did so. In the hundreds of interviews Beuys gave throughout his career, he mentioned Duchamp more frequently than almost anyone else.[32]

Beuys's employment of a personal name in the title of his 1964 action was unusual, but not without precedent. In 1959 he had made a drawing, *Der Lehrer von John Cage* (*The Teacher of John Cage*), a title that shows admiration for both the composer and his

"instructor." It was not, however, until 1964 that Beuys actually met Cage, at a concert held at the Kunstakademie Düsseldorf, which Beuys himself seems to have arranged.[33] Cage was inspired by two men in particular: Duchamp, who was a friend; and Joyce, whose *Ulysses* may partly have inspired Duchamp and whose *Finnegan's Wake* may in turn have been inspired by Duchamp. Indeed, after chancing upon a reproduction of Duchamp's *Comb* (1917) on the cover of the winter 1937 edition of *Transition* magazine, Joyce jokingly commented, "The comb with the thick teeth shown on the cover was the one used to comb out *Work in Progress*." Joyce's *Work in Progress* (completely revised between 1937 and 1939) resulted in the publication of *Finnegan's Wake* in 1939.[34] In the late 1950s, several critics and artists became increasingly interested in links between Duchamp's and Joyce's methods, among them Richard Hamilton.

Hamilton had been making drawings inspired by Joyce's *Ulysses* since 1948, as well as constructing a typographical interpretation and layout of Duchamp's *The Green Box* that was published in 1960.[35] He first visited Beuys in Düsseldorf in 1968. They continued to discuss their mutual interest in Joyce (and their differences concerning Duchamp) until at least 1977.[36] Beuys, in fact, admired both Duchamp's *The Large Glass* and the manner in which he had "elaborated"—albeit it "privately"—on his original ideas for the sculpture in the notes and sketches enclosed in *The Green Box*. He particularly appreciated Duchamp's success at positioning the linguistic and conceptual forms of *The Green Box* "in new riddle-like formal associations to a different kind of physical thing [*The Large Glass*] that had its own associations, like a kind of poetry."[37] Beuys's words reference connections between the two works established by both their dissimilar media and the gap of time between their construction: *The Green Box* appeared eleven years after Duchamp ceased working on the sculpture. The activation and expansion of the meanings of earlier artworks also informed Beuys's manner of working; he often continued to augment bodies of work over many years.

Beuys's statement reveals that he recognized that *The Green Box* demonstrated Duchamp as "a self-styled linguist and 'scientist' of

Joseph Beuys, *ich kenne kein Weekend* (*I Know No Weekend*), 1971–72

language." As Linda Dalrymple Henderson has argued, "with the exception of Leonardo's notebooks, [the notes in *The Green Box*] are unique in the genre of artists' writing, and their content clearly signals [Duchamp's] role as scientist, engineer, or geometer."[38] About six years after discussing these two works, Beuys commented, "I have already extended the concept of art (however, I do not wish to claim exclusive credit for this; in this respect, even Marcel Duchamp achieved something). . . . If I extend the concept of art to include the concept of creativity, I may also be able to modernize the concept of science and prevent it from remaining static."[39] The declaration is astounding: it implies that though Leonardo may have inspired Beuys in 1958 to develop an expanded concept of art detached from science, it was Duchamp's pre-1923 ideas about aesthetics—firmly attached to science—that seem to have really spurred him on.

Between 1971 and 1972, Beuys made a multiple, *ich kenne kein Weekend* (*I Know No Weekend*), which consists of a portfolio case, a bottle of Maggi seasoning, and a Reclam edition of Immanuel Kant's *Kritik der reinen Vernunft* (*Critique of Pure Reason*). Beuys's unusual decision to subtitle this multiple *Ready-made* underscores the object's dialogue with Duchamp. In fact, the multiple seems to take issue with one of Duchamp's most renowned multiples, his 1941 portable museum *Box in a Valise*. To begin with, Beuys's portfolio does not contain reproductions of his own work. Instead, stripped down to food for the mind and spice for the circulatory system, the object recommends that art results from tireless, mobile proselytizing. Needless to say, such a stance was at loggerheads with Duchamp's retreat from the art world and laissez-faire approach to making art.

The bottle of Maggi seasoning also subtly poses a question at the heart of Duchamp's philosophy: "What is art; is it taste or not?" Moreover, while Kant's *Critique of Practical Reason* (1788) deals with traditional issues surrounding aesthetics, his *Critique of Pure Reason* (1781) takes up questions of time and space, issues much closer to Beuys's theory of "social sculpture." By stamping "Beuys: Ich kenne kein Weekend" (Beuys: I know no weekend) on the cover of the Kant book and pinning this object and the bottle of liquid spice to the inside cover of the portfolio, Beuys produced a new kind of readymade that marks the beginning rather than the end of the process of making art. The method—spicy exchanges and philosophical reflection—trumps the outcome—the presentation of finished works of art in a space designated for art. Beuys recommends such an idea by concealing graphic works by several colleagues—Klaus Peter Brehmer, Karl Horst Hödicke, Peter Hutchinson, Arthur Köpke, Sigmar Polke, and Wolf Vostell—within the walls of the portfolio.[40] Rather than creating a visible monument to himself (as Duchamp had done with *Box in a Valise*), Beuys, at first glance, offers his viewer a space in which a two-way dialogue can take place. In so doing, he argues that art results from invisible processes that unfold in time—such as hearing, pondering, and willing.

The same year that Beuys began working on this multiple, he purchased Richard Ellmann's biography of James Joyce. He marked this passage in the book:

> Don't you think there is a certain resemblance between the mystery of the Mass and what I am trying to do? I mean that I am trying . . . to give people some kind of intellectual pleasure or spiritual enjoyment by converting the bread of everyday life into something that has a permanent artistic life of its own . . . for their own mental, moral, and spiritual uplift.[41]

The process of transubstantiation referenced here not only profoundly preoccupied Joyce but also Beuys. Beuys's own interest in transubstantiation dates back to at least 1958, when he began to use *Braunkreuz*, an antirust substance that both effectuates change and

changes itself over time. Beuys's employment of it is inseparable from his concern with "spirituality of material." It is this concept that most deeply informs his second multiple: *Zwei Fräulein mit leuchtendem Brot* (*Two Women with Glowing Bread*), 1966. In 1970 Beuys explained the later work, "Man does not nourish himself from bread alone, but also from spirit—actually in the same manner as in transubstantiation. In the multiple with the ladies a journey is undertaken through so-to-say the medium of the bread."[42] These ideas fundamentally oppose Duchamp's readymades, to which the artist generally did not apply his hand apart from an occasional title or signature. Beuys's marking of a work with *Braunkreuz* or rendering a chair unusable by adding a sloping pile of fat physically changes the object, emphasizing its metamorphosis.

Beuys readdressed Duchamp's silence in two multiples: *3-Tonnen-Edition* (*3-Ton-Edition*), 1973–85, and *Das Schweigen* (*The Silence*), 1973. While the former contains two photographs of *Das Schweigen von Marcel Duchamp wird überbewertet*, the title and form of the latter suggest Beuys's aim to bring an end to the idea of silence. This multiple consists of five galvanized film spools of Ingmar Bergman's 1963 film *The Silence*. With this, Beuys effectively both paid an act of homage to this magnificent film—embalming it, as it were—and, by preventing it from being screened again, subtly argued for the need of man to reinvent himself—to break the gruesome, mysterious silence that threatens daily existence.[43] Behind all this was one aim, unequivocally confirmed some ten years later: "I am the one who, today, develops the theory [Duchamp] could have developed."[44]

1974: Duchamp and Beuys in America

In 1974 Beuys made a poster for the exhibition "Multiples: Ein Versuch die Entwicklung des Auflagenobjektes darzustellen" ("Multiples: An Attempt to Represent the Development of an Editioned Object"). This show, which was the first in Germany to present a retrospective of multiples, opened at the Neuer Berliner Kunstverein, two months before Beuys began working on the *Codices Madrid* multiple. The poster consists of a diagram

superimposed over a reproduction of Man Ray's object *Le Cadeau* (*The Gift*), 1921/1963. Beuys placed Duchamp's name at the top of this circular chart; his own name appears directly below. Between the names circulate seven spheres inscribed with various art movements and the artists affiliated with them. Despite the gulf between them, the diagram clarifies that Duchamp remained a diametrical point of reference for Beuys.[45] From Duchamp's domain in the poster, a one-way arrow moves in either direction, while from Beuys's realm reciprocal two-way arrows emerge. Unilateral arrows emanating from Duchamp intimate that though the French artist may have stimulated other art movements, he was not reciprocally affected. Two-way arrows also oscillate

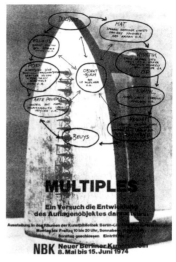

Poster for "Multiples. Ein Versuch die Entwicklung des Auflagenobjektes darzustellen" ("Multiples: An Attempt to Represent the Development of an Editioned Object"), exhibition at the Neuer Berliner Kunstverein, 1974

between the circle at the chart's center with the label "Objekt Buch" (object book) and the other spheres, including Duchamp's. However, no arrow emanates from Beuys's sphere toward this center, indicating that even though the *Codices Madrid* might resemble an artists' book, for Beuys it was unrelated to the genre. Finally Beuys's enclosure of Duchamp's and his own name in spheres unoccupied by others relates to this statement in René Block's introduction to the catalogue: "Duchamp and Beuys are the two most outstanding art personalities of the twentieth century. . . . The spectrum of contemporary art unfolds between the two poles of Duchamp and Beuys."[46]

The squaring off of Beuys and Duchamp in 1974 was not just theoretical but also actual. Beuys first traveled to America that year at the invitation of Ronald Feldman, who organized a series of public lectures for him in New York, Chicago, and Minneapolis. His arrival in New York on January 9, 1974, coincided with a flurry of

euphoria around Duchamp. The largest retrospective of Duchamp's work to date had just opened at the Museum of Modern Art with an extensive catalogue, featuring *L.H.O.O.Q.* on its cover. Feldman presented a large concurrent Duchamp show; however, he prematurely deinstalled it to hold the reception he had arranged for Beuys on January 12. On December 7, 1973, Feldman Fine Arts issued this statement in a press release about its Duchamp exhibition:

> The exhibition, which has been extended through the end of January, includes examples of early drawings and paintings, ready-mades, and other objects: copperplates, hand-colored etchings, and the complete set of etchings from *The Large Glass.*

> During the week of January 7, the Duchamp exhibition will be closed. The gallery will be devoted to various scheduled events of Joseph Beuys.[47]

As it turned out, the Duchamp exhibition was never reinstalled. Instead, following the reception, during which Beuys publicly discussed his concept of social sculpture, the walls of the gallery remained bare until February 16, when a Chris Burden show opened. Whether Beuys intended these empty rooms as a show remains unclear, but a comment from an interview that appeared in the German weekly newspaper *Die Welt* on February 6, 1974, indicates that Beuys had no desire to greet the public in a room filled with Duchamp works: "It was my condition that the gallery would be completely empty to enable us to better discuss with one another."[48] Though Beuys's lectures and reception were well attended, he was received in a less than welcoming manner. One critic observed, "Beuys and his work were greeted in America with derision, suspicion, and distaste, as well as fascination and awe."[49]

Beuys returned to New York to make the action *I Like America and America Likes Me*, between May 23 and 25 at the Galerie René Block in New York. It took place just fifteen days after the opening of the Neuer Berliner Kunstverein's "Multiples" exhibition, which had also been organized by Block. Given the less than enthusiastic reception of his work just a few months earlier, the title of his action

was partly "a neat piece of (self-mockery)."[50] Indeed, if there was one European artist that Americans upheld in 1974, it was Duchamp. That year no fewer than four books appeared on the artist, among them one by Jack Burnham.[51] Although he was more than likely indifferent to the posthumous fanfare around Duchamp, Beuys's 1974 postcard statement "Lasst Jack Burnham ruhig Essen" ("Let Jack Burnham eat in peace") indicates that he felt the increasing popularity of Burnham's ideas in Germany should not escape comment.

Joseph Beuys, from *Drawings after the Codices Madrid of Leonardo da Vinci*, 1974

The title and iconography, however, of *I Like America and America Likes Me* addressed Americans, inviting them to come to terms with their heartless massacre of the Indians in the interests of capitalistic westward expansion. Beuys's first public action on American soil, it opened some fifteen months after members of the American Indian Movement and their sympathizers at Pine Ridge Reservation began to occupy the historical site of the Battle of Wounded Knee. It took seventy-one days for the Federal Bureau of Investigation and the United States Army to crush this final demonstration of the Oglala Sioux. Dominated by an image of Beuys as a kind of medicine man enclosed in a cage conducting a dialogue with a coyote, the action evoked their now muted voices of howling protest, about which Beuys refused to remain silent.

Together these events most likely informed Beuys's decision that year to date three sheets of his *Codices Madrid* 1964. On their versos, one reads: "Joseph Beuys/~~1974~~ 1964" (Dia 80.435); "Beuys 1964/Seven Palms/Kenia" (Dia 80.502); "Joseph Beuys/1964" (Dia 80.497). While the last inscription is straightforward, the date of Dia 80.435 has been deliberately and obviously altered, and Dia 80.502 apparently misdated: Beuys spent Christmas in Kenya in 1974. The multiple veils these facts, but it bluntly exposes Beuys's

conviction in drawing as a form of speaking. If this multiple has a theme, then it is the power of lines to awaken inner reflection, thinking, and communication. Note, for example, the first drawing reproduced in it: a man looks outward and then back into himself; lines swirl into his ear and trickle out through a form that resembles Beuys's object *Lavendelfilter* (*Lavender Filter*), 1965. That work, too, advocated discursive processes. Beuys explained its meaning: "The spreading of ideas to the different force fields of human ability, a kind of inspiration that takes effect through a physical process of capillary absorption: psychological infiltration, or even the infiltration of institutions."[52]

The concept of infiltration is essential to Beuys's aim with his multiples: the dissemination of his ideas to a broad-based public. His decision to translate into English all the textual passages within his *Codices Madrid* multiple further underscores his preoccupation with continuing a dialogue with an English-speaking audience, whether in America, Ireland, or England. In 1965 Beuys made his first multiple—*Von Tod zu Tod und andere kleine Geschichten* (*From Death to Death and Other Small Stories*)—consisting of this book by Richard Schaukel and an original Beuys drawing placed in the first fifteen of the 115 editions. The genre of multiples, as Beuys was well aware, is partly informed by aesthetic maneuvers that Marcel Duchamp had conducted a half a century before. Spawned by a wish to duplicate his originals, Duchamp in 1914 decided to make five editions of *The Box of 1914*. The *Box* was actually a commercial photographic-supply carton, in which Duchamp placed photographic facsimiles of sixteen handwritten notes and a drawing relating to *The Large Glass*. Duchamp enclosed these photographs in a standard box for photographic plates. Although Beuys was probably unaware of it, Duchamp's *Box of 1914* may have been stimulated by Charles Ravaisson-Mollien's six-volume facsimile of Leonardo's notebooks, published between 1881 and 1891. Such an inspiration would explain why Duchamp took photographs, rather than copying by hand, his first notes for *The Large Glass*.[53]

Duchamp was fascinated by Leonardo's notebooks, for they not only exhibited his mental prowess but also established ideas

in written form, of notation, as an art form in and of itself. Beuys's 1974 *Codices Madrid* multiple also intentionally aligns the work with Leonardo's compulsive note-taking practice: Identical in size to Leonardo's *Codices Madrid*, its outer shell duplicates a standard school composition notebook.[54] A quotation from Leonardo's first notebook of the *Codices Madrid* appears on the multiple's title page:

> Peruse me, reader, if I bring you joy, for but seldom will I return to this world. For few have the perseverance to pursue this profession and the inclination to invent such things anew. And come, my fellow-humans, to behold the wonders that nature discloses through such studies.[55]

By commencing the multiple with this passage, Beuys not only took up Leonardo's gauntlet but also hurled it toward his own future "readers." His aim was nothing less than to attempt to "reinvent" Leonardo through the transformative medium of his own drawings. Art was never static for Beuys. As he put it: "The work of art is the greatest riddle, but man is the solution." Taking up such a challenge is what makes writing about Beuys so rewarding.

December 3, 1998

Notes

I am grateful to Dieter Koepplin, who not only made vital suggestions concerning source materials but also critically read this manuscript. The text has greatly benefited from his comments.

1 The four drawings used in the multiple but not in Dia's collection are owned by Götz Adriani, Roland Hanssel, and the Marx Collection, Berlin. All of these are dated 1974. Six drawings not in the multiple but reproduced as granolithographs and inserted into special editions of the multiple are illustrated in *Joseph Beuys: Die Multiples*, ed. Jörg Schellmann (Munich: Schirmer/Mosel, 1992), pp. 174–81, plate 166 (*Figur*, 1955); 169 (*Untitled*, undated); 170 (*Untitled*, undated); 172 (*Lycon Puctus Hunting Dog*, 1974); 173 (*Untitled*, undated); 176 (*Untitled*, 1956). See, also, p. 454. Several drawings made for this project but not used in the multiple have emerged in several exhibitions over the years; their locations today are largely unknown. Compare plate 176 in Schellmann's book with the original drawing signed and dated on its face, reproduced in *Hauptstrom Jupiter: Beuys und die Antike* (Munich: Glyptothek, 1993), p. 37. When the print was made, Beuys apparently had not signed and dated the drawing for it, a fact consistent with Hanssel's statement that Beuys only signed and dated the drawings reproduced in the multiple. Since these six drawings were not part of the multiple as such, but used as supplementary granolithographs, it is likely that Beuys signed and dated them sometime after he completed working on the multiple in 1975, possibly when he sold them. Hanssel, conversation with the author, March 17, 2004.

2 *Joseph Beuys: Drawings after the Codices Madrid of Leonardo da Vinci*, ed. Lynne Cooke and Karen Kelly (New York: Dia Center for the Arts, 1998).

3 See Götz Adriani, Winfried Konnertz, and Karin Thomas, *Joseph Beuys: Leben und Werk* (Cologne: DuMont, 1994), p. 144. (An English translation of this book, now out of print, was published in 1979: *Joseph Beuys: Life and Works* [New York: Barron's, 1979].) This information contradicts that from a letter of June 20, 1987, to Dia Art Foundation from the Beuys Estate. In it, Eva Beuys-Wurmbach states the trip took place between July 20 and 30, 1974.

4 Götz Adriani, afterword to Joseph Beuys, *Zeichnungen zu den beiden 1965 wiederentdeckten Skizzenbücher "Codices Madrid" von Leonardo da Vinci* (Stuttgart: Manus Presse, 1975), pp. 152–53.

5 Beuys, quoted in Martin Kunz, "Gespräch mit Joseph Beuys" (Düsseldorf, March
 10, 1979), in *Spuren in Italien—Tracce in Italia* (Lucerne: Kunstmuseum, 1979),
 n.p. "Und die ersten Zeichnungen sind entstanden gleich nach dem Auftrag, den
 ich bekommen hatte, in Italien, wo ich hinmusste. Ich habe mir gleich Papier
 mitgenommen und habe dann auch angeknüpft an diese Erlebnisse aus dem Krieg,
 die ich vorhin geschildert habe. Da kommt auch Wasser und Felsen vor, dass
 Wasser und Felsen fast lemurenhaft übergehen und so Gestalt annehmen."

6 See Adriani, Konnertz, and Thomas, p. 207.

7 Eva Beuys-Wurmbach, *Die Landschaften in den Hintergründen der Gemälde
 Leonardos* (Munich: Verlag Schellmann & Klüser, 1974).

8 Leonardo da Vinci, quoted in Adriani, in Beuys, *Zeichnungen zu den beiden 1965
 wiederentdeckten Skizzenbücher "Codices Madrid" von Leonardo da Vinci*, p. 151.

9 Beuys, quoted in "If nothing says anything, I don't draw," a conversation between
 Joseph Beuys, Heiner Bastian, and Jeannot Simmen (Düsseldorf, August 8, 1979),
 in *Joseph Beuys: Zeichnungen, Tekeningen, Drawings* (Rotterdam: Museum Boymans-
 van Beuningen and Nationalgalerie, Berlin, 1979), p. 98.

10 See Matthias Bunge, "Joseph Beuys und Leonardo da Vinci: Vom 'erweiterten
 Kunstbegriff' zu einem erweiterten Kunstwissenschaftsbegriff—Teil I," in *Das
 Münster* 46, no. 2 (1993), p. 95.

11 Leonardo da Vinci, quoted by A. Richard Turner, *Inventing Leonardo* (Berkeley:
 University of California Press, 1992), p. 205. For Beuys's conception of energy as
 an invisible force, see "If nothing says anything, I don't draw," p. 29.

12 Kenneth Clark, "Leonardo's Notebooks," *The New York Review of Books* 21, no. 20
 (December 12, 1974), pp. 12–17.

13 Beuys, quoted in Adriani, Konnertz, and Thomas, p. 44: "dass die beiden Begriffe
 Kunst und Wissenschaft in der Gedankenentwicklung des Abendlandes diametral
 entgegenstehen . . . und dass erweiterte Begriffe ausgebildet werden müssen."

14 Richard Ellmann, *James Joyce* (Oxford: Oxford University Press, 1983), p. 99. Beuys
 acquired the German translation of this book in 1971 and marked the following
 passage along with twelve others: "He thought it possible that an avatar might be
 born in Ireland." (Richard Ellmann, *James Joyce*, trans. Albert W. Hess, Klaus and
 Karl H. Reichert [Frankfurt: Suhrkamp, 1959].) Beuys's copy is located in the Beuys
 Estate, Düsseldorf.

15 See note 3. The German edition of Adriani, Konnertz, and Thomas's *Joseph Beuys:
 Leben und Werk* was originally published by DuMont in 1973; it was subsequently

reprinted in 1981 and 1994. An English translation by Patricia Lech was published by Barron's, New York, in 1979 as *Joseph Beuys: Life and Works*. All editions use the *Lebenslauf/Werklauf* as an organizing source.

16 Adriani, Konnertz, and Thomas, pp. 23–24.

17 See Christa-Maria Lerm-Hayes, *James Joyce als Inspirationsquelle für Joseph Beuys* (Hildesheim: Olms, 2001), p. 29. When I visited the Beuys Estate in 1993, I was only shown the 1939 Faber and Faber, London, edition of Joyce's *Finnegan's Wake*, which was not marked by Beuys. See Pamela Kort, "Joseph Beuys's *Arena*: The Way In," in *Joseph Beuys: Arena—where would I have got if I had been intelligent!* (New York: Dia Art Foundation, 1994), pp. 23–25.

18 See Sabine Fabo, *Joyce und Beuys: Ein intermedialer Dialog* (Heidelberg: Universi-tätsverlag C. Winter, 1997), p. 184. I am also grateful to Klaus-D. Pohl, curator at the Hessisches Landesmuseum Darmstadt, for further information regarding these images.

19 I was shown the original version of Beuys's *Lebenslauf/Werklauf* in 1993 by Armin Hundertmark, its owner. This entry was positioned in the year 1961 in that docu-ment and every reproduction of it until 1994, when it was repositioned to the year 1963 in the most recent edition of Adriani, Konnertz, and Thomas's *Joseph Beuys*. I was also shown the typescript referenced in Adriani, Konnertz, and Thomas, p. 207, n3. As the position of this entry during Beuys's lifetime, I remain convinced that the entry belongs in 1961.

20 Beuys, quoted in "If nothing says anything, I don't draw," p. 100.

21 A related term, *Wärmeplastik* (warm sculpture), appears on several of the sheets of the *Codices Madrid* drawings. See, particularly, Dia numbers 80.418 and 80.450, in *Joseph Beuys: Drawings after the Codices Madrid of Leonardo da Vinci*, pp. 59 and 104.

22 See Gerhard Kaldewei, "'Unsere Arbeit war nicht umsonst': Beuys, Kleve, Getlinger 1950–1986. Lokale Chronologie eines spannungsvollen Beziehungsgeflechts," in *Getlinger Photographiert Beuys, 1950–1963* (Cologne: DuMont, 1990), p. 9

23 See Robert Lebel, quoted in Marcel Jean, *Geschichte des Surrealismus*, trans. Karl Schmitz-Moormann (Cologne: DuMont Schauberg, 1959), p. 380. Cited in Theodore Reff, "Duchamp and Leonardo: L.H.O.O.Q.—Alikes," in *Art in America* 65, no. 1 (January–February 1977), p. 83.

24 See Linda Dalrymple Henderson, *Duchamp in Context: Science and Technology in* The Large Glass *and Other Works* (Princeton, N.J.: Princeton University Press, 1998), p. 72. See also Reff, pp. 83–93.

25 Beuys, "Krawall in Aachen," *Kunst* 4 (1964), and Beuys, "Plastik und Zeichnung,"

Kunst 1 (June–July 1964), pp. 127–28.

26 See Uwe M. Schneede, *Joseph Beuys: Die Aktionen* (Ostfildern-Ruit, Germany: Verlag Gerd Hatje, 1994), pp. 80–82. See also Marie-Luise Syring, "Der Duchamp-Konflikt," in *Um 1968: Konkrete Utopien in Kunst und Gesellschaft* (Düsseldorf: Städtische Kunsthalle, 1990), pp. 17–27.

27 See Matthias Bunge, "Vom Ready-made zur 'Fettecke': Beuys und Duchamp— ein produktiver Konflikt," in *Joseph Beuys: Verbindungen im 20. Jahrhundert* (Darmstadt: Hessisches Landesmuseum, 2001), p. 29.

28 See Antje von Graevenitz, "Das Schweigen brechen: Joseph Beuys über seinen 'Herausforderer' Marcel Duchamp," in *In Medias Res: Festschrift zum siebzigsten Geburtstag von Peter Ludwig,* ed. Marc Scheps and Frank Günter Zehnder (Cologne: Dumont, 1995), pp. 197–224.

29 Beuys, quoted in Gerhard Storck, "Stoff-Wechsel: Neue Materialien für eine lebendige Geometrie," in *Transit: Joseph Beuys—Plastische Arbeiten 1947–1985* (Krefeld: Kaiser Wilhelm Museum, 1991), p. 30: "Am 12.5.63 stürzt sich Marcel Duchamp ins Schwert."

30 Beuys, "Das Nomadische spielt eine Rolle von Anfang an," interview by Keto von Waberer, in *Joseph Beuys: Eine innere Mongolei,* ed. Carl Haenlein (Hannover: Kestner-Gesellschaft, 1990), p. 218. "Ich halte ihn ja sowieso für einen außerordentlich interessanten Künstler."

31 Beuys, "Joseph Beuys, Les Levine, Krzystof Wodiczko, and Stephen Willats," produced by William Furlong and Michael Archer, audiotaped discussion, 1985, cited in Graevenitz, p. 198.

32 See Monika Angerbauer-Rau, *Beuys Kompass* (Cologne: DuMont, 1998). In the interviews catalogued here, Beuys refers to Duchamp twenty-nine times, in comparison with only seventeen mentions of Leonardo, ten of Cage, and eight of Joyce.

33 See Mario Kramer, "Joseph Beuys und der Zeitgenosse John Cage: Im Dialog mit Marcel Duchamp, Erik Satie und James Joyce," in *Joseph Beuys: Verbindungen im 20. Jahrhundert* (Darmstadt: Hessisches Landesmuseum, 2001), p. 91.

34 See *Les Années Vingt: Les Ecrivains Américains à Paris et Leurs Amis, 1920–1930* (Paris: Centre Culturel Américain, 1959), p. 72. Cited in Arturo Schwarz, *The Complete Works of Marcel Duchamp,* vol. 2, 3rd ed. (New York: Delano Greenidge, 1997), p. 744.

35 See Richard Hamilton, *Imaging James Joyce's Ulysses* (Ljubljana: Cankarjev Dom Galerija, 2002); and Hamilton's *The Bride Stripped Bare by Her Bachelors, Even,* a typographic version of Marcel Duchamp's *The Green Box,* trans. George Heard

Leonardo da Vinci, Marcel Duchamp, and Joseph Beuys **61**

Hamilton (London: Percy Lund Humphries, 1960). See, also, the biographical chronology in *Richard Hamilton* (London: Tate Gallery, 1992), pp. 186–92. According to this chronology, Hamilton first began to make studies for *Ulysses* in 1947. However, the more recent Ljubljana catalogue dates Hamilton's first *Ulysses* drawings to 1948.

36 Hamilton, interview by the author, 1995. Unfortunately, a show planned of Beuys's six *Ulysses* sketchbooks and Hamilton's *Ulysses* drawings for the Joyce Tower at Sandycove, Dublin, where Joyce's manuscripts were kept, was cancelled due to the owner's concern that Beuys's sketchbooks were too fragile. See Caroline Tisdall, *Bits and Pieces: A Collection of Work by Joseph Beuys from 1957–1985* (Edinburgh: Richard Demarco Gallery, 1987), p. 12.

37 Beuys, quoted in Kunz, p. 13: ". . . privater Zusammenhang deswegen, weil er seine Ideen also für dieses Beispiel 'Grosses Glas' ja selbst elaboriert hat. Ich sage auch ganz bewusst: elaboriert hat, weil das, was er gemacht hat, wiederum in einem rätselhaften formalen Zusammenhang steht zum anderen physischen Zusammenhang, wie eine Art von Dichtung."

38 Henderson, p. 191.

39 Beuys, "Death keeps me awake," interview by Achille Bonito Oliva, in *Energy Plan for the Western Man: Joseph Beuys in America. Writings and Interviews with the Artist*, ed. Carin Kuoni (New York: Four Walls Eight Windows, 1990), p. 173.

40 See Bunge, "Vom Ready-made zu 'Fettecke,'" p. 28.

41 Ellmann, p. 163.

42 Beuys, quoted in "Fragen an Joseph Beuys," interview by Jörg Schellmann and Bernd Klüser, in *Joseph Beuys: Die Multiples*, p. 11. ". . . daß der Mensch sich nicht von Brot allein ernährt, sondern vom Geist. Eigentlich in derselben Weise wie die Transsubstantiation. . . . Bei dem Multiple mit den Fräuleins wird sozusagen mit dem Brot eine Reise unternommen."

43 See Dierk Stemmler, "Zu den Multiples von Joseph Beuys," in *Joseph Beuys: Die Multiples*, p. 542. See also Heiner Bastian, "Die Sprache des Spiels und die Sprache der Trauer: Über das werk 'Das Schweigen' von Joseph Beuys," in *Joseph Beuys* (Berlin: Nationalgalerie im Hamburger Bahnhof, 1999), pp. 26–28.

44 Beuys, interview by Bernard Lamarche-Vadel, in *Canal* 58–59 (Winter 1984–85), p. 7. Quoted in Thierry de Duve, *Kant after Duchamp* (Cambridge, Mass.: MIT Press, 1997), p. 285.

45 Werner Spies was perhaps the earliest critic to argue for Duchamp's influence on Beuys. See "Das Schweigen von Beuys: Anmerkungen anlässlich einer

amerikanischen Wanderausstellung," in *Frankfurter Allgemeine Zeitung*, September 18, 1993, no. 217, p. II.

46 René Block, introduction to *Multiples: Ein Versuch die Entwicklung des Auflagenobjektes darzustellen* (Berlin: Neuer Berliner Kunstverein, 1974), p. II.

47 Ronald Feldman Fine Arts, press release, December 7, 1973. Archives of Ronald Feldman Fine Arts. I am grateful to Ronald Feldman and Peggy Kaplan for supplying me with documents and information concerning their Marcel Duchamp exhibition and their work with Beuys in 1973 and 1974.

48 Beuys, quoted in "Die Kunst ist nicht im Überbau," interview by Willi Bongard in *Die Welt* (Hamburg), February 6, 1974, p. 18. An English translation of this article is in the archives of Ronald Feldman Fine Arts.

49 Kim Levin, introduction to *Energy Plan for the Western Man*, p. 2.

50 Caroline Tisdall, "Beuys in America, or The Energy Plan for the Western Man," in *Energy Plan for the Western Man*, p. 13.

51 Reviewing these books a critic wrote: "After decades of enigmatic silence, denials of meaning and disguises of nonsensicality on his part ... Duchampian scholars are now hot on the trail of an elaborately concealed iconography." (Kim Levin, "Early Modernism," in *Art in America* 62, no. 6 [November–December 1974], p. 48.)

52 Beuys, quoted in Caroline Tisdall, *Joseph Beuys* (New York: Solomon R. Guggenheim Museum, 1979), p. 148.

53 See Francis M. Naumann, *Marcel Duchamp: The Art of Making Art in the Age of Mechanical Reproduction* (New York: Harry N. Abrams, 1999), p. 56.

54 Klaus-Gerrit Friese (Manus Presse), letter to Gary Garrels (Dia Art Foundation), July 27, 1987, Dia Art Foundation archives.

55 Leonardo da Vinci, *Codex Madrid I*, title page to Beuys, *Zeichnungen zu den beiden 1965 wiederentdeckten Skizzenbücher "Codices Madrid" von Leonardo da Vinci*.

Robert Irwin and the Condition of Twilight

JONATHAN CRARY

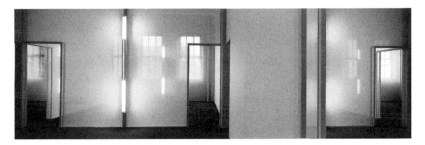

Robert Irwin, *Prologue: x 18³*, 1998

The discussion of how Robert Irwin's work engages and reconfig-
ures the problem of perception is a well-traveled route into his art.
One of the most persistent observations in this discussion, over
several decades, has been that Irwin's work produces a heightened
awareness of the operation of our own perceptual faculties and that
the subject of his art is perceptual experience itself.

Essentially, I have no disagreement with these broad characteri-
zations, but my own focus is turned more toward how these issues
intersect with major historical and cultural problems. Instead of
being seen as a self-enclosed arena in which novel or complex forms
of experience and perception are possible—like some kind of
sublime fun house—Irwin's art should, I believe, be regarded in
relation to a contemporary crisis of perception. His two installations
Prologue: x18³ and *Excursus: Homage to the Square³* (1998) offer, in
some ways, a meditation on the fate of experience at the turn of the
millennium. I will also say that in important ways, these are *somber*
works in their conception, over and above any of their sensory
effects. I mean this somewhat in the way Meyer Schapiro referred to
Paul Cézanne's later work as "an art of grave attention."[1] To imply
that Irwin's work is grave, or somber, might seem off target in
terms of much of what we know, at least publicly, about him and

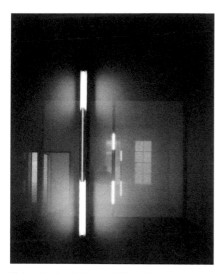

Robert Irwin, *Prologue: x 18³*, 1998

his practice. But the apparently unflappable cultural optimism that is genuinely part of Irwin's outlook, especially in his recent public projects, takes on a fuller meaning when we consider both the stakes and challenges of maintaining that affirmative position. I see his work as posing a set of counterpractices whose effects become fully understandable only in relation to dominant ways in which perceptual experience is currently being reconstructed and refashioned. I am referring to how a pervasive set of social imperatives is increasingly accepted as desirable or inevitable, or both. These are imperatives that presume that productive time, social time, leisure time—essentially all waking time—can or should be usefully spent in the immobilizing interface of a human subject with a luminous screen and keyboard. It is as if the exponential increase in the possibilities of accessible information produces a related atrophy and devaluation of the range of possible perceptual and sensory experience.

The two consecutive installations at Dia may be seen as rejections of the contemporary values of speed, storage, uniformity, and exchangeability, against which Irwin sets up a field constituted of singular nonrecordable phenomena for a mobile and spatialized observer. Beyond its ephemeral surfaces and anomalous chromaticism, his project is the provisional staking out of a clearing in which effects of slowness and silence are produced within a larger field of sensory dilation. One of the words that comes to mind is *muffled*—like the experience of the city immediately after a snowstorm—implying that there is a latent auditory component to the work as well. I am convinced that the sense of an auditory modification has more to do with a subjective shift in the ratio of the senses

than with any acoustical properties of the materials used and their arrangement in the show. However, Irwin is not proposing any kind of return or restoration of some more natural or authentic conditions of perception. Perception for him is always a construction, an interpretation, rather than a direct grasp of the world. But his work suggests that there is an immense and unexplored range of possible ways in which perception can be constructed. Reality may not be given to us immediately, but we do have choices about the forms of its mediation.

Irwin's work has long been seen as deploying various strategies of defamiliarization, as an effort to detach the audience from conventional visual expectations and habits. Like William James, who was also responding to what he saw in the late nineteenth century as a depreciation of perception, Irwin redefines the very terms out of which experience is assembled. This means thinking of Irwin not so much in terms of a language of dematerialization and etherealization, but instead seeing his project in its intellectual affiliation with what James called "radical empiricism"—that is, a reconceiving of the actual concrete elements of experience: in a sense, a sweeping redefinition of what constitutes so-called facts.[2] Instead of attributing priority to stable objects, discrete forms, or individual entities or instants, James believed that the heart of experience was made up of vague in-between states, transitions, passages, overlappings, a collapsing of figure into ground, intuitions of relatedness and flux. And it is in this sense that Irwin's work redirects us to the fringes, the penumbral overtones around transitive processes both in consciousness and in our lived activity. *Vagueness* here is synonymous with *richness of experience*, with holding forth the promise of future revelation or discovery. Perception no longer operates in support of a principle of identity.

There are many ways in which we can associate Irwin's thought with more recent philosophical work as well. For example, in the work of a thinker with whom Irwin is clearly familiar, philosopher of science Michael Polanyi, we see another important project of "reinstating the vague" (to use James's phrase). Polanyi, in his book *Personal Knowledge*, rehabilitated the word *ineffable* to define crucial

Robert Irwin, drawing for *Prologue: x 18³*, 1997–98

components of awareness and perception that most twentieth-century science and philosophy had rejected as meaningless, and he suggested ways in which Irwin's work might indeed be described as "ineffable" without recourse to a mystical vocabulary.[3] Polanyi, crucially for understanding Irwin's work, insists on the significance of subsidiary, peripheral awareness in the constitution of experience. But, having said this much as a way of approaching what are the most palpable and most seductive effects of Irwin's work, it is important not to overlook the larger organization and impact of the work and the tensions and oppositions that animate it.

Let me start by suggesting the dense historical terrain that is embedded in the installations by the site specificity so central to Irwin's practice. While the layout of the work is derived from the specific structural elements of Dia's converted nineteenth-century warehouse building (the columns and beam arrangement), the third floor is one cubic module in a multistory building that is itself a modular unit within the grid of Manhattan—as all the north-south alignments with which Irwin works coincide effectively with the grid of New York City's 1811 urban plan. But perhaps more important are the resonances of this potent historical model, this dream of an urban imaginary, going back to antiquity, of imposing an ideal set of formal relations onto the singularities, the accidents of social and natural life. So any engagement with site here is an engagement with a distillation of the complex destiny of this foundational utopian project, which had long involved the coincidence of visionary ambitions with techniques of administration and regulation.

But this familiar project of a quantifiable parceling out of space is also bound up in the history of pictorial practices. The title of the second piece, *Excursus: Homage to the Square*[3], clearly suggests some kind of transformational relation between the variables and coordinates of two-dimensional and three-dimensional form, that is, between a square and a cube. Whether Irwin is modeling a proposition about a threshold space of creation *between* painting and architecture is a topic for a whole other lecture. In any case, the presence of at least the template of this historical model is a crucial part of the operation of the piece. It exists as at least the possibility of a legible space that is unified by its metric relations, and in which distance is abstractly comprehensible. But we should remember Erwin Panofsky's thesis that perspectival construction had no necessary or intrinsic connection to human vision but was, rather, the artificial imposition of a rationalized and quantifiable system onto the idiosyncrasies of embodied human sight. That is, it was a technique for making visual experience conform to a Euclidean model of external reality and for transcending the limitations and deformations of subjective perceptual experience. Crucial for an artist of Irwin's intellectual leanings is how this system coexists in the Dia installation with a range of counterpractices. What is at issue here is not some reductive notion about an artist subverting perspective but, rather, the more difficult problem of work that insists on the inescapably mixed character of contemporary perceptual experience, or what might be called its "patchwork" nature.

All of us in the present-day technological culture inhabit a shifting mix of new and old perceptual modalities, of hybrid zones composed of Euclidian space and dimensionless experiences of electronic networks that often appear to be seamlessly connected. Thus amid the fluctuating and unstable character of Irwin's work is a human subject who is still at least partially anchored within the remnants of a Newtonian universe, even if these surviving components have been rendered contingent and spectral. It recalls how Colin Rowe characterizes some contemporary urban spaces as simultaneously "theaters of memory and theaters of prophecy."[4]

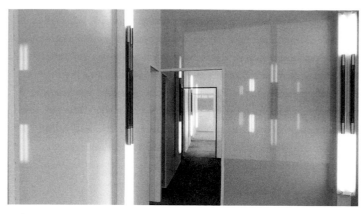

Robert Irwin, *Excursus: Homage to the Square³*, 1998

One of the canonical definitions of postmodern space is
that it transcends the capacity of the individual human body, in
Fredric Jameson's words, "to locate itself, to organize its immediate
surroundings perceptually, and cognitively to map its position in a
mappable external world."⁵ I believe Irwin's work distances itself
from this kind of hypothesis—certainly, he is presenting a complex
environment with labyrinthine features, but, like most of the envi-
ronments in our lives, it is one to which we are able to bring a tool-
box of partial maps and imperfect perceptual skills, which allow the
emergence of something more coherent than the postmodern model
of incomprehensibility and opacity.

Irwin's work seems manifestly more "architectural" than pictorial,
and it is therefore important to remember how central the problem
of architecture was to perspectival practices, whether in the work of
painters or architects. But I am more interested here in a third arena
in which perspective is articulated—one that brings together both
the architectural and subjective perceptual dimension of Irwin's
work—and that is the history of theater scenography. Hubert
Damisch and others have indicated the dense intersection of paint-
ing, architecture, and theater in the origins of perspective; what is
particularly relevant here is how classical theater design was always
a mix of three-dimensional or quasi-architectural forms and illusory
two-dimensional pictorial elements, or flats, which, when synthesized

together, made up an illusory approximation of extensive space, unified by the checkerboard grid of the stage. In Irwin's work we are, at any given position in the piece, embedded in a kind of scenography, although more as actors than as audience, since we do not have the immobility or distance from the stage that would be set up by a proscenium. As we move and turn through the work, there is a kaleidoscopic reconfiguration of orthogonals that define at least a hypothetical vanishing point around which a given static position might be oriented.

Within these elements, however, Irwin imposes a very different kind of system, one that has important links with a more recent conception of theatrical experience—I am referring to his use of theatrical partitions, or scrims. If you research this word you'll find that it has only a vague etymological history: there is no agreement on what language it derives from, but significantly it was first used in the early 1790s to describe a new, durable, industrially manufactured fabric. By 1815 this kind of fabric (or variants of it) was being used in a radically new approach to stage design, and this is where the word *scrim* acquired its modern meaning. The year 1803 brought the first tentative use of gas in theatrical lighting; just fifteen years later it was pervasive in theaters across Europe. The new technology meant that stage illumination could depart from the relative uniform and symmetrical use of candlelight and oil lamps, and that lighting could be controlled in terms of both direction and intensity. The scrim took on its full practical meaning with this technological shift, for—as we well know—when lit from behind a scrim seems relatively transparent, whereas when lit exclusively from the front it seems completely opaque. The range of illusions that could be created and the spatial and temporal dislocations now possible were myriad, but what is especially relevant are the ramifications of a technique that has the properties of both solid and void, of both translucence and opacity, of something both tactile and dematerialized.

Despite Irwin's remoteness from this historical field, the issues of aesthetic appearance are not completely dissimilar—that is, there is still the double-sided problem, coming out of German

John Henry Pepper, *The Pepper's Ghost Illusion*, 1863

Romanticism, of appearance as something fraudulent, as mere illusion, and at the same time as a threshold at which the material symbol is transmuted into numinous experience. Perhaps the best-known experimenter with the properties of theatrical scrims was one of the most consequential figures in the history of modern visual culture—Louis Daguerre, who as an unsuccessful academic painter moved into stage design and became famous for the luminous effects he created in Paris theaters, basically producing transparent paintings as part of an overall design. By 1822 the optical possibilities inherent in the use of scrims and their illumination led Daguerre to design one of the most important nineteenth-century forms of spectacle—the diorama. It was called that because of the transparent properties of the materials he used in connection with lighting techniques—this is, incidentally, the sense of the prefix *dia*. I note this because it is an instance of a modernized perceptual experience that depends on the expectations of an intelligible apprehension of space and distance, but that simultaneously dismantles the conceptual foundations of that older model of spatial order and rationalization. The diorama basically consisted of transparent paintings, presented as a display of stage-type lighting effects that unfolded temporally. Spectators would see a slowly changing scene—a sunny day in the Alps turning to a brooding storm, Gothic ruins appearing out of mist in a valley, torchlight revealing the throngs in the Temple of Solomon. The spectacle coincided with the breakdown of a homogenous, unified conception of theatrical space. There are numerous accounts of spectators experiencing dizziness and vertigo because of the uncertainty of spatial distance in the illusory effects; it was not uncommon for audience members to throw coins at Daguerre's scrims as a crude way of attempting to figure

out how the illusion was created or how far away it really was.

Daguerre's next project after the diorama was the daguerreotype. Like the experience of multiple effects of a painted scrim, the experience of the daguerreotype is one that cannot be portrayed in a photograph: the image on the metallic surface of the daguerreotype oscillates in

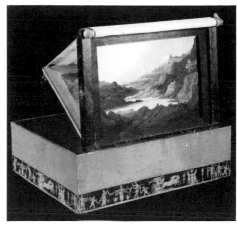

John Clark, *The Portable Diorama*, 1826

and out of visibility depending on how light strikes it. It does not have a stable optical identity in relation to the shifting view of an individual observer. I bring this up simply to encourage a consideration of the implications of a system of variable transparency that is designed for simultaneous orientation and disorientation.

Not surprisingly, Irwin's use of scrims has been discussed as a *tactile mode of vision*, a term borrowed from the Viennese art historian Alois Riegl. I disagree with this characterization and believe that Irwin is in fact more usefully understood in light of Riegl's model of an *optical mode of vision*. For Riegl, a tactile art (or a *haptic* art, deriving from the Greek word for "touch") is one in which the world is made present in an eternal, unchanging objective form. His example was ancient Egyptian art, the self-evident tactility of which was posed against the idea of opticality. Optical art, in contrast, incorporates into it the distortions and concealments of light and shadow, the relativization of distance, and above all the subjective experience of the eye itself. Leonardo da Vinci's paintings, with their effects of sfumato, would be a decisive example of work that defined an optical mode: they affirm that vision is not about a grasp of stable and discrete forms, but about a dissolution and blurring of identities, about the nebulous intervals between and among objects. This dimension of Leonardo stands behind a long

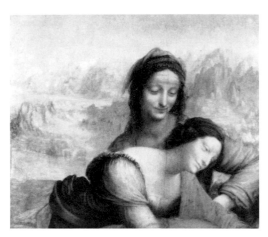

Leonardo da Vinci, *The Virgin and Child with Saint Anne*, 1510, detail of sfumato

history of perceptual practices that can be traced through Rembrandt, Turner, and Monet. Some of the ramifications of Irwin's work become clear in relation to this larger genealogy, which goes back beyond his more obvious affiliations with twentieth-century experimenters, including Henri Matisse, Josef Albers, and Mark Rothko.

Thus much of Irwin's work is an affirmation of a heightened optical experience, in which we are made aware of the operation of our own perceptual capabilities—and their limitations. An extreme optical orientation diminishes the ability of the individual to discriminate distance, position, contours, and substance; it devalues John Locke's "primary qualities," qualities—such as size, shape, movement—that an object actually has, regardless of the condition under which it is being perceived. Yet simultaneously—and this is part of the extraordinary impact of this installation—Irwin amplifies conditions that enable the eye and the body to make astonishingly subtle and nuanced distinctions between intensities of hue, tone, and luster amid the delicacy of overlapping veils of shadow and soft radiance. This is in part why low-light conditions are essential here, for it is under low light that the human eye demonstrates its remarkable superiority over forms of machine vision (as Albers noted in his 1963 book *Interaction of Color*). It is not a question of night vision—for which all sorts of technological sensors exist—but, rather, conditions of dimness and obscurity in which nothing mechanical can match the discriminations of which the human eye is capable. Especially in the inner rooms or units of Irwin's piece, the illumination is subdued enough so that we are using *scotopic*

vision—that is, dim-light vision—basically processing information with the rods of the retina. There may be an essential uncertainty or vagueness about the objective identity of what we are looking at, but we are able to discern the circumstances of that uncertainty with an astonishing clarity and precision. Scotopic vision (the rod-dominated periphery of the retina) is generally believed to be one of the oldest parts of the human eye, associated with a range of animal survival mechanisms, but also, according to Anton Ehrenzweig and others, linked with unconscious processing and dreaming.[6]

Of course, if this achromatic level of seeing is in effect, we must be using our *photopic* vision as well—that is, daylight, foveal color vision—in order to register the complex binary hues of the fluorescent lighting. In fact, most regular indoor visual experience involves an overlapping of scotopic and photopic vision, but in Irwin's piece what is extraordinary is the particular overall deployment of these two modes of seeing, especially at certain times of the day. There is often sunlight directly striking the floor on the south side of the work, and the windows at both the north and the south open directly onto the expanse of sky, city, and daylight. Normally, in such a space, this would involve jarring but familiar experiences for us as spectators looking out the windows or at the pools of sunlight on the floor, and then an abrupt and extended period of optical accommodation as we turn and move toward the dimmer interior of the space. This kind of adaptation between such varied intensities of light generally goes unnoticed. But Irwin's "window treatment" (if I may call it that) is absolutely crucial in creating what I think of as the "twilight conditions" of his work. He reduces

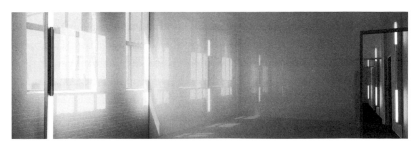

Robert Irwin, *Prologue: x18³*, 1998

the amount of light entering the space, yet still preserves the feeling that we are looking at daylight. Whatever filtering he has used simultaneously maintains the sense of the outside everyday world in all its familiarity and also, strangely, produces effects of de-realization. Significantly, the brightness is diminished, filtered to the point that when we scan or turn around in the space there is no noticeable effect of accommodation, moving from a bright to a dim point of focus. This "twilight condition" is something with which we are all familiar: when, for example, after sunset we see a still-bright blue sky, and then scan down to below the horizon to distinguish streetlights or houselights already on among the gathering but detailed pools of shadow. No matter how many times we experience it there is always something miraculous about that straddling of two different kinds of vision. What Irwin has done is to bring a related kind of twilight uncanniness to an experience that can happen throughout the day (and the piece itself has specific temporal boundaries that change throughout the year: it always closes at dusk rather than at a specific clock time). Daylight, then, is an integral component of the piece; it would of course have been easier for Irwin simply to cover the windows and create a sealed-off light show inside.

What we have instead is this redistribution of luminous values, producing a seamless sensory continuum between daylight and the fluorescent tubes and their multiple effects inside. I do not mean that there is any homogeneity of light and its effects—far from it—but what Irwin has achieved is a quietly disruptive scale of disparate intensities and sources. I cannot give any scientific or physiological explanation, but my hunch is that these manipulations of light, and the resulting absence of obvious optical adjustments or accommodations, produce the sense of a smooth kinesthetic itinerary through the work, a slower register of movement. I use the word *smooth*, borrowing Pierre Boulez's use of the term, to suggest a vague, amorphous idea of time, which overrides the apparent striations or the metric structural distinctions on which the work seems to be based.[7]

In ancient churches, the narthex, or vestibule, was defined as an intermediary space where one made both an optical and a spiritual

adjustment between the bright profane light of the outside world and the much dimmer but sanctified illumination of the nave. Irwin reverses this principle and constructs a space where that duality is inoperative, where interior and exterior flow into one another. Transcendence is never an issue for him. In connection with the architectural dimension of the piece, it's worth remembering the premodern sense of the word *contemplation*, meaning *to go into the space of a temple*, to enter a sacred sphere. Particularly in a work that is so patently "auratic," it would be a mistake, as Theodor W. Adorno insists, to ignore in it at least the historical afterimages of the long presecular vocation of art.

It is important to say that, for Irwin, perception is an ethical problem; for him the quality of our perceptions of the world is inseparable from choices we make about the kind of lives we decide to live. Thus there is more than an implied critique of redundant, prefabricated modes of sensory and cognitive life. Irwin's strategies of defamiliarization recall the work of John Ruskin, one of the first critics to denounce the reification and impoverishment of the senses within the context of modernizing European culture. Like Irwin, Ruskin insisted on the importance of indistinctness and obscurity. The truth of perception, for Ruskin, could only be understood in conditions in which there was never a final grasp by a perceiver of an object or the contents of a visual field. Part of his celebration of Turner was based on this notion—"the law that nothing is ever seen perfectly but only under various conditions of obscurity."[8] The mysteriousness and suggestiveness inherent in sustained observation of certain art and forms of nature seemed to Ruskin a defense against the modern trivialization of seeing. Perception became an inexhaustible activity of continuously extricating novelty from the same forms. As spectators, we then had the capacity to transform the world into a cascade of self-differentiation, a world that was never inert or fully present. Ruskin was seeking a way of reinscribing an apprehension of the infinite within a disenchanted universe. Thus it is misleading to think of Irwin as reducing or minimizing the amount of sensory information he gives us. It could be argued that he gives us far more information than we are used to, but it is

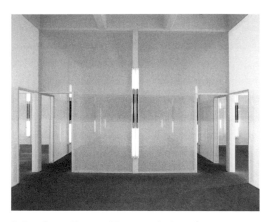

Robert Irwin, *Excursus: Homage to the Square³*, 1998

information of a different kind.

It may seem digressive to look back at the nineteenth century when considering an artist like Irwin, but I think that part of the significance of his work can be disclosed by reading it against other historical positions on the status of perception. In the last decade of the nineteenth century, both artists and philosophers confronted the general standardization and automation of perceptual response, brought about by new patterns of consumption and technological changes. Philosopher Henri Bergson was one of many who attempted a revitalization of perception in the face of the habitual and numbing forms of behavior, inseparable from an emerging mass visual culture, behavior that has its contemporary parallels in the most pervasive uses of television and computers today and the quasi-automatic routines they produce. Crucial for Bergson was a subjectivity capable of renewing and extending its perceptual capacities, and he deliriously attempted to map out an intuition that was able to grasp the manifold vibrations and uninterrupted *becoming* of the world. Bergson believed that the more habitual and predictable one's perceptual relation to one's environment, the less freedom and autonomy one had. In one of his evocative formulations he proposed that the most creative human behavior occurred in what he called "zones of indetermination."⁹

Bergson's model of indetermination provides some valuable terms for thinking about Irwin's work. For Bergson, the richest apprehension of the world occurred during the delay, a rift between the onset of a stimulus and its recognition. That perception in this state had a *variable* relation to its objects was essential to Bergson's notion of freedom. The experience of this variability, he said, allowed us to understand that:

the separation between a thing and its environment cannot be definite and clear cut; there is a passage by insensible gradations from the one to the other: the close solidarity which binds all the objects of the material universe, the perpetuality of their reciprocal actions and reactions, is sufficient to prove that they have not the precise limits which we attribute to them. . . . Matter thus resolves itself into numberless vibrations all linked together in uninterrupted continuity, all bound up with each other and traveling in every direction like shivers through an immense body.[10]

In a sense, the issue was then and continues to be the nature of "novelty"; that is, what does the experience of the "new" mean within a social and economic environment founded on the continual production and consumption of novelty?

Despite the parameters of Bergson's project, there were some who remained profoundly ambivalent about it, in particular the critic Walter Benjamin. Benjamin admired Bergson for attempting to overcome the degradation of experience in an anaesthetizing culture founded on amnesia and habit, but he deplored Bergson's insistence that the damaged character of perception could be healed on a purely subjective level, through individual acts of will.

In this sense, what we have discussed thus far could be taken to imply that Irwin's work is designed for an individual viewer, for the psychological experience of a private autonomous subject. But one of the most potent features of his work is its insistence on a tension between the private and public character of perception. I have already referred to some of these private aspects—those strategies of the work that produce our sense of intimate absorption in its perceptual enticements and ambiguities: our rapt engagement with its chromatic attractions, its equivocal radiances, the pleasures of its novel disorientations. In principle, the piece could be viewed by a solitary observer, but I believe the institutional conditions determining its use during its existence as an exhibition preclude that from happening. One always inhabits and circulates through this space along with at least a few other people. But the mere presence of other people is not what I mean by the work's social or public dimension; otherwise we would be talking about the problem of

contemplation as it is posed in the context of any traditional gallery or museum space. Part of what I see as the private experience of Irwin's work is the very apprehension of other people and their movements, but apprehended through the scrims, apprehended amid what I have tried to designate as the *optical texture* of the work. In fact, I do not believe that the scrims and fluorescent tubes by themselves would have any comparable kind of effect. What activates the piece is the copresence of dimly seen or sensed figures in varying degrees of obscurity, lacking any specific identity so that they can easily, if temporarily, become phantasms within the terrain of our own psychic and perceptual economy. With the generality and indistinctness of shadows, they may overlap with fleeting, barely remembered movements of those we once knew, of fragments of forgotten scenes, encounters or reunions yet to occur, or even as murky nonsynchronous mirror images of ourselves. The imprecision with which we can situate them in terms of distance or position suggests some of the operations of condensation and displacement in what Gaston Bachelard describes as reverie, a waking suspension of the reality function.

But the modularity of Irwin's work—the cube as the figuration of monadic isolation—is also defined by portals opening onto passages, onto routes of circulation that disrupt the possibility of reverie or of self-absorption. In other words, the entrance of other people—in all their vivid concreteness, their prosaic intrusiveness—into one's unobstructed field of vision cancels one's private immersion in a proprietary perceptual event. This is not a sort of Sartrean reversal in which the observer (or the voyeur) suddenly becomes the object of another's gaze; rather, Irwin is simply insisting that the fragile intimation of a shared collective space is inseparable from but not easily consonant with the recognition of our own solitude and separateness. And the reconciliation of collective and individual, of obscurity and clarity, of structure and dematerialization, of rationalization and illegibility, is left deferred and unachieved.

In the framework of these issues let us return to the late nineteenth century and Riegl's articulation of tactility and opticality as part of his anxiety about the fate of European culture. It must be

emphasized that these were not just Riegl's formal or analytical categories, they were charged with significant cultural and even political valuations. One of the artists who was crucial for him was Rembrandt— for Rembrandt's chiaroscuro seemed to him to pose a rare and precious balance

Rembrandt, *The Syndics of the Clothmakers' Guild*, 1662

between the cognitive clarity of tactility, its affirmation of a solid tangible reality, and the subjectivity, relativity, and insubstantiality of opticality. It was out of his study of seventeenth-century Dutch painting that Riegl postulated a subject whose integrity depended on a reciprocal relation between an unwavering subjective contemplation and a coherent, objective world. And in his book *The Dutch Group Portrait* he made clear that his privileged model of the individual observer presupposed an ideal of meditative *intersubjectivity*, as opposed to modern forms of interiority, absorption, and psychic isolation, or to the dissolution of this communal world that he saw figured within the general cultural phenomenon of "Impressionism." Thus the group portraits of seventeenth-century Holland, and above all the group portraits of Rembrandt, provided, at the start of the twentieth century, a utopian figuration of a world of mutual communication—a secular equivalent of religious experience; it was a world in which art could be inseparable from an imaginary harmony of individual and community, of a meditative solitude and social collectivity. For Riegl, the goal of these paintings was the "representation of a selfless psychological element (attention), by means of which the individual psyches were forged together as a whole in the consciousness of the beholding subject."[11] Modern distraction or self-absorption, in this context, could only erode the possibilities of democracy. But, for Riegl, the dream of community, of a hushed moment of psychic communion—as figured, say, in Rembrandt's *The Syndics of the Clothmakers' Guild* (1662)—existed

as an aesthetic construction to be apprehended by the individual as a solitary observer, finally an elitist and regressive fantasy of a premodern and ethically charged visuality.

If we can, in a qualified way, speak of chiaroscuro in Irwin's work (and I do not intend to dehistoricize that word), it is in the service of something very different from an imaginary realm of social and aesthetic harmony. Instead, there is a disquieting restlessness in the oscillation between the private and public poles of the work. Within that oscillation is a sense of what Geoffrey H. Hartman has recently called *phantomization*—by which he means the effect, in modernity, of the feeling of individual wonderment as inseparable from an unsettling sense of nonpresence or self-estrangement.[12] An acute sensation of homelessness can occur in tandem with an intuition of art's *promesse du bonheur*. Everything today, Hartman says, tends toward a condition of placelessness, even as our desire for authentic or auratic experience is artificially stimulated. But at the core of Hartman's argument is the insistence that to take seriously the very possibility of culture is to keep hope in embodiment alive, to maintain hope for a living and functioning milieu. It is possible to identify aspects of Irwin's work as utopian, although it is not a self-enclosed compensatory utopian practice (using Ernst Bloch's categories), but, rather, a concrete anticipatory utopian imagination, which operates on the basis of an ameliorative relationship to an actual collective future.

In many ways, utopian thought today coincides with debate over the nature of the "virtual." At the turn of this century, the idea of virtual reality, in electronic and digital forms, is indifferently associated with new possibilities of invention and innovation. But Irwin's work is much closer to an idea of "virtuality" that is crucial in Bergson's work: the virtual designates that which is not yet seeable, explainable, representable as existing concepts or expectations. Thus the actualization of the virtual must involve the creation of the unforeseen, the emergence of an event that is not deducible from conditions that preceded it. The American philosopher John Rajchman writes that "a virtual construction is one that frees forms, figures and activities from a priori determination or grounding of

the sort they have, for example, in classical Albertian perspective, allowing them to function or operate in other unanticipated ways—the virtuality of space is what gives such freedom in form or movement."[13]

When William James wrote, in 1890, his concise proposition, "My experience is what I agree to attend to," he clearly meant it as an affirmation of an autonomous self-choosing, world-creating subject, liberated from the *receptive* status of a subject for whom experience was "the mere presence to the senses of an outward order."[14] James probably did not suspect that this equation might be an indication of a historical crisis in the nature of experience itself. That is, perception, as an indispensable part of an expanding terrain of modern spectacle, becomes both a simulation of and a compensation for a chimerical "real" experience. As perception is posed as fundamentally constitutive of subjectivity, "experience" is increasingly resituated outside of collective, lived historical time. In a way, the problem for Irwin is not fundamentally different from what it was for James: how can a reflective individual absorption in the fringes, transitions, pulses of one's own particular "pure experience" be effectively reconciled with "experience" as immersion in the tangled confusion of a shared, mutually inhabited world?

In its overwhelmingly pervasive forms within contemporary technological culture, perception coincides with an individual evasion of both history and memory. In its myriad commodified modes, it becomes an imaginary deletion of all that is unbearable

Robert Irwin, *Excursus: Homage to the Square³*, 1998

or intolerable in collective and individual experience. But for all the ways in which perceptual selectivity is indispensable to the functioning of what Georges Bataille calls *homogenous* society—where it is about usefulness and efficiency—perception is also, as Irwin shows us, an opening onto a *heterogenous* world of nonproductiveness, of decomposition: in itself, it leads to the end of certainties and stabilities. It produces the conditions in which the apparent necessity and self-sufficiency of the present might be dissolved, allowing the tentative formation of a clearing in which its forgetfulness can be the basis for a reclaiming of the derelict objects of memory.

April 8, 1999

Notes

1 Meyer Schapiro, *Cézanne*, 2nd ed. (New York: Harry N. Abrams, 1962), p. 9.

2 See William James, *Essays in Radical Empiricism: A Pluralistic Universe* (New York: Longmans, Green, 1912).

3 See Michael Polanyi, *Personal Knowledge: Towards a Post-Critical Philosophy* (Chicago: University of Chicago Press, 1958), pp. 87–91.

4 Colin Rowe and Fred Koetter, *Collage City* (Cambridge, Mass.: MIT Press, 1978), p. 49.

5 Fredric Jameson, *Postmodernism, or, The Cultural Logic of Late Capitalism* (Durham, N.C.: Duke University Press, 1991), p. 44.

6 See Anton Ehrenzweig, *The Hidden Order of Art: A Study in the Psychology of Artistic Imagination* (Berkeley: University of California Press, 1967), pp. 273–74.

7 See Pierre Boulez, "Time, Notation and Coding," in *Orientations: Collected Writings*, ed. Jean-Jacques Nattiez, trans. Martin Cooper (Cambridge, Mass.: Harvard University Press, 1986), pp. 84–89.

8 See John Ruskin, "Of Truth of Space—Secondly, as Its Appearance Is Dependent on the Power of the Eye," in *Modern Painters*, ed. David Barrie (New York: Knopf, 1987), pp. 83–87.

9 Henri Bergson, *Matter and Memory*, trans. Nancy Margaret Paul and W. Scott Palmer (New York: Zone Books, 1988), p. 39.

10 Ibid., p. 208.

11 Alois Riegl, excerpts from "The Dutch Group Portrait," trans. Benjamin Binstock, *October* 74 (Fall 1995), p. 11.

12 Geoffrey H. Hartman, *The Fateful Question of Culture* (New York: Columbia University Press, 1997), pp. 21–27.

13 John Rajchman, *Constructions* (Cambridge, Mass.: MIT Press, 1998), p. 119.

14 William James, *The Principles of Psychology*, vol. 1 (1890; New York: Dover, 1950), p. 402.

Andy Warhol: *Shadows*

LYNNE COOKE

This text is reprinted from the exhibition brochure for "Andy Warhol: *Shadows*," held at Dia Center for the Arts from December 4, 1998, to June 13, 1999. It is reprinted here to preface Victor I. Stoichita's "Beyond the Peter Pan Complex: Warhol's Shadows."

Shadows had fascinated Andy Warhol long before he devoted himself to them as a subject in their own right during a brief, if concentrated, foray in 1978.[1] The result was an exceptional series of paintings, which included one vast environmental work in 102 parts, plus sundry others in different formats and with different motifs, though still based on the theme of a negative reflection. "There is almost nothing on them. Yet they seem to be pictures of something," Julian Schnabel asserted in the preface to the catalogue marking their first comprehensive exhibition in 1989, adding in a telling afterthought that they are "as full of imagery as any of Andy's other paintings."[2] Both the precise sources for and the manifest references engendered by these enigmatic images remain, however, contested. For, notwithstanding the artist's own lapidary description of their genesis in "a photo of a shadow in my studio," alternate and even conflicting accounts of their origins have been offered, among which the most persuasive is that given by Warhol's studio assistant from that time, Ronnie Cutrone, who remembers Warhol asking him to take photographs of shadows generated by maquettes devised expressly to create abstract forms.[3]

Of the seven or eight different compositions in the series based on this subject, two were used extensively, the remainder very seldom. Only the preferred pair were employed in Dia's environmental work entitled *Shadows*. With two silver exceptions, the tall, narrow form dubbed "the peak" always appears as a positive, in black, on a

colored ground. These grounds, which range in hue from a Day-Glo acid green to a majestic purple, from a lurid turquoise to a sober brown, are mostly treated as a flat, matte surface. Occasionally, they are broadly handled so that bravura brushwork irregularly fills the canvas, creating a lively field onto which the motif was then silkscreened. Shorter and more organic in form, the second image, known as "the cap," always appears, paradoxically, as a negative in a black milieu: an "absent" shadow. Also monochromatic, these panels partake of the same palette as their counterparts.

Purchased as a single entity by Lone Star Foundation (now Dia Art Foundation), this cycle of 102 paintings was first exhibited in January 1979 at 393 West Broadway in Manhattan (a site that now houses Walter De Maria's *Broken Kilometer,* 1979).[4] Its current presentation at 545 West 22nd Street in New York City mimics that debut, for it, too, incorporates as many canvases, hung edge to edge and close to the floor, as will fit the space, and it adopts the same sequence—though here the panels have been ordered in a clockwise, as opposed to a counterclockwise, direction. Warhol left decisions regarding the initial order of the individual paintings to Ronnie Cutrone and Stephen Mueller, to whom he had entrusted the installation. Adhering to no system, they conformed to Warhol's own practice when he chose the colors for the grounds or selected prints from contact sheets to be made into screens. Yet, appearances to the contrary, such a method was far from completely arbitrary. Restricting the vocabulary of this group to two compositional formats, confining the total number of hues to seventeen, and limiting each canvas to a single color, Warhol filtered a controlled and circumscribed serendipity through the proclivities of taste to create an environmental ensemble that pertains as much to décor as it does to high art.

In typically disarming fashion, Warhol referred to *Shadows* as not art but "disco décor."[5] Soon after, it was employed as a backdrop in a fashion shoot for the April 1979 edition of his magazine *Interview.* Its multiple roles and hence ambiguous status derive from the innovative and often provocative approach to installation the artist had developed over the course of his career. For his first

European retrospective, which opened at the Moderna Museet in Stockholm early in 1968, he had covered the Neoclassical facade of the building with his Cow wallpaper. At the Whitney Museum of American Art in 1971, during the final stage in a second and more comprehensive retrospective that had toured the United States the previous year, he hung the paintings directly over the Cow wallpaper, which now covered the gallery interiors. (He had first proposed showing only the wallpaper in this last venue.) And when, in 1974, he presented his Mao series in Paris at the Musée Galliera in a landmark installation that superimposed paintings and prints featuring the Chinese leader over wallpaper depicting the same subject, the result was "a colorful, decorative salon" appropriate to this grandiose, sumptuous fin de siècle architecture, yet also "subtly subversive in political and aesthetic senses."[6] Finally, just before his death, he proposed installing his small camouflage paintings directly on their larger counterparts, which now differed only in the scale of the motif and the color combinations. In creating an environment with *Shadows* that could function equally as a social arena for collective activity and a museal space for solitary contemplation, Warhol synthesized aspects of painting, photography, décor, and film, all art forms central to his endeavor.[7] Its sequential repetition with variation recalls a filmstrip, while its grainy magnification of the motifs to vast scale evokes the aura and hyperrealization integral to cinematic closeup. Thematically, the shadow has a seminal role in the originary accounts of both painting and photography as art forms. In Warhol's variants, reduced to essentials, it assumes a paradigmatic identity: devoid of identifiable origin or source, detached from its maker or creator, it exists in and of itself, a purposefully made image of "nothing."[8]

If precedents in his own exhibition history may have directly impacted on the installation of *Shadows*, models for the notion of a single, monumental work in many parts were readily at hand, not least in Blinky Palermo's *To the People of New York City* (1976), an abstract painting in fifteen parts but comprising thirty-nine panels, which had been shown the previous January in the same space, also subsequent to acquisition by the Lone Star Foundation. In Minimal

art, too, and specifically in the oeuvres of Donald Judd and Carl Andre, related formal strategies may be found: large-scale works whose serially repeated units are installed contiguously along the gallery wall(s) close to the junction with the floor.

Ultimately, however, it was not the examples provided by his peers but those of the Abstract Expressionists that occasioned Warhol's abiding preoccupation with making abstract art. In many circles this Pop painter's practice was routinely regarded as the nemesis of that movement, whose canonical expressions were considered the last refuge of spirituality and transcendence. Yet when embarking on this hallowed terrain, Warhol adopted a far from direct or reverential approach. Read as an homage to Pollock, his Oxidation series was as sardonic as it was celebratory: if allusion to Franz Kline may be discerned in *Shadows*, so may associations with apocalyptic wallpaper, a reference frequently applied to Action Painting by its detractors. Nonetheless, in its iconography and consequently in its metaphysics, this series is conceptually more akin to work by Marcel Duchamp, longtime exemplar for Warhol, than it is to that of any American artist.

In taking up this subject, Warhol cannot have been unaware of similar experiments made by Man Ray, such as found in *Interrogation of Shadows* of 1919 and his series of Rayographs from 1922, several of which exist mysteriously in both a positive and negative guise. Duchamp's cryptic *Tu m'* (1918), made in the same year as his friend Man Ray's celebrated image of an eggbeater and its reflection, presages the work of Warhol in that it contains, *inter alia*, a color chart in the form of specimen lozenges juxtaposed with three shadows, two of which are derived from his readymades, while the third, the anamorphically elongated corkscrew, having no prototype in Duchamp's oeuvre, might be said to occupy a phantom or fictive place in that corpus.[9] In its complex and subtle play with issues of representation and with discourses of reality and illusion, presence and absence, *Tu m'* rehearses many of the subjects raised in Warhol's series. Grounded in the material, the literal, and the illusory, such metaphysics are far removed from the spiritual and transcendent.

Meditations on the *vanitas* and the afterlife had been invited in Warhol's series previous to *Shadows*: the Skulls. They, too, were based on photographs made in raking light by Cutrone at Warhol's behest. During the early 1980s, Warhol continued to make so-called abstract paintings that loosely focused on questions of representation, most notably the Rorschachs of 1984,[10] but only in 1986 did he embark on two series that again brought into direct opposition such larger concerns. In the series of Last Supper paintings, issues relating to the spiritual and transcendent arise in the context of figuration. Their vehicles are the banal and the mass produced, that is, through clichéd reproductions of artisanal copies of an image that was both a masterpiece of Western art and a compelling religious icon. In the concurrent series, the Camouflages, Warhol once more explored epistemological questions concerning representation and reality. As in *Shadows*, this entailed a complexly oxymoronic notion of abstraction. Such archetypal paradoxes typify this contrarian's sophisticated and subtle response to what was considered the most profound art of the time.

Notes

1 In the mid-1970s, shadows began to assume importance for Andy Warhol as compositional elements in their own right, as found in the series of Still Life drawings of 1975 and the Hammer and Sickle series of 1977 (also titled *Still Life*), where they take on an idiosyncratic, almost independent, existence. All were based on photographs made by Ronnie Cutrone under Warhol's direction. In the former body of work, the inclusion of an eggbeater may be a sly nod to Man Ray and his infamous *Woman*. In the Skulls of 1977, the shadow assumes a more expressive, ever-fanciful character. In a 1981 self-portrait Warhol adopted the persona of the Shadow, the ubiquitous hero of a popular radio serial and of pulp fiction and comics originating in the 1930s. He then canonized his phantom alter ego in *Myths* (1981), juxtaposing it in the guise of a filmstriplike bestiary alongside other fictional heroes—Superman, Mickey Mouse, Uncle Sam, et al.

2 Julian Schnabel, preface to *Andy Warhol: Shadow Paintings* (New York: Gagosian Gallery, 1989), p. 4.

3 Ronnie Cutrone, telephone conversation, November 26, 1998. Mark Francis cites a slightly different account by Cutrone, suggesting that these images were produced by small children's building blocks. (See Mark Francis, "No There There or Horror Vacui: Andy Warhol's Installations," in *Andy Warhol: Paintings 1960–1986* [Lucerne: Kunstmuseum, 1995], p. 72.) Other proposals include the shape cast by an erect penis or by the Empire State Building.

4 The initial commission from Lone Star was for a cycle of 100 paintings. Warhol decided to make an additional eight paintings in this vein for his own purposes. In the end, Lone Star's aquisition comprised 102 paintings. By contrast, neither the Campbell's Soup Cans nor the Flowers, which Warhol later described as "one big painting that was cut up into small pieces," were initially conceived as a single entity. (See Phyllis Tuchman, "Pop-Interviews for George Segal, Andy Warhol, Roy Lichtenstein, James Rosenquist, and Robert Indiana," *Art News* 73, no. 5 [May 1974], p. 26.)

5 Andy Warhol, "Painter Hangs His Own Paintings," *New York Magazine*, February 5, 1979. Reprinted in *Warhol Shadows* (Houston: The Menil Collection, 1987), n.p.

6 Francis, p. 70. Francis argues persuasively that "Warhol attempted constantly to create a kind of 'social space,' an atmosphere which subverted the pristine vacuity of a conventional modern gallery space, and at the same time reconnected

the museum with its repressed or forgotten siblings, the department store, the supermarket, the dance club, the discothèque, the attic, and the basement" (p. 65).

7 *Shadows* came into being at a moment when the artist was variously taking stock, summarizing, recapitulating, and reflecting on his prior work, as seen in the two series Reversals and Retrospectives, which followed soon after but which operate in somewhat different ways in that they plunder his previous repertoire of imagery rather than engage with a multiplicity of media and art forms.

8 A shadow is at once an image of nothing—a negative—and something in its own right. Made by silkscreening, Warhol's shadows are unequivocally real, not invented: literally the trace of something, they, like the photographs from which they are derived, necessarily are indexically linked to their sources. For a discussion of Warhol's *Shadows* as primarily informed by his ongoing meditation on death, refer to Trevor Fairbrother, "Skulls," in *The Work of Andy Warhol* (Seattle: Bay Press, in association with Dia Art Foundation, New York, 1989), pp. 95–114.

9 Commissioned by collector Katharine Dreier to fit above some bookshelves in her New York apartment, *Tu m'*, which measures 27½ by 122¾ inches, is the largest painting in Duchamp's oeuvre. Describing it as "a kind of inventory of all my preceeding works, rather than a painting in itself," Duchamp confessed that he "never liked it because it is too decorative" (Arturo Schwarz, *The Complete Works of Marcel Duchamp*, vol. 2 [New York: Delano Greenridge Editions, 1996], p. 658).

10 In addition to *Shadows* and the Rorschachs, these paintings included the Oxidation, Camouflage, Yarn, and Egg series, and were shown in a traveling exhibition, "Andy Warhol: Abstrakt," from 1993 through 1994 (Kunsthalle Basel/MAK, Vienna). Ironically, the only nonrepresentational abstractions in Warhol's oeuvre, a series of sixteen diminutive paintings executed circa 1982, were omitted from this exhibition. Although they directly reference other art, notably Action Painting, these are arguably the sole works among Warhol's so-called abstractions that have no direct relationship to everyday phenomena in the real world. (For a fuller discussion of this series, see James Hofmaier, "The Abstractly Abstract Paintings: Chevrons of Vanquished Humiliation," in *Andy Warhol: Fifteen Abstract Paintings* [New York: Anton Kern Gallery, 1998].)

Beyond the Peter Pan Complex:
Warhol's Shadows

VICTOR I. STOICHITA

In J. M. Barrie's 1904 play *Peter Pan*, when Wendy sews Peter's wayward shadow to her friend's heels, the audience easily understands the symbolic meaning: with his shadow restored, Peter Pan becomes *substantial*. One might say he regains the reality he once could escape whenever he wished. This is a metaphorical constraint in which the shadow represents the principle of reality, which can vanish at any moment, leaving its owner in a state of bewilderment. It is a modern myth that has deep and—with the help of Walt Disney's 1953 cartoon film of the story—far-reaching implications.

I do not intend to explore here the complexity of the character of Peter Pan, the boy who wouldn't/didn't want to grow up; I am touching on the topic only in order to approach one of the many

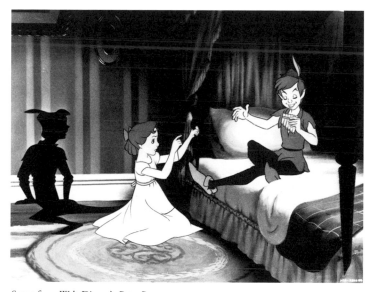

Scene from Walt Disney's *Peter Pan*, 1953

Andy Warhol, *Myths: The Shadow*, 1981

key facets of the work and of the world of Andy Warhol, an American artist who left his own undeniable mark on our century.

In 1981 Warhol created one of his most impressive self-portraits, known as *The Shadow*, which he integrated into a series of ten images, together titled *Myths*.[1] Because of its position in final place in this series of ten screen prints, Warhol's double self-portrait acquires the significance of a duplicated "signature." His visage looks at the spectator from one side, while his cast shadow contemplates the other personae in the series: the Star, Uncle Sam, Superman, the Witch, Mammy, Howdy Doody, Dracula, Mickey Mouse, Santa Claus—all leading ultimately to himself, the Shadow.

This was not, of course, the first time Warhol made a self-portrait, nor was it the first time he approached the theme of the double (indeed he explored it almost obsessively), but it was the first time he used the device of the cast shadow to express it. In his 1967 self-portraits the artist's eyes are turned to the spectator; his hand makes a gesture that conceals his lips; his head keeps a strictly frontal position, framed in the middle of the surface of the picture on an asymmetrical background. The left side of the image is dominated by a darker screen so that half of the face lies plunged in such a deep shadow that it is almost invisible. In certain later variations of this self-portrait there are no essential distinctions between the dark background and the half face, ensuring the continuity between face and background. The shadow is, so to speak, internal as well as external: it divides both the painting and the face. This is Warhol's way of inviting us to discover his double nature: the split is total.

In his 1981 self-portrait, the artist's face is turned so as to produce a straight-nosed, firm-jawed shadow. Shadow and face together form an antinomy: the shadow reaches into the space of the representation,

whereas the face is partially cut off. This work contrasts with the 1967 self-portrait, as it proposes an external split in which the cast shadow seems to be expanding—perhaps demanding its own freedom.

Andy Warhol, *Self-Portrait*, 1967

Between these two sides of the same obsession—what we might call the "clear-obscure portrait" of 1967 and the "cast-shadow portrait" of 1981—there are a number of other self-portraits. One of the most important was painted in 1978, which was unquestionably a pivotal year in Warhol's career. It was in 1978–79 that he created his *Shadows*, a series of 102 paintings exhibited for the first time, immediately following completion, at Heiner Friedrich Gallery in New York. On the white wall just above ground level (so as to accentuate their position on a baseline different from that of the spectator's), these frameless canvases are hung one after the other in a steady rhythm, following a route that ends precisely where it began. This continuous and circular frieze is, however, made up of independent units. It would be difficult to classify this group as traditional "paintings," as their shape, content, and exhibitional context defy such categorization.

A salient feature of *Shadows* is the fact that a single unit, isolated from the series—that is, a unit bought separately and exhibited on its own—is essentially invalidated. Furthermore, these are "canvases" —the vehicle bequeathed by the lofty tradition of the *tableau*— and it is significant that Warhol used synthetic polymers applied through the process of silkscreen printing to transfer the image to this particular support.

The debate around Warhol's cycle was spotlighted by a Dia exhibition in 1998–99 and was amply explored at the time (see pages 83–89 in this volume). I would here like to focus on a parallel problem: specifically, Warhol's way of dealing with duplication and multiplication in his 1978 self-portrait. Never before had the artist

Andy Warhol, sitting in front of *Shadows*, 1979

exploited so intensively the expressive forms of the photographic negative. *Reduction* and *reversal* were the themes on which Warhol was now discoursing. It was the same approach that he had taken for *Shadows*, in the same year. This should be remembered, not only because of the coincidence (in no way gratuitous) of this series and the self-portrait, but also because of the implications that derive from an "iconology of materials," so often overlooked by commentators.[2] If we were to take into account all the representational technicalities and the symbolic significance of this self-portrait, we might say that it represents both the negative and the duplicated image of Warhol, as well as its own polymerized image.

According to the *Oxford Reference Dictionary*, a *polymer* is a compound whose molecule is formed from many repeated units of one or more compounds. Polymerization is the combination of several molecules to become one larger molecule. This operation produces that ubiquitous material commonly referred to as plastic.

Throughout the 1960s, Warhol implemented the "polymerization of the image." He did this in two ways: first, by literally plasticizing likenesses and, also symbolically, by rendering a shiny, artificial, indestructible unity to the multiplicity of life. In his 1978 self-portrait he pushed this combination of representational form and

technique to its limit. It is an image based on a double interaction of the photographic negative. As always, the negative represents the object in its phantom state.[3] Warhol had used this method toward the end of the 1960s, and he reused it in the 1970s and 1980s in his "reversal" series of eighteen multicolored Marilyns and in his twelve white Mona Lisas. Warhol's message is clear and owes much to Marcel Duchamp, as we can see by glancing at the French artist's 1917 *Autour d'une table* (*Around a Table*).

Although Warhol was notoriously secretive about his age and went to great lengths to mislead the world about the year of his birth, it is now known that he turned fifty in 1978. In his "two-times-three self-portraits" of that year, he was expressing, in a modern way, the old theme of the Three Ages of Man. It is difficult to trace the origins of his interest in this traditional theme, which is perhaps best represented in Titian's painting, now at London's National Gallery, which was studied and analyzed at length by Erwin Panofsky in his much-read *Meaning in the Visual Arts* (1955).[4] Panofsky—himself a myth in the world of art, before and especially after his death in 1968—demonstrates that the three-headed sign (*signum triciput*) is used to create a complex allegory of wisdom (*prudential*) and also of the inexorable passage of time. Warhol must have been familiar with this tradition. In a drawing he made the same year, both the idea and the form of the three-headed portrait are even clearer than in the silkscreen.

We can be sure, however, that Warhol had no intention of giving his audience a scholarly lesson on the Three Ages of Man and the virtues of human wisdom. On the contrary, he proposed a new and original formulation of this

Marcel Duchamp, *Autour d'une table* (*Around a Table*), 1917

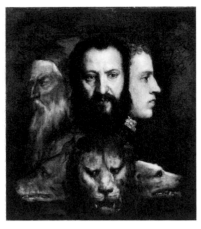

Titian, *Allegory of Prudence*, 1565–70

time-honored topic, in complete accord with his own philosophy. While written documentation on the subject is scarce and insufficient, Warhol's work would seem to speak for itself. The most striking characteristic of this 1978 self-portrait is the two groups of three-headed beings. The motif makes explicit the relation with the traditional representation of the three-headed being, as depicted in Titian's painting, and of which Panofsky gives us such an incisive reading.

The notable absence of evidence of Warhol's consciousness of the *signum triciput* tradition is, however, made up for in his *Myths* portfolio. Here we discover a secret dialogue between Mickey Mouse—the fetish animal of American imagery—and Warhol's own split self-portrait. In the large canvases that follow Warhol's *Myths* cycle, Mickey Mouse holds a central place, while Warhol gives himself only a marginal position. Both cycles, Mickey Mouse and the

Andy Warhol, *Self-Portrait*, 1978

self-portrait, follow a similar process of "de-realization"; that is, if we examine the two columns of images from top to bottom, we can see that at the lower part of each column the characters have lost their reality and, by a negative-positive reversal, are turning into their own "ghosts." On the self-portrait column the cast shadow changes from dark to light, and the face changes from light to dark (a true "shadow of a shadow") before fading out completely into an undifferentiated darkness. On the Mickey Mouse column there is a similar

phenomenon, but here the last Mickey appears to be as "unrealized" as the first one. Thus, on the self-portrait column, the shadow is a substitute for the face (and vice versa), whereas on the Mickey column the end echoes the beginning.

Andy Warhol, *Myths*, 1981

This may be the reason why, in 1981, Warhol decided to add to his *Myths* cycle a huge screen print next to his Mickey Mouse, titled *Double Mickey Mouse*. The chronological coincidences once again transcend the boundaries of a merely metaphorical link, or offer the latter a foundation: Warhol (we now know after much research) was born on August 6, 1928,[5] and Mickey Mouse, according to the historians of the cinema and comic strip, was born on November 18 of the same year. Warhol and Mickey are therefore products of the same "generation," and it is entirely probable that the artist capitalized on the coincidence of this well-kept secret.[6]

Double Mickey Mouse is not only double, he is also a giant—especially if you compare him with a normal mouse. He measures 30½ by 43 inches (77.5 by 109.2 cm). But then Mickey was, of course, never a "normal" mouse. He is a mascot, a semblance. And it is in this capacity that he is naturally split. The "double" in *Double Mickey Mouse* does not imply the original-versus-copy dialectic—and this is troublesome: the two are both original and copy alike. Identical and different, each is both the same and the other, interchangeable and monumental. Warhol portrays the Mickey/Mickeys against a background of

Andy Warhol, *Double Mickey Mouse*, 1981

Marcel Duchamp, frontispiece for Robert Lebel's *Sur Marcel Duchamp*, Editions Trianon, Paris, 1959

diamond dust, a technical (and symbolic) process he often used in his pseudoicons. This procedure takes the image to the dizzying heights of postmodernism, the school of thought that elicited the rise and triumph of the "Semblance."[7]

Unlike *Double Mickey Mouse*, the 1981 self-portrait, *The Shadow*, addresses the problematic of duplication that is the result of a split. The shadow shows the profile of a person (Warhol) whom we can also view from a quasi-frontal position. We should bear in mind that a whole dialectic of Western representation has taught us that frontality—and the mirror—constitute the symbolic form of the relationship between self and same, whereas the profile—and the shadow—constitute the symbolic form of the relationship between self and other.[8]

The process is not unfamiliar. Duchamp had an abiding interest in both the shadow and the technique of *reversal*. There is a hint of this interaction in the majority of Duchamp's self-portraits, but here we will examine only a few examples. His use of the profile as a "signature" is found in his early photographic self-portraits as well as in some of his later experiments. For example, for Robert Lebel's monograph *Sur Marcel Duchamp*,[9] the artist designed a frontispiece in which he appears as an outlined profile against the green background of his famous "boxes" (*The Green Box*, 1934). The composition was also used for the poster advertising the exhibition organized to launch the book in Paris's Latin Quarter bookshop La Hune. It is not difficult to recognize in this composition the tradition of Johann Caspar Lavater's physiognomic silhouettes. Why did Duchamp not use this technique earlier? The La Hune poster offers us one possible explanation: both the book and the exhibition challenge a mysterious, indeed more often than not *indecipherable*, "Duchamp."

In this context we should point out that during the same period Duchamp did another self-portrait in which his profile is delineated in the positive, a copy of which he sent to a few friends. To anyone vaguely familiar with the rhetoric of Duchamp's gestures and of Lavater's tradition, the door is open to an interpretation of these two images: as with Lavater's works, positive and negative are counterparts, but in the case of Duchamp it is the black profile that, although it

Marcel Duchamp, *Profile Self-Portrait*, 1958

remains virtually illegible, is consigned to the public domain. As to the white profile, although it is nothing more than an illusion, it is destined only for friends, as its "original" no longer exists.

In the case of the Warhol works, while the permanent cheery profile of Mickey Mouse is the estranged image of the "other," Warhol's self-portrait creates an unwavering tension between the two views. The focus is exclusively on the face. This enormous visage (nearly one square meter) demands a heightened rhetoric and a format that is not that of the Western pictorial portrait, but that of the cinematographic close-up.

As has been said time and again, Warhol considered the image to be more real than the real. Enlargement is just one method of hyperrealization; others are splitting and multiplying. This last method, widely used in Warhol's postmodernist icons, is in this instance addressed in a particular way: through the device of the cast shadow. Again, shadow and face together form an antinomy: the shadow reaches into the space of the representation, whereas the frontal face is cut off by its boundaries. Where are we? The blue background is reminiscent of the sky, the unusual color of the face is more like the reflections in a photographer's darkroom. Can these two areas be reconciled? Perhaps, but only on one condition: that the link be made in a symbolic way. In the

darkroom of his studio, Warhol *develops* himself. In so doing, he *unmakes* himself. What we see is both a self-portrait and a scenario of production that could only have been created in the photographic age.

Let us examine the shadow: it is flat, one-dimensional, and its actual shape is unstable. It is the result of the face having been developed—not just as a photogram, but also more tangibly, from solid body to surface. As Warhol himself said: "I see everything that way, the surface of things, a kind of mental Braille, I just pass my hands over the surface of things."[10] And: "If you want to know all about Andy Warhol, just look at the surface of my paintings and films and me, and there I am. There's nothing behind it."[11]

Because the surface *is* the self, because it *is* the person, the extraordinary unfolding of the face in the cast shadow is no longer a process that confirms "real presence," as the tradition of Western art had dictated. It is a process that focuses on the final stage of the hyperrealization of the person: its ultimate realization in its own nothingness. Great ectoplasm projected onto a blue background sprinkled with diamond dust; the depthless, shapeless face of one who examines himself, signifying the paradox of a representation of the self—a monumental and cosmic disappearance.

This discussion might end here if it weren't for the title, which I feel it is my duty to explain. At this point, we can admire the complexity of Warhol's treatment of the great myths. It isn't really necessary to spend more time explaining the link between Mickey and the shadows. With Peter Pan, however, things get more complicated.

In his 1981 self-portrait, Warhol, the perennial child in spite of his fifty-three years, declared that his shadow was more powerful, more important, and more real than his own person. One step further and the "sewn-on" reality will ask for its own independence. The self-portrait was only a metaphor, and we had to wait a few years to learn the truth from the artist himself. In 1985 Warhol created an installation at the Area nightclub in New York City, a work he referred to as the *Invisible Sculpture*.[12] On a little platform close to a pedestal at the club was Warhol himself, dressed (as usual)

in black, one of his silver wigs on his head. Like a photographic negative, this "installation" turned Warhol into an image of himself, into his own ghost. Witnesses who were present remember the artist leaving his place on the platform from time to time. The inscription on the wall—*Andy Warhol: "The invisible sculpture"*—remains ambiguous.

There is no way to explain the link between the subject and the object of the representation, except in the silence suggested by Warhol himself. If Peter Pan needed to have his shadow sewn to him in order to become "real," Warhol saw himself as the ghost of his invisible self. The truth is that on that pedestal there was *nothing*, and, more importantly, near the empty pedestal on the platform, there was *nobody*.

June 3, 1999

Andy Warhol, *Invisible Sculpture*, 1985, installation at Area nightclub, New York

Notes

1 Frayda Feldman and Jörg Schellmann, *Andy Warhol Prints: A Catalogue Raisonné, 1962–1987*, 3rd ed. (New York: Distributed Art Publishers, 1997), pp. 118–19.

2 On the notion of "iconology of materials," see Günter Bandman, "Bemerkungen zu einer Ikonologie des Materials," *Städel Jahrbuch*, no. 2 (1969), pp. 75–100. See also Thomas Raff, *Die Sprache der Materialien. Anleitung zu einer Ikonologie der Werkstoffe*, Kunstwissenschaftliche Studien, vol. 61, Munich (1994). For Warhol's case, see Marco Livingstone, "Do It Yourself: Notes on Warhol's Techniques," in *Andy Warhol: A Retrospective*, ed. Kynaston McShine (New York: Museum of Modern Art, 1989), pp. 63–80.

3 Regarding this problem, see Charles F. Stuckey, "Andy Warhol's Painted Faces," *Art in America* 68, no. 5 (May 1980), pp. 102–11, and particularly Reinhard A. Steiner, "Die Frage nach der Person. Zum Realitätscharakter von Andy Warhols Bildern," *Pantheon*, no. 42 (1984), pp. 151–57. See, also, Nicholas Baume, Douglas Crimp, and Richard Meyer, *About Face: Andy Warhol Portraits* (Cambridge, Mass.: MIT Press, 1999).

4 See Erwin Panofsky, *Meaning in the Visual Arts* (New York: Doubleday, 1955), pp. 146–67.

5 Date discovered by Andreas Brown, and revealed in *Andy Warhol: His Early Works, 1947–1959* (New York: Gotham Book Mart, 1971).

6 For details, see Victor I. Stoichita, "Les Ombres de Warhol," *Les Cahiers du Musée national d'art moderne*, no. 66 (Winter 1998), pp. 78–93 (especially p. 87); and Stoichita, "Mickey Mao. Glanz und Misere der virtuellen Ikone," in *Homo Pictor*, ed. Gottfried Boehm (Munich: K. G. Saur, 2001).

7 See Gilles Deleuze, *Différence et Répétition* (Paris: Presse Universitaires de France, 1968), pp. 164–68; and Deleuze, *Logique du sens* (Paris: Editions de minuit, 1982), pp. 292–307.

8 Details in Stoichita, *A Short History of the Shadow* (London: Reaktion, 1997), pp. 22–41.

9 Robert Lebel, *Sur Marcel Duchamp* (Paris: Editions Trianon, 1959). Published in English as *Marcel Duchamp*, trans. George Heard Hamilton (New York: Grove Press, 1959).

10 Warhol, quoted in Gretchen Berg, "Andy: My True Story," *Los Angeles Free Press*, March 17, 1967, p. 3. See, also, Jean-Claude Lebensztejzn, "Braille mental," *Critique*, no. 522 (1990), pp. 875–90.

11 Warhol, quoted in Berg, "Andy: My True Story," p. 3. See also Benjamin H. D. Buchloh, "Andy Warhol's One-Dimensional Art: 1956–1966," in *Andy Warhol: A Retrospective*, pp. 39–61.

12 See the chronology prepared by Majorie Frankel Nathanson, in *Andy Warhol: A Retrospective*, p. 419.

Douglas Gordon's *left is right and right is wrong and left is wrong and right is right*

ELAINE SHOWALTER

What do you do with your hands when you are watching movies?

—Douglas Gordon

I am a critic because out there in the writing of the other, the distance is perfect and I am safe.

—Allon White, "Why I Am a Literary Critic"

As a cultural historian and critic dealing with hysteria (we call ourselves the New Hysterians), I am presented with plenty of fodder in the work of Douglas Gordon, as he has routinely tackled the subject many times over in ways both veiled and vivid. One of Gordon's biographical notes explains that he loved to draw stuffed birds as a youngster, enjoys reading Bret Easton Ellis's *American Psycho* (1991), and in 1994 posed as though hitchhiking with a sign

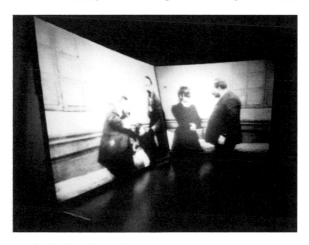

Douglas Gordon, *Hysterical*, 1994–95

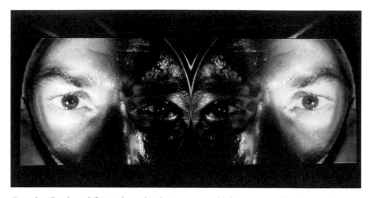

Douglas Gordon, *left is right and right is wrong and left is wrong and right is right*, 1999

reading "psycho." *Hysterical* (1994–95), an installation work, is based
on medical film footage from 1908, in which two doctors try to
soothe a hysterical masked woman. The film used in another
installation, *10ms⁻¹* (1994), shows a naked man struggling to get up
from the floor; it's an excerpt from a World War I medical film on
shell shock, the first international epidemic of male hysteria. For
24-Hour Psycho (1993), Gordon slowed down, to a twenty-four-hour
running time, the Alfred Hitchcock film *Psycho* (1960), which fea-
tures the most famous male hysterical character, Norman Bates. *Left
is right and right is wrong and left is wrong and right is right* (1999),
exhibited at Dia, is a new venture into the territory.

 This latest work seems, at first, unusual for Gordon, in that
he normally uses canonical or iconic film sources as raw material.
Selma Klein Essink, discussing *24-Hour Psycho*, for example, pointed
out that regardless of your age or your cultural orientation, you are
likely to know something about Alfred Hitchcock's *Psycho*, even if
it is only that a woman is slashed to death in a shower by a maniac
whose sexual identity is somewhat confused.[1] In contrast, the source
here, Otto Preminger's 1949 thriller *Whirlpool,* is far from paradig-
matic. It is, in fact, rather forgettable. Preminger himself, when
asked to comment on the making of *Whirlpool*, replied that he
could not remember anything about this film. Furthermore, it's
unavailable; it is not easily found on video, not shown in movie
theaters, and it does not rerun on television.

A second glance, however, reveals that the use of *Whirlpool* is consistent for Gordon, in that it aligns with his ongoing interest in the hysterical narrative, issues of splitting and disruption of narrative sequence. Preminger's *Whirlpool*, starring Gene Tierney, Richard Conte, and José Ferrer, is an exceptionally confusing and contradictory film noir, exploiting the classic hysterical triangle—a woman and two "doctors" (her psychiatrist husband and a hypnotist). Anne Sutton, wife of the wealthy William Sutton, suffers from insomnia and kleptomania (incidentally, unrelated neuroses). She is caught stealing jewelry by a hypnotist, David Korvo, who intervenes in her crime, persuading her to undergo therapy with him. Meanwhile, she is unwittingly implicated in a secret plot: he will set her up to take the blame for the murder of his ex-mistress. He sends a hypnotized Anne, the kleptomaniac, to the house of the mistress, where she is caught beside the dead woman's body and arrested. Korvo, the hypnotist, is ostensibly in the hospital at the time of the murder recovering from surgery, an apparently unshakable alibi. But Anne's astute husband figures out that Korvo has hypnotized himself, thereby enabling his clandestine exit from the hospital just after surgery. Despite his pain, under the effect of posthypnotic suggestion, he murders his ex, returns to his hospital bed, and plugs

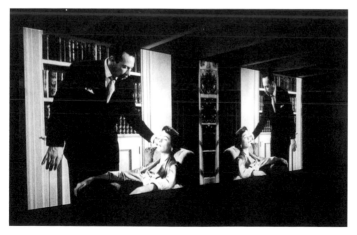

Douglas Gordon, *left is right and right is wrong and left is wrong and right is right*, 1999

in his tubes. This is the kind of film noir worthy of the distinction—a vortex of motives, suspicion, hysteria, hypnosis, and amnesia.

Gordon's title, *left is right and right is wrong and left is wrong and right is right*, most directly refers to the method and technique of the work: *Whirlpool* has been edited so that the odd-numbered frames are projected onto a left-hand screen, with the corresponding soundtrack emerging from a left-hand speaker, and the even-numbered frames and soundtrack treated analogously on the right-hand screen and speaker. The odd frames are also flopped, mirroring the right.

The title can also be decoded in terms of the life and times of its author. Growing up in a Protestant, Calvinist family in Glasgow, Gordon became accustomed to the divisions not only between the political left and the political right but also between working-class liberals and upper-class conservatives and between Protestants and Catholics. Gordon's father, who worked as an engineer in a shipping factory, ordered all of his four children to be politically left wing, an injunction the young Gordon took seriously. He witnessed bullying and heckling and, on one occasion, even a murder motivated by class and religious divisions. This stratified, divided, belligerent society left him, perhaps, feeling that both left and right can be wrong. Roland David Laing, the psychiatrist who also grew up in Glasgow and has written about the city on a number of occasions, observed that it, and Scotland generally (with its geographical and metaphorical highlands and lowlands), is a schizophrenic environment, a location of what he called "the double bind," caused by these identically confining alternations and oppositions. Within many of his works, Gordon deals with dichotomies: two-handedness, two-facedness, duality, reversal, and moral, psychological, and sexual ambiguity, taking them all to hysterical proportions.

Again and again, he has constructed his own literary "hysterical narrative," a term first applied by Sigmund Freud to the disjointed stories told by his hysterical patients. To accompany exhibitions, Gordon provides a biography or a statement, ostensibly written by some anonymous friend or relative but likely by Gordon himself taking on these various personas, as they each betray trademark repetition, catchphrases, and style. These essays often begin with

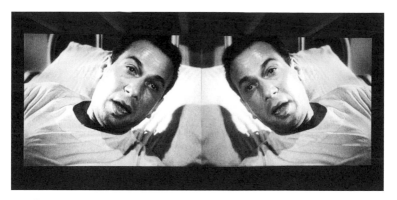

Douglas Gordon, *left is right and right is wrong and left is wrong and right is right*, 1999

the scene of Gordon's extraordinary birth, one in which it seems his mother died and came back to life. In one essay, Gordon's "brother" confides, "I'm not entirely sure what Douglas is up to. I've never been quite sure. He was always into weird things as far as I can remember. I suppose that's what it's like to be an artist."[2] These narratives are punctuated by allusions to significant events, a characteristic parallel to the narratives documented in Freud's case studies of hysterics: stories are only touched upon, then postponed for further elaboration at a later date, saved for a better time.

It was the Greeks who first diagnosed hysteria as a female disorder caused by the uterus wandering around the body (*hysteron* is Greek for "uterus"): if a woman was choking, she had the famous globus hystericus (the lump in the throat), which meant the uterus was in the throat; if she was limping, the uterus had migrated to the knee; if she couldn't bend her arm, it was in the elbow. The idea of the wandering womb finally dropped out of fashion once scientists and doctors began to dissect bodies and discovered that the uterus was actually firmly attached in its position. But the idea that hysteria is a disease of the uterus, a disease of reproduction—specifically female reproduction—continues even into the twentieth century with modern psychiatry.

Doctors began to discover cases of male hysteria as early as the seventeenth century, but believing them rare exceptions to the paradigm, they dismissed the condition for as long as possible.

Jean-Martin Charcot lecturing on hysteria at Salpêtrière Hospital, 1887

When the medical establishment finally acknowledged it, the uterus was again implicated: male hysteria was then understood as formed by maternal heredity. Gordon's early installation *Something between my mouth and your ear* (1994) is set in a blue "womb" room, within which plays popular music his mother would have heard when she was pregnant with him. The renowned late nineteenth-century French neurologist Jean-Martin Charcot would have loved this re-creation of Gordon's own womb experience: Charcot, considered the father of clinical neurology, would say that hysteria in the mother begets hysteria in the son. Interrogating his male patients in his clinic in Paris's Salpêtrière Hospital, he would first ask, "What was your mother like? Was she nervous? Was she an alcoholic?"

Though the hysterical women in Charcot's clinic were thoroughly (and notoriously) photographed, his small ward of about twenty male patients, sadly, were not so well documented. In written records, Charcot describes their bodies in more heroic terms than those of the women, as athletic and classically beautiful. Some of the men were heavily tattooed, in a symbolic body language. The male patients in the hospital were primarily working class and heterosexual, and included a number of homeless people, street singers, circus performers, delinquents, vagabonds, and vagrants. One scholar who has written about Charcot's hysterics says that if mobility of mind is one of the chief characteristics of female hysteria, mobility of social place is the hysterical male equivalent. These runaways and migrants are the striking social counterpart of the unruly migrating uterus.

The doctors at Charcot's clinic noticed that hysterical men tended to exhibit symptoms on the left side of their bodies. In one of the most frequently documented symptoms, the hemianesthesia,

the whole left-hand-side of the body would become numb. Charcot claimed that male physical symptoms often occurred in the left flank. He also noticed that the left testicle was more sensitive than the right, and that if it were twisted, the patient might have a hysterical fit. Another French physician observed male hysterics with pain on the left side of the abdomen, as if they had hidden ovaries.

Doctors also noticed that these male hysterics typically displayed few emotions. Unlike the histrionic women, men were straight-faced. Only twice do the doctors at the Salpêtrière document a male patient crying. Nonetheless, male hysteria was seen as a stigmatizing, deviant detour from normal masculinity. The male doctors, embarrassed by encounters with men exhibiting classic hysterical symptoms, tried to conceal these symptoms by camouflaging their syndrome under various other diagnostic labels. At the same time, partly because it was such a public phenomenon in Paris, hysteria became a significant creative metaphor for male artists. Writers and artists, including Charles Baudelaire, Gustave Flaubert, and the Goncourt brothers, adopted hysteria as a metaphor for the creative process. While Freud and his contemporaries in the 1890s viewed women who told disorderly stories as hysterics, similar stories by men were not seen as neurotic, but instead as adventurous, experimental, avant-garde, open-ended, and daring. The classic psychoanalytic case studies of women end like Victorian novels, with marriage, madness, or death. The male analogues, by contrast, writes Susan Katz, "get more play in narrative because men get more play in life."[3] The male hysteric could appropriate the diagnostic label for transgressive and androgynous behavior or pass it off as the nature of the creative process to transcend convention.

Popular culture exploits the same stereotypes: Lynne Kirby discusses male hysteria in relation to early silent

Jean-Martin Charcot's patient Augustine, 1878

Charlie Chaplin

cinema's central metaphor, the train.[4] Noting that male hysteria first drew wide and serious medical attention in the context of railway accidents, she argues that silent cinema portrayed their traumatized victims like female hysterics. Kirby sees these film images as part of a technological seduction fantasy, in which one imagines one-self aggressed, raped, seduced, or destroyed by the train. Film theorists have applied the adjective *hysterical* to Buster Keaton, Charlie Chaplin, and Mack Sennett, as well as the more recent entertainers Jerry Lewis, Pee Wee Herman, Woody Allen, and even Clint Eastwood.[5] Sometimes these so-called hysterical actors are comedians using a particularly expressive body language, and sometimes, like Eastwood, they are stoic, repressed, and continuously subjected to punishment. In *Tight Rope* (1984, directed by Richard Tuggle), Eastwood presents the male hysteric as a masochist; the actor's body is subjected to punishment, beatings, and abuse, only to be recon-stituted and almost magically healed.[6] Of course, a central trope of the American Western is man's capacity to endure pain, a trait that signifies true masculinity.

Dead Ringers, directed by David Cronenberg, 1988

In the realm of popular movies, David Cronenberg has most successfully explored the subject of male hysteria, which often emerges in the form of womb envy. His male hysterics consistently try in one way or another to create life, an exploit that peaks in the horribly

upsetting and disturbing film *Dead Ringers* (1988), when two twin-brother gynecologists invent a set of gynecological instruments for examining mutant women. The point of the movie is that the men themselves are mutant women, who preside over the reproductive process, although they cannot give birth themselves.

Douglas Gordon, *A Divided Self I and II*, 1996

In the film's conclusion, one attempts to dissect the other's body as if in search of a uterus, in a grisly imitation of birth; for the male appropriating femininity and creation, birth and death are the same.

The noir film *Dark City* (1998), made by the young director Alex Proyas, is set in an anonymous stylized urban landscape. Its ominous plot revolves around extraterrestrial male strangers who penetrate the human soul to capture memory. It is based on *Memoirs of My Nervous Illness* (1903), a famous case study of a hysterical male, Daniel Paul Schreber, who believed that he was a victim of a plot of soul murder, that God was subjecting him to mysterious phenomena designed to turn his anatomy into that of a woman. Schreber heard voices urging him to take purifying baths and suggesting that it must be rather pleasant to be a woman. So even in recent dramatizations of male hysteria, the feminine lingers in its historical sense.

By contrast, Douglas Gordon increasingly deals with hysteria in the here and now by probing his own biography, his own body. Russell Ferguson says that Gordon's work has the recurrent theme of inscribing memory

Douglas Gordon, *Monster*, 1996–97

on the body through processes of circular repetition and through splitting and doubling the body itself.[7] In recent works, Gordon has concentrated on the divided male body: in the piece *Hand and Foot (Left) and Hand and Foot (Right)* (1995–96), a foot steps on a hand, the right one on the left one; in *A Divided Self I and II* (1996), a hairy arm and a hairless arm wrestle each other on a bed, like Jacob and Isaac—both arms are Gordon's; in *Monster* (1996–97), a double image of the artist portrays him first clean-cut and handsome in a white shirt, and then alongside with Scotch tape horribly twisting and distorting his face.

The critic, like me, seeks the safety of distance in writing a paper about manifestations of hysteria: French psychoanalyst André Green says that we are all hysterics except when we are writing. The artist, like Gordon, goes into the heart of this darkness—the whirlpool of hysteria, fear, violence, sadness, and ennui. What do I do as a critic with my hands when I watch a movie? Usually I take notes: that is the right thing to do with my hands. Gordon reaches for the scissors; that might be the wrong thing—but for this occasion probably right.

September 23, 1999

Douglas Gordon, *left is right and right is wrong and left is wrong and right is right*, 1999

Notes

1 Selma Klein Essink, "Nothing Will Ever Be the Same," in *entr'acte, no. 3: Douglas Gordon* (Eindhoven: Stedelijk Van Abbemuseum, 1995), p. 6: "In his work he draws on the assumption that everybody has some idea of Hitchcock's classic film (whether they have seen it or not). Over the years *Psycho* has acquired the status of a cultural icon and an accompanying mythology which has developed quite independently of the intentions of its maker."

2 ". . . by way of a statement on the artist's behalf, a letter from the artist's brother, David Gordon," in *Douglas Gordon: Kidnapping* (Eindhoven: Stedelijk Van Abbemuseum, 1998), p. 81.

3 Susan Katz, "Speaking Out Against the 'Talking Cure': Unmarried Women in Freud's Early Case Studies," *Women's Studies*, no. 13 (1987), p. 300.

4 See Lynne Kirby, "Male Hysteria and Early Cinema," *Camera Obscura: A Journal of Feminism and Film Theory*, 17 (1988), pp. 113–31.

5 See Lynne Cooke, "Douglas Gordon: A Visuel, A Seer," in *Douglas Gordon* (Hannover: Kunstverein Hannover, 1998), n.p.

6 See Paul Smith, *Clint Eastwood: A Cultural Production* (Minneapolis: University of Minnesota Press, 1993).

7 See Russell Ferguson, "Divided Self," *Parkett*, no. 49 (May 1997), p. 58.

Stan Douglas's *Win, Place, or Show*

BÉRÉNICE REYNAUD

1. Strathcona and the Impossible Shot

My relationship to cities is that of total disorientation. I used to perceive this as a personal weakness, until I realized that it was a symptom of our postmodern age. My mother was born in a small village of eight hundred inhabitants. She married, and I was born in a one-million-inhabitant city. I moved to Paris, which was even bigger, then to New York, which was bigger still, and then I ended up in Los Angeles, which is both bigger and smaller because it is made up of a collection of suburbs. That story and others like it represent our condition. We come from places where we do not live, and many of us, within a few decades, move from places that have few inhabitants to places that have many, from simple places to complex urban structures. In effect, most people are actually disoriented. Julia Kristeva has concluded that history in North America is spatialized, meaning it is no longer represented by the passing of time, but instead by display in space.[1] In New York City, she pointed out, various eras of immigrants coexist side by side, but from one neighborhood to the next people do not know one another. There are gaps between moments of temporality.

Stan Douglas, *Win, Place, or Show*, 1998

Stan Douglas, *Win, Place, or Show*, 1998

The setting for Stan Douglas's installation *Win, Place, or Show* (1998) is ostensibly in a housing complex in a neighborhood of Vancouver called Strathcona. It shows two men in an argument that repeats itself, in a series of variations put in a loop. One shot, however, is markedly different from the others. It shows a night view onto the city with light drizzle coming down. There is no eye-line matching with any of the protagonists, yet the viewer is tricked into believing that this shot represents what you could see, on that particular night, from the window of the tenth floor of the Strathcona apartment that the two men share, with the old False Creek industrial park in the distance. This shot is strikingly different; its occurrence seems more irregular than that of the others in the installation. As we catch it, then and again, always too quickly, we start getting uncertain about the nature of what we are being shown. There is something uncannily static in this view, we are not even sure that this particular cityscape would be visible from the window. And, in our doubts, we are right. For this shot is a trompe l'oeil, an impossible point of view: Douglas shot a painted backdrop in a studio—a totally artificial reconstruction of the urban background that is the hidden subject of *Win, Place, or Show*. While the entire installation produces an effect of disorientation and dislocation in the spectator, the fleeting presence of this "impossible shot" gives this disorientation an almost surreal quality.

Through a lucky coincidence, I was in Vancouver, attending the International Film Festival. While there, I decided to go to Strathcona, but it does not appear on any of the tourist maps

I had. Following various tips, I started to walk from the downtown area toward the east through Chinatown. There, I asked the waitress who had just served me lunch, "Where is Strathcona?" She replied, "What?" It turns out that Strathcona was about a ten-minute walk from her restaurant, but she didn't know it. I continued walking east, past a number of transient hotels. I made a wrong turn and ended up on the docks, which was fine with me, for I'm fond of industrial landscapes. A clean-cut man was walking by, and when I asked for his help, he told me to go south, adding: "But I'm not too sure because I'm not from here, I'm from the Westside," which is a chic part of the city.

Then I realized why he had been there in the first place: A young woman called me, and then, identifying me as a tourist through the map I was holding, apologized for her mistake. She was very young, very poor, and not too clean; she was one of the many teenage prostitutes that—as I was informed later—walk the docks. The drug problem and the homeless teenage problem experienced by Vancouver are among the most serious in North America.

So this is how I discovered Strathcona, which turned out to be a collection of lovely—though sometimes decrepit—little wood houses, churches, some grocery stores, and an early twentieth-century school. Today Strathcona is a working-class, immigrant community. Perhaps surprisingly, it is the original location of Vancouver, which was founded in 1865 by Captain Edward Stamp. Stamp would build, in 1873, the Hastings sawmill, along with housing for its workers, creating a town then called Grandville. Rumors that the Canadian-Pacific Railway was going to turn Grandville into its terminal stimulated a boom, so that by the 1880s the town had become a typical Western city with saloons and hotels. A number of people would come to work as lumberjacks or on the harbor. Two brothers, David and Isaac Oppenheimer, began to offer lots for sale. Craftsmen, schoolteachers, shop clerks, factory men, millworkers, accountants, and grocers moved into houses on the lots, which could be purchased on ten-year installment plans. Chinese rooming houses were registered, and later sea captains, miners, engineers, and skippers would begin to rent the houses. Thus, from the very

beginning, Vancouver was envisioned and realized by powerful real-estate interests that played with and against individual interests and working-class dwellers.

Vancouver is surrounded by water—on the north by the Burrard Inlet and on the south by False Creek. In 1905, plans were drawn up to dig a channel to connect the two bodies of water, but competition between two major railway companies made it impossible. Eventually, it was the Canadian Northern Pacific that obtained the rights to fill up a large part of False Creek for its terminal, which was accomplished in 1918. The landfill produced more than the railroad needed, so neighborhood farmers used the resulting fields and meadows of the area to graze cattle. During the Great Depression, the city retook possession of the land, which became a city dump, a district of transients and unemployed workers, a city park, and a community garden.

In 1957, as part of a twenty-year urban-renewal plan, the Vancouver authorities planned a complex network of freeways whose downtown route would cut through Strathcona. The inhabitants of the area were moved out of their homes and into public housing constructed where the park had been. An entire block was demolished in order to build a new park. In the late 1960s, residents organized themselves in a tenant association that made so much noise that Strathcona's urban-renewal campaign was forestalled and the conservative city government was defeated in 1972.[2]

Win, Place, or Show is a two-channel projected video of about six minutes. It loops continuously during the course of its installation, but with each cycle a computer edits it anew with shot-by-shot variations so that the same scene might be seen from different camera angles or with altered dialogue. The variations seem to follow a few basic rules; for example, a medium shot is always paired with another medium shot on its facing screen, while a long shot is always paired with another long shot. A medium shot is never paired with a close-up. The relationship of the angle on the left screen to the angle on the right screen is impossible to figure out, as the camera angles shift to the point it seems as though Douglas moved the objects around the setting, though in fact he did not.

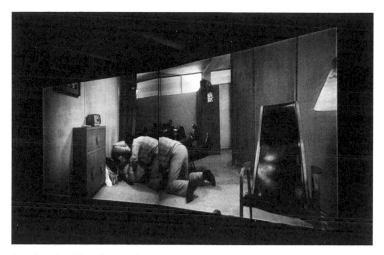

Stan Douglas, *Win, Place, or Show*, 1998

It is dusk. It is April 20, 1968 (just before the events in Europe and in the United States around May 1968, events that are considered pivotal to the structure of contemporary Western culture and, incidently, inspired one of Douglas's previous installations, *Horschamps* [1992]). Two men—Bob, in his late thirties, wears a beige, plaid shirt; Donny, in his early thirties, wears a white shirt—can be distinguished, but just barely, because their hair and clothes have basically the same cut. They are not particularly handsome or remarkable. They are ordinary, average men who become engaged in a silly and enthusiastic scuffle that seems either a reconstruction or a parody of the acting style of 1970s shoddy television shows; the scuffle ends up in a physical confrontation. The same pattern repeats ad nauseam, for perhaps nine hours, fifteen hours, even twenty hours, depending on the exhibition site.

Don or Donny, the younger man, who is supposed to have come from Saskatchewan, asks, "Been to a big city before, Bob?" To which Bob replies, "This not big enough?" Don continues, "You know what I mean—a real big city?" Bob answers, "That will be a frosty Friday." Frustrated, Bob perseveres, "Yeah, well, a city like Pittsburgh. Okay?" He continues, referring to the radio—a trope that Douglas has used frequently to signify how radio or mass

Stan Douglas, *Win, Place, or Show*, 1998

media in general repeats itself while feigning variance. "They could all be from anywhere, right?" His inference is that the radio does not give a sense of place; there is an absolute dislocation between what is presented in the media and the place where you are.

Bob and Don are typical of the longshoremen and millworkers who came for better jobs from various parts of British Columbia—mostly from rural areas—to Vancouver, where they are housed in insipid 1950s architecture in a place that is neither here nor there, a neighborhood isolated from the rest of the city and surrounded by industry and wasteland. These are single men, living close to the docks haunted by drug addicted teenage prostitutes. The sense of claustrophobia produced by *Win, Place, or Show* arises from Bob and Don's anxiety over their displacement. Douglas asserts that it could go one way or the other. They are suspended in this no-space and no-time. Bob and Don's inane exchange is a symptom of their alienated relationship to space.[3] Their alienation, as perceived by Douglas, is a condition of the uncanny, produced by the mundane urban nightmare of displaced populations.

2. The Mirror

The premise for the longshoremen's argument is presumably that Don cannot stop telling stupid stories, which irritates Bob. One of Don's stories goes like this: "A drunk walks up to the bank teller's window to cash a check. The teller asks if he can identify himself. The drunk looks at his reflection in the window and says, 'Yep, that's me alright.'" At the punch line, Donny stands up and faces

himself, mirrored in *Win, Place, or Show*'s two screens, signifying an important moment of recognition. The joke, boosted by Don's doubled image, proposes the function of a mirror, proof of identity. Mirror reflections help us to identify ourselves to ourselves; somehow they prove to ourselves our own existence.

As a trope, the mirror features in various horror stories of the cultural collective. In one such story, an aging character, after looking at himself in a mirror, says, "They do not make mirrors like they used to." Avant-garde director Yvonne Rainer describes her 1974 *Film About a Woman Who* as the poetically licensed story of a woman who finds it difficult to reconcile certain external facts with her image of her own perfection. It is also the same woman's story if we say she can't reconcile these facts with her image of her own deformity. The image one has for oneself never corresponds to the representation that others have: the schizophrenic sees himself in the mirror and fails to identify himself for pathological reasons. In the realm of the horror film, a subject looks at himself in the mirror and sees a monster. In a germane scene in René Clair's *La Beauté du Diable* (*Beauty and the Devil*), 1950, Faust, played by the older French actor Michel Simon, is tempted by a young, attractive devil, played by Gérard Philipe. At the moment he signs a pact with the devil, Faust looks at himself in the mirror, which reflects not the old man but the young and handsome, devilishly attractive visage of Gérard Philipe.[4]

Beyond one's own reflection is the search for that of yet another. In Jacques Lacan's mirror stage, the young subject first senses his or her own wholeness by catching his or her own gaze in a mirror, but he or she also glimpses another—the gaze of the mother. There is always a third gaze that constructs the identity of a subject, and the act of looking at oneself in the mirror implicitly invokes the search for the gaze of a third party. In Donny's story, it is the bank teller who fills the role. Without the presence of the third gaze, we are faced with the narcissist, who gets so involved in his own reflection that he drowns in it.

When the image in the mirror starts to lead an independent life, the essence of the fantastic emerges, which comes to pass in

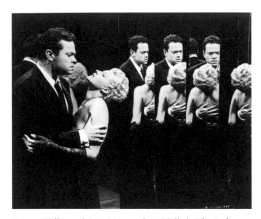

Orson Welles and Rita Hayworth in Welles's *The Lady from Shanghai*, 1948

La Beauté du Diable once Faust has transformed into the young man whom he was longing to be. His reflection starts living a life of its own instead of that of the man standing in front of the mirror. Another narrative device, employed in German nineteenth-century expressionistic stories and then later in cinema, involves the protagonist's reflection leaving the mirror to wander the city committing horrible murders, usually of a sexual nature. The reverse situation, which is also another form of the fantastic and horror, is the vampire, who sees no reflection in the mirror. Because the vampire is dead, the mirror can only reflect an absent field.

In his seminal text *The Uncanny*, Sigmund Freud develops the psychoanalytical implications of the doubled image. *Uncanny* in German is *unheimlich*; its opposition is *heimlich*, or *homey*. Though *uncanny*, consequently, implies displacement and deterritorialization, Freud was unhappy with uncovering just the most superficial meaning of uncanny, so in English he found that there are a number of equivalents, such as *unfamiliar*, *uncomfortable*, *uneasy*, *gloomy*; to describe a house using *unheimlich* would suggest that it was haunted. The word *canny*, the opposite of *uncanny* in English— not a common word—means *cozy*, something, say, close to home but also endowed with magical powers. Freud concludes, "*Unheimlich* is customarily used, we are told, as the contrary only of a first signification of *heimlich* and not of a second. On the other hand everything is *unheimlich* that ought to have remained secret and hidden but has come to light."[5] Within the idea of *unheimlich* is the notion of representation, which leads to my hypothesis that cinema is one of the best tools with which to present the uncanny.

Unheimlich— and this connects to Douglas's installation— refers to dolls or dummies possessing an apparently animate being. This connotes waxwork figures and automata but also relates to mental phenomena, such as

Face/Off, directed by John Woo, 1997

epileptic fits and various psychological disorders in which, says Freud, automatic or mechanical expressions are at work behind the appearance of ordinary mental activity. The feeling of unease produced by *Win, Place, or Show* results from the randomized selection of these images because we know there is a computer program behind this process. We know there is not a consciousness that is deciding what shots will be included, since it is a computer that arranges these shots in as many combinations as possible. The sequence becomes uncanny because the constraints of the program prevent a close-up from ever being paired with a long shot. Behind this artificial intelligence, the spectator becomes challenged as a speaking subject. The age of mechanical reproduction has made possible not only the advent of cinema and video but also the apparatuses and devices that produce this strange doubling and repetition. It is through doubling and repetition, Freud insists, that the uncanny presents itself—and in Douglas's work these two instances actually redouble each other. In most cases, an instance either of formal doubling or thematic doubling alone would produce a feeling of the uncanny. In *Win, Place, or Show* they are layered, which intensifies the feeling.

In "The Work of Art in the Age of Mechanical Reproduction," Walter Benjamin quotes the playwright Luigi Pirandello: "The film actor," Pirandello says, "feels as if in exile—exiled not only from the stage but also from himself. With a vague sense of discomfort he feels an inexplicable emptiness: his body loses its corporeality, it

The Mummy, directed by Karl W. Freund, 1932

evaporates, it is deprived of reality, life, voice. . . . The projector will play with his shadow before the public, and he himself must be content to play before the camera."[6] Benjamin adds, "This feeling of strangeness that overcomes the actor before the camera is basically the same kind of estrangement felt before one's own image in the mirror."[7] Since, for Douglas, the reflected image has become superior and transportable, and it is this separateness and transportability that figure as familiar tropes in the horror genre.

On the theme of doubling, which he describes as "the dividing, the interchanging of the self, mixed with a constant recurrence of the same thing,"[8] Freud quotes Otto Rank's studies on the double, in which he argues that even though our contemporary reaction to the double is that of fright and horror it was originally invented as "an energetic denial against the power of death." The ancient Egyptians manufactured little figurines to resemble the living in order to ensure immortality. While the Egyptian culture of the dead was designed to reassure and comfort mortals against the inevitability of death, mummies became twisted into figures of horror in twentieth-century popular cinema—note Karl W. Freund's *The Mummy* (1932) with David Manners, Edward Van Sloan, and Boris Karloff. Rank claims that the double has become a "thing of terror"[9]: the gods of non-Western religions have been understood and reinterpreted by the West as objects of secret demonic and pagan cults.

At stake is the question of the return of the repressed. The unconscious always functions in reverse: what was designed to console is rendered as a cause for terror. The double gave rise to consciousness, providing the possibility for man to self-reflect, to have a chance to look at himself as if in a mirror. By a strange reversal, this consciousness, instead of acting as an ally, has become

the demon. The double rests on ambiguity: in the beginning having a godlike power, assuring against the unconscious and death, evolving into a metaphor for the return of the repressed and the death instinct.

The theme of the double, an expansion of the theme of the mirror, is Douglas's centerpiece in *Win, Place, or Show*. His tool, cinema, is an invention contemporary to Freud's invention of the unconscious. Douglas himself says that once you find a language to name something, it starts existing. The unconscious exists because Freud conceived of it, and the unconscious exists also because cinema housed it. Douglas's installation can be read as one of the latest adventures in the naming and housing of the unconscious.[10]

3. The Suture and the Nightmare

In 1966, Jacques-Alain Miller used the theories of the founder of modern mathematical logic, Gottlob Frege, to describe and assess what he calls Lacan's algebra of the unconscious. Frege suggested that numbers do not naturally progress from one to the next—that is, you cannot go from one to two without the invention of zero. Miller emphasizes Frege's declaration that "each thing is identical with itself." For one to become two you need to go *through* zero. The subsumption of zero into one allows the progression from one to two, from two to three, and so on. Thus, zero, as an invention, is present solely as a stand-in, allowing for the succession of numbers. Zero is the lack that comes as the condition for the emergence of one, and Miller insists that this notion is capital to understanding the discourse of the unconscious.[11] The subject, for Miller, must be represented by zero in Lacanian algebra. For Lacan, the locus of truth is located in the Other, not in the subject: there must be something that looks at the subject in order for the subject to exist as subject. So, the subject must be signified by a lack (zero).

Only through the vanishing of the subject and its passage as lack can the unconscious progress to constitute the chain in the order of thought. On the level of this constitution, the definition of a subject comes down to the possibility of one signifier more.

Stan Douglas, *Win, Place, or Show*, 1998

Consider now the position of the subject of cinema: the spectator is
constructed as a subject by looking at a film. Miller mentions that
for Lacan the *sign* represents something for someone, but the *signi-
fier* represents the subject to another signifier, meaning that the sub-
ject is inserted into a chain of discourse. Each signifier becomes a
stand-in for a subject, because, insofar as the signifier is inserted
into the chain, there is a signifier before and a signifier after. Again
this describes cinema: one shot follows another and another. At the
moment you are absorbed into one shot, you are signified by that
shot, then another one is going to come to displace you. For, in
Lacanian psychoanalysis, the unconscious is structured as a language,
the subject only exists through language. The subject is the effect
of a signifier and the signifier a representative of a subject. This
relationship is circular, though nonreciprocal. *Win, Place, or Show*
strikingly illustrates this circular algebraic formulation. The disqui-
eting effect of the installation comes from the fact of how closely it
represents this relationship of the subject to the signifying chain.

In 1969 film theorist Jean-Pierre Oudart expanded and system-
atically applied Miller's thesis to describe the flickering effect of
cinema on the subject in his landmark text "Cinema and Suture,"
where he suggests that after every film frame, the spectator is abol-
ished in order to be represented by the next one. This is how film
creates an imaginary field. He argues, "Every filmic field traced by
the camera and all objects revealed through depth of field . . . are
echoed by another field, the fourth side and an absence emanating

from it."[12] Douglas has explored this field before, such as in the work *Hors-champ*, a title actually connoting off-screen space. Cinema has such a hold on us because it projects an imaginary field in which we somehow have a place. Simply and concretely, when a cinematic cowboy and his horse ride through the open range from left to right to disappear at the edge of the screen, we don't assume that the cowboy has fallen into a void but that he continues galloping through the prairie, though we no longer see him. We are still as horrified as early film spectators were when they saw the train accelerate toward them as though directly into their seats.[13] These processes of identification and terror and pleasure are based on the fact that cinema produces this imaginary field. This wide-screen space is structured and articulated through the angle–reverse angle strategy. A *is* talking to B, even though the camera may have recorded them at different times or in different spaces.

What is the essence of our pleasure in cinema? "Every filmic field," Oudart continues, "is echoed by an absent field, the place of a character who is put there by the viewer's imaginary and which we shall call the Absent One. At a certain moment of a reading, all the objects of a filmic field combine together to form the signifier of its absence. At this key-moment the image enters the order of a signifier."[14] What this means is that a field of poppies on the cinematic screen represents not merely poppies but the absent one who looks at the poppy field. The presence signifies the absence. Cinema conjures the existence of an absence by using the visible to suggest the invisible. Cinema would not be what it is without this mechanism.

Oudart went against the grain of conventional assumptions, which construct the cinematic exchange through the succession of shots. Though he does not deny that there is some form of exchange between each shot, he suggests further that: "Prior to any semantic "exchange" between two images . . . and within the framework of a cinematic *énoncé* constructed on a shot/reverse-shot principle, the appearance of a lack . . . is followed by its abolishment by someone (or something) placed within the same field—everything happening within the same shot or rather within the filmic space defined by the same take."[15] He uses the early films

Pickpocket, directed by Robert Bresson, 1959, film poster

of Robert Bresson, especially *Pickpocket* (1959) and *The Trial of Joan of Arc* (1962), to illustrate his claim: Bresson's images are haunted by the presence of the off-screen. Something from the imaginary field always materializes within one shot: Joan might glance off-screen enough so that it's apparent she is talking to someone in the viewer's field, or a voice might be heard from off-screen. The image, which is circumscribed by the frame, is haunted by the presence emanating from the absent field. There is a constant dynamic between what is shown and what is not, what is seen and what is not, what is present and what is absent. For Oudart, it is this dynamic that drives cinema; anything else he dismisses as subjective cinema; where the exchange is merely between shot and reverse angle shot. As a result of the strategy, he says, the field of absence becomes the field of the imaginary—of a film space formed by the two fields, the absent one and the present one. The imaginary field is not your imaginary construction of what is missing, but your imaginary construction of what is there and what is not. It is a sum of the presence and the absence. Oudart specifies that in the suturing process the exchange does not take place between two consecutive images, as I said before, but: "first and foremost between the filmic field and its echo, the imaginary field."[16]

It is the Western habit to read from left to right, so when looking at the two screens of *Win, Place, or Show* the spectator's tendency might be to give primacy to the screen on the left and read the screen on the right as that which came after. Oudart's term for the imaginary field, *echo*, which has the qualities of being simultaneous and slightly delayed, seems appropriate to apply to the installation. In its spatial simultaneity, *Win, Place, or Show* does not overcome the slight split in consciousness of a left-to-right reading. The ideal chain in the suture discourse is, according to Oudart, "one which

is articulated into figures which it is no longer appropriate to call shot reverse-shot, but which mark the need—so that the chain can function—for an articulation of a space such that the same portion of space be represented at least twice, in the imaginary field—with all the variations of angle that the obliqueness of camera

The Trial of Joan of Arc, directed by Robert Bresson, 1962

with regard to the place of a subject allows."[17] The ideal chain progresses as a duplicating representation evoked in a to-and-fro movement, punctuated by framing. Douglas's skillful experiment with almost all possible framings makes the spectator aware of not only the frame as frame but also its arbitrariness.

Douglas also succeeds in breaking down linear time. One shot demands more than one reading. He captures Oudart's perfect suturing moment—after the scuffle, after Bob tells Don, "If I wasn't so tired, I would slug you again." And Don says, "I know it." Or, alternatively, "I hear you." They both sit, Don on the edge of a bed, picking up a newspaper to read. In the context of the scuffle, this shot suggests that Don is trying to calm himself down—he is sullen, sulking. Because of the work's circularity, however, this shot immediately opens up. While looking at the paper—in which, it turns out, he is not terribly interested—Don begins again to tell a story, one of the three versions of which is that of the drunk who walks into the bank. In another version, Bob tries to interest Don in horse racing. These versions are all presented to us from continually different focal lengths and from different angles, generating different meanings. As subjects, we are caught within this circularity of shifting meanings.

In the seventeenth century, René Descartes defined consciousness as a product of time. His major detractor, Baruch Spinoza, insisted

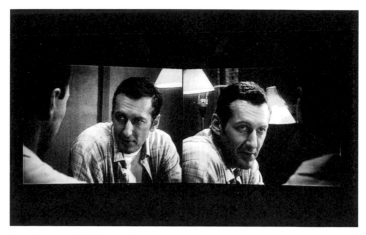

Stan Douglas, *Win, Place, or Show*, 1998

that space was time negated, thus propounding the dichotomy
between consciousness and time and body and space. Spinoza
uncovered within human subjectivity an area of the unknowable.
For him, there were two attributes to God: thought and space.
Man could more or less master thoughts, but space was much more
mysterious. Stan Douglas's *Win, Place, or Show* proposes that the
unconscious unfolds in space. For, though we are aware of ourselves
as conscious in time, we are much less aware of ourselves as
unconscious in space. Douglas's strength is articulating the specific
spatiotemporal ecstatic nightmare hinted at by Oudart: the feeling
that all possible camera angles, all possible editing combinations
will be exhausted and that the world, this Borgesian parody, will
be nothing but a hall of cinematic mirrors.

October 7, 1999

Notes

1 Julia Kristeva, "D'Ithaca à New York," in *Polylogue* (Paris: Seuil, 1977), pp. 495–515.

2 This information is excerpted from the chapter "Strathcona," in Michael Kluckner
 and John Atkin, *Heritage Walks around Vancouver* (Vancouver: Whitecap Books,
 1992).

3 Elizabeth Grosz has acutely written about this condition: "The body and its envi-
 ronment produce each other as forms of the hyperreal, as modes of simulation
 which have overtaken and transformed whatever reality each may have had into
 the image of the other: the city is made and made over into the simulacrum of the
 body, and the body, in its turn, is transformed, 'citified,' urbanized as a distinctive
 metropolitan body." (Elizabeth Grosz, "Bodies/Cities," in *Sexuality and Space*, ed.
 Beatriz Colomina [Princeton, N.J.: Princeton Architectural Press, 1992], p. 242.)

4 John Woo's *Face/Off* (1997) presents an interesting twist on the genre. A cop and a
 gangster (John Travolta and Nicholas Cage) exchange facial features and become
 each other's grotesque, inverted mirror. The film contains a scene involving
 mirrors and a gun, in an homage to Orson Welles's *The Lady from Shanghai* (1948),
 another variation on the monstrous, treacherous double. I should also add that,
 since this lecture was originally given, one of the most successful Asian movies was
 released, *The Eye* (Jian Gui, 2002) by Danny and Oxide Pang. In it, a young blind
 woman receives the cornea of a dead woman. Upon seeing a photograph of herself,
 she fails to recognize it and realizes, to her horror, that the image she was seeing in
 the mirror was that of the body of the dead woman whose "vision" still lives in her.

5 Sigmund Freud, "The Uncanny" ("Das Unheimliche," 1919), in *The Standard
 Edition of the Complete Psychological Works by Sigmund Freud*, vol. 17, ed. James

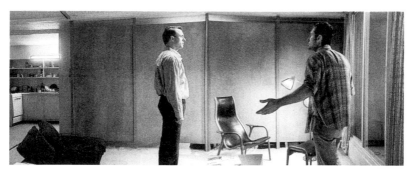

Stan Douglas, *Win, Place, or Show*, 1998

Strachey (London: Hogarth, 1953), pp. 219–52.

6 Walter Benjamin, quoting Pirandello, "The Work of Art in the Age of Mechanical Reproduction," in *Illuminations* (New York: Harcourt, Brace & World, 1968), p. 232.

7 Ibid.

8 Freud, "The Uncanny," p. 234.

9 Freud, quoting Rank, in ibid., p. 235–36.

10 The work of Giuliana Bruno is particularly helpful here. In *Streetwalking on a Ruined Map: Cultural Theory and the City Films of Elvira Notari* (Princeton, N.J.: Princeton University Press, 1992), she characterizes the unconscious as "housed"— with specific connection to post-nineteenth-century urbanism and the invention of cinema.

11 Jacques-Alain Miller, "Suture: Element of the Logic of the Signifier," *Screen* 18, no. 4 (Winter 1977–78), pp. 24–34. (This essay was first published in French in 1965.)

12 Jean-Pierre Oudart, "Cinema and Suture," *Screen* 18, no. 4 (Winter 1977–78), pp. 35–36. (This essay was first published in French in 1969.)

13 *L'Arrivée d'un train en gare de La Ciotat* (*The Arrival of a Train in La Ciotat Station*), directed by Louis Lumière, 1895.

14 Oudart, p. 36.

15 Ibid., p. 37.

16 Ibid., p. 39.

17 Ibid.

The Case of Thomas Schütte

BORIS GROYS

It is not an easy task to address the oeuvre of Thomas Schütte, as it cannot be analyzed using the usual terms to describe an individual style, a clearly defined personal artistic program, or a recognizable attitude. Imagine an exhibition of Schütte's complete body of works: such a virtual exhibition would look like a collection of heterogeneous objects reflecting extremely different artistic styles, programs, and attitudes—like an exhibition not of an individual artist but of several artists. It is possible to identify in this exhibition separate groups of artworks. Within each of those groups, the works have common styles and attitudes, but there is no clear or understandable connection between the various groups of works.

To be sure, many artists change their attitudes and methods during the course of their artistic careers, and such changes can be significant, which is why art-historical writing predominantly deals with the development of an individual artistic project, with its history. Usually, such a development is described in Hegelian terms, as a movement of self-reflection. Artists reflect on their previous works and move further, considering their own achievements and failures, formulating new goals, or reinterpreting old works. Such a movement of self-reflection can be—up to

Thomas Schütte, *The Collectors*, 1988/1999

a certain degree, but nevertheless in a more or less plausible way—understood and described by a spectator, an art critic, or an art historian.

In this virtual exhibition of Schütte's collected works, though, the change from one group of works to another betrays no clear progression; it does not seem to represent a process of self-reflection on the artist's side. Instead, the spectator confronts abrupt, seemingly unmotivated changes, shifts, and gaps that cannot be described as either a continuous development or an individual artistic project. Rather, as spectators, we encounter a Foucauldian notion of the historical archive. The deviations seem just to happen. It is difficult to imagine a conscious, subjective self-reflection—self-reflecting subjectivity—unifying all these heterogeneous artistic strategies. The collection of Schütte's works looks like the result of transferring the Foucauldian notion of universal historical archive to an individual artistic archive. The archive of the individual creation presents itself as a combination of continuities and ruptures that does not allow understanding and explanation in the traditional terms of an art-historical analysis. Every such homogenizing, unifying interpretation must function as an act of violence, ignoring the fundamental heterogeneity of Schütte's work.

The strategy of creating a personal collection consisting of ostensibly incongruous objects by following obscure, hermetic, or even random rules of choice is well known and established in the context of contemporary art, but, as a rule, contemporary artists who create their own collections and personal museums do so by using readymades, photographs, or videos, which provide the possibility for these artists to collect the world rather than produce it. The contemporary artist acts, then, not as a creator but as a consumer, as an appropriator of things produced by modern technology, which circulate anonymously in our mass culture. This artistic practice is often characterized in terms of the "death of the author," but it may be more apt to describe it as the emergence of a different type of authorship, which manifests itself not through an act of production but through an act of consumption, of appropriation—a deferred, assumed authorship *post factum*. The mechanism of such

a deferred assumption of authorship has been suggested long before Marcel Duchamp. This alternative notion of authorship was proposed much earlier by Søren Kierkegaard, who described authorship as taking ethical and social responsibility for something that one has not done or has done "unknowingly"—that is, not as a conscious subject or as producer of one's own actions.[1]

The case of Schütte is, however, much more complicated. He produces all the objects of which he claims to be author. When he speaks about his own work, he stresses the point that his methods of fabrication are traditional and do not relate to or rely on contemporary technology. Schütte does not appropriate. He is an author-creator. Still, the obvious discontinuities and gaps in his artistic production suggest the repudiation of the traditional notions of artistic identity or creative subjectivity. But Schütte is able to demonstrate the fate of artistic subjectivity in modernity precisely because he does *not* reject the traditional role of the artist as creator, as many other artists do. Schütte consciously takes on this traditional role, and, at the same time, he presents the collection of his own works as a kind of *Kunstkammer* consisting of disparate, disconnected series of objects and images.

A complicated interplay between two different notions of authorship—between artist-creator and artist-appropriator— determines the inner dynamic of Schütte's work. The strategy

Thomas Schütte working on a sculpture

of Schütte is not one of self-reflection but of self-appropriation, as if two different authors are living and acting in one and the same authorial inner space—the post-Foucauldian author-collector appropriating the pre-Foucauldian author-creator. It is as if the artist picks up images from different parts of the individual world of his creative personal imagination and memory, but he does it in such a way that the general topography of this world as a whole remains concealed, and the history of the creative development of his imagination also remains hidden. As spectators we are confronted here, in the first place, with gaps and shifts that deny any possibility for the usual reconstruction of the inner landscape of the artistic imagination. Therefore, we become the spectators not of the death of the traditional author but of his calculated and carefully staged suicide. The whole world of the creative, personal, and romantic imagination is shown by Schütte as debris of the past, which we cannot understand or reconstruct but can only collect.

It is thus important to recognize the similarities between the artistic strategy of Schütte and the Foucauldian description of historical memory as an arrangement of gaps and ruptures. The fact that the objects produced by Schütte are also fabricated by him and are not simply chosen, as readymades, makes the experience of a *loss* of self-reflective subjectivity and of the possibility of a continuous historical narrative much more acute, much more immediate. The absence of continuity, of a unifying project, of the subject of universal history as stated by Foucault seems to leave us more or less cold. The news that history has no subject and that historical memory cannot be organized according to a dominant narrative seems, at first glance at least, to be even liberating, optimistic, and prospective in its promise of a new individual freedom in the handling of history. But, as the art of Schütte shows, if we accept this Foucauldian model, we immediately confront the same problems in relation to our own personal history. Our personal development suddenly loses its logic and its memory, and it turns into a heap of heterogeneous objects open to a more or less unmotivated and random choice of collected items.

This parallel between universal and individual histories is underlined by Schütte's complicated deployment of art-historical citations. The images he uses in his production are derived from a world whose phenomenology is primarily familiar to us not from our own inner, psychological experience but from art history, dream

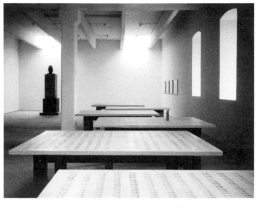

Thomas Schütte, "Gloria in Memoria," at Dia in 1999, installation view of *Kleiner Respekt* (*Small Respect*), 1994, and *Wo ist Hitlers Grab?* (*Where Is Hitler's Grave?*), 1991

analysis, and popular culture. The objects crafted by Schütte suggest, in a certain way, private traumata and obsessions, but at the same time they are placed in cold, neutral spaces that make them look like collector's items. The art-historical references are rarely direct and explicit, but they are always present, always suggested, and because of that Schütte's works never pretend to be immediate, eruptive manifestations of the artist's compelling personality. Schütte does not follow Duchamp, but neither does he present himself as a postmodern "genius," like, say, Georg Baselitz or Markus Lüpertz.

Schütte is not especially fascinated by modern technological civilization or commercialized artistic production, which he—like many European artists of his generation—associates with the United States, specifically with American art of the last few decades and with the American art market. In this sense, his art also attempts to formulate an alternative, distinctly European way of aesthetic reflection and art making, in effect, as a polemic against American art. As such, the following questions determine his art: What has actually happened to traditional European art and artistic attitudes in our time? How can an artist, raised within and by the European cultural tradition, work under the contemporary—that is,

American-dominated—conditions of art production and distribution? How can the artist deal with the seemingly irrelevant disparate remnants and traces of the old European tradition? Schütte does not rely on easy answers, as do some of his French and German colleagues—who seem to believe that in order to restitute the concept of the "true artist" in the European tradition all they need to do is to look deeply into their own souls. Although Schütte acknowledges the death of the old European artistic subjectivity, he still tries to collect its remnants and traces from his personal memory and imagination.

European and, especially, German twentieth-century art history is characterized by the conflict between, on one side, a direct expressive gesture, an individual revolt, a violent eruption of inner passion directed against its suppression by the coldness of the modern age and, on the other, a neutral and objective, yet ironic, description of the conditions of modern life: consider, for example, the opposition between Expressionism and Neue Sachlichkeit in the 1920s. Schütte takes no sides in this old conflict, which resurfaced in the 1980s in Germany with the rise of Neo-Expressionism. Schütte instead avoids this rigid opposition by posing his personal emotional statement in the form of an understatement and by distancing himself from internationally dominating readymade aesthetics, as well as from the pathos of Expressionist painting. At the center of Schütte's work is not an artistic genius but a certain void, an absence—an inner space presented in a way similar to the neutral space of a modern museum, not an eruptive space, as found in the work of many of his colleagues. He ironically demonstrates his subjectivity by demonstrating a loss of subjectivity. His work remains subjective because it gathers up the lasting residue of the purely subjective, free, dreamlike, European imagination and, furthermore, because the artist performs a eulogy, or a bereavement, for this lost subjectivity. One can say that new contemporary subjectivity and authorship are founded on this sacrifice of the traditional notion of the artist as genius.

In his well-known theory of "symbolic exchange," Marcel Mauss describes the role of sacrifice in so-called traditional cultures

as a freely induced loss of one's wealth by means of a sacrifice or a gift, which brings with it symbolic compensation in the form of honor and glory.[2] Within the framework of his "general economy," Georges Bataille applies this model of voluntary loss to art, suggesting that the artist acquires utmost glory when he loses himself most radically in his work. Bataille

Thomas Schütte, *Modell für ein Museum* (*Model for a Museum*), 1981–82

describes the particularly spectacular forms of such loss of self through the excess and delirium that characterizes the *poète maudit* in the French tradition.[3] But, there are more subtle and even more radical forms of sacrifice, for example, by fabricating art through artisanal techniques in this time of rampant technological and readymade production. By using traditional methods, Schütte's handwork does not simply return to the traditional persona of the artist—that is, his methodology is not a reactionary movement back to the notion of art-making as it existed before the technological era. Rather, his manual work manifests itself *in* our time as an unnecessary, excessive, superfluous act—as pure sacrifice of time and vital energy. Precisely this subtle effect of excess and sacrifice is central for the artistic strategy of Schütte.

In this respect, it is notable that early in his career Schütte established an immediate relationship between collection, museum, and sacrifice. In 1981–82, he constructed *Modell für ein Museum* (*Model for a Museum*). From the outside, the model museum looks conventionally impressive, but a closer inspection inside reveals it to be a huge crematorium with ovens installed to burn the collected works. The museum functions not as an institution for collecting and preserving art but as a machine for consuming and destroying art. With *Modell für ein Museum*, Schütte is advancing a long-standing metaphor: the museum as cemetery, a comparison that poses the scenario that what is already presented in the museum

Thomas Schütte, *Mein Grab* (*My Grave*), 1981

is automatically regarded by our culture as belonging to the past—as already dead. If we encounter, outside the museum, something that reminds us of the forms, positions, and approaches represented inside the museum, we will not see this thing as real or living, we'll see it as a dead copy of the dead past, incapable of being truly present or relevant, like a walking corpse. Schütte employed the analogy—the museum as cemetery and curators, art critics, and art historians as gravediggers—in 1981 in a design for his own grave, on which he declared his date of birth, November 16, 1954, while also assigning a date for his own death, March 25, 1996. But, with *Modell für ein Museum*, Schütte takes on a different, much more radical metaphor: the museum as crematorium.

In so doing, he brings to the mind of the spectator a short but important text of the early avant-garde, Kazimir Malevich's "On the Museum," from 1919. There is an immediate and striking parallel between this text by Malevich and the work of Schütte. At the time the text was written, the newly established Soviet government feared that the old Russian museums and art collections could be destroyed through the civil war and through the general collapse of state institutions and the economy, so the Communist Party tried to secure and save these collections. In his text, Malevich protests against the regime's promuseum policy and calls on the state not to intervene on behalf of the old art collections because their destruction would open the path to a new, truly living art. Malevich writes:

> Life knows what it is doing, and if it is striving to destroy one must not interfere, since by hindering we are blocking the path to a new conception of the life that is born within us. . . .

In burning a corpse we obtain one gram of powder: accordingly thousands of graveyards could be accommodated on a single chemist's shelf.

We can make a concession to conservatives by offering that they burn all past epochs, since they are dead, and set up one pharmacy.[4]

Malevich gives a concrete example of what he means: "The aim [of this pharmacy] will be the same, even if people will examine the powder from Rubens and all his art—a mass of ideas arise in people, and are often more alive than actual representation (and take up less room)."[5] So, though Schütte materialized the museum and crematorium's conflation, the conception had in fact emerged with the birth of the avant-garde.

This modern way to deal with corpses of history fascinated many artists and intellectuals in the nineteenth and twentieth centuries, and many of them actually professed a desire to be cremated in order to obliterate any traces that could connect them to history and the past. They believed this sacrifice would open the way for a new conception of life as Malevich describes it. Nevertheless the remains are still collected, and that is the subject of another, later project Schütte titled *The Collector's Complex* (1990), a work that implies the housing and presentation of the ashes of burned, old works. It is a kind of museum-pharmacy that enumerates, arranges, names, and titles. Malevich also concedes to the establishment of an archive of ashes that could provoke memories and "ideas" in the imagination of the spectator.

Indeed, collection, cataloging, categorization, and description have deep, clear connections to burial, destruction, and cremation. Being identified and classified, singled out and categorized, corresponds to being endangered, cast away, thrown away, destroyed, or even eliminated. Categorizations, classifications, and identifications, which seem to facilitate the smooth functioning of historical memory, allow for judgments on both the individual work and the individual artist potentially dangerous, destructive judgments, or even convictions. These arbitraments are made, of course, not only in art but also in political and social life. On the contrary, the ability to evade

Thomas Schütte, "In Medias Res," at Dia in 1999–2000, installation view of *Ohne Titel (Urns)* (*Untitled [Urns]*), 1999

or to escape identification can save the work and the person. Losing identity is here not just a negative loss then, it is instead a calculated sacrifice that promises survival. Nonclassification makes it possible for one to sneak through borders—and to remain alive.

The tendency and even struggle to avoid classification and categorization is characteristic of many German artists working after World War II—including Gerhard Richter, who was Schütte's teacher and influenced him in many ways. The calculated, consciously performed loss of identity is seen by many artists not as tragedy but as opportunity. Their relationship to the archives of history and memory is ambiguous and complicated: on one hand, the museum gives the system of historical memory a chance to be preserved, especially in our secular time, when we can no longer rely on the eternal memory of God; on the other, the same archive, the same system of categorization, can be used and in fact is used to destroy, to isolate, and to kill. Historical experience in Schütte's work is in many ways tenuous in its relationship to collection.

Schütte's particular will to escape identification from time to time takes even a somewhat obsessive form, leading to artworks that in a certain sense are invisible, unrecognizable, and unidentifiable. One group of works, including *E.L.S.A.* (1989), *Studio* (1983), and *W.A.S.* (1989), resembles Bauhaus projects. They could be taken and interpreted as utopian, urban spaces of the future. Half functional, half nonfunctional, they are somehow situated between an artwork and an architectural project. On further consideration, though, these models are anything but utopian. In fact, in an interview with James Lingwood, Schütte admits that while he was strongly

influenced by the Russian Productivist movement, by Constructivism in general, and by the Bauhaus, he also blames the Bauhaus as being responsible for the monotony of contemporary cities, and he claims that for him postmodern architecture was a liberation from modernist dogma.[6]

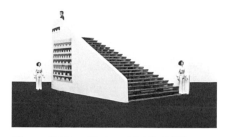

Thomas Schütte, *Westkunst Modelle: Schiff* (*Westkunst Models: Ship*), 1980

These are complicated negotiations. Though Schütte shares the interest of the Bauhaus to bring art into life, these models are nevertheless postmodern precisely in their quotation of modern architectural styles. At the same time, they do not share in the postmodern celebration of exclusivity and the classical tradition. Schütte's is a rather "cheap" art, a kind of Arte Povera architecture. This approach characterizes the *Zweite Moderne* (*Second Modernity*)—the catchphrase, which became popular in Germany in the 1990s (in art as well as in architecture), to identify modernity after postmodernity, a modernity that stylistically reflected the art of the twentieth century, a modernity that had gone through a period of (postmodern) self-reflection and evolved into a second modernity.

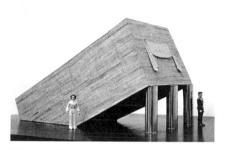

Thomas Schütte, *Westkunst Modelle: Kiste* (*Westkunst Models: Box*), 1980

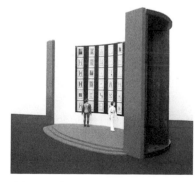

Thomas Schütte, *Westkunst Modelle: Bühne* (*Westkunst Models: Stage*), 1980

I tend to interpret this second modernity as a second*hand* modernity,

Thomas Schütte, *Große Geister* (*Big Spirits*), 1996

a boring, uninspired, shabby modernity that follows everyday life, and still determines contemporary life. This modernity is our destiny, our fate. It does not expose any hope or project for the future, but it typifies the inescapable condition of everyday existence. I would say that Schütte constructs precisely the Second Modernity, the secondhand modernity, in his models. The main opposition, at least in immediate art-historical terms, that Schütte tries to escape with these models is precisely the opposition between modernity and postmodernity. It is an intense, sharply formulated opposition, which permeated the German art scene in the 1980s. Schütte withdraws from this neo-, post- attitude and instead embraces humdrum reality.

Große Geister (*Big Spirits*), 1996, reminds us of the first moment of the film *Terminator 2: Judgment Day* (1991, directed by James Cameron), and it also reminds us of the sculptor of Italian Futurism, Umberto Boccioni, who demanded that artists free themselves from the past and embrace modern technological civilization. Using both art-historical and pop-culture icons, recognizable and unrecognizable, the artist employs an obvious irony, combining his fascination for the fluid condition of Futurist culture and for the Terminator's corporeal fluidity, for filmic and virtual fluidity. Schütte asks us to imagine a body with no clear structures, a virtual body, a transient body, an *Übergang*, a stage, a momentary still from a series of transformations. This work relates art to the infinite prospective of metamorphosis, which is ancient as well as modern.

The centrality of the protean dimension of Schütte's artistic project is also clearly formulated in the well-known series *United Enemies* (1993–94), a series of works that latently quotes from art-historical tradition. Though it appears to be his most

"postmodern" work, the artist is cautious to distance himself from this impression: he claims to have been inspired to make the work by events in 1991 in Italy, where he lived at the time. He describes those events as a peaceful revolution— when prominent corrupt politicians were exposed and sent to jail. In a conversation with Lingwood, Schütte described his *United Enemies* figures as "sticks with a head on top and another stick that builds the shoulders." He continues, "I used my own clothes to wrap them in and form the body. For me they were puppets and not related to classical art."[7] When Lingwood suggests that they look classical, Schütte reacts negatively and distances himself from the characterization. The role of tradition seems less important to him than the actual message of the work. In the faces of the figures we see expressions of aggression and contempt; they have old faces immobilized by animosity, and it is this hate that unites them. It is struggle, not love, that provides their common ground.

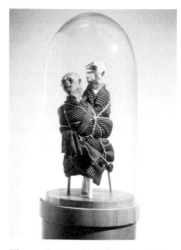

Thomas Schütte, *United Enemies: A Play in Ten Scenes*, 1994

This work reminds me of Ernst Jünger's description of the war between Germany and France as an expression of an ecstatic unity more intense than all peace declarations.[8] Such a vision of history makes utterly superfluous the idea of a unified history, that of a peaceful unity achieved through the Hegelian *Aufhebung* (sublation) of old historical conflicts. History happens, it changes—but not in a peaceful, predictable way. Shifts, gaps, and ruptures are internally connected to this vision of history as battle, as a struggle that intimately connects adversaries—the destiny of a battle is nonpredictable and essentially happenstance. The battlefield moves from one place to another, from one configuration to another without clear logic, without making a difference. Looking at a series of these works, one gets an acute sense of their inner rhythm. The position of the figures shifts, their faces and their poses change, but the facial

expression and the body language remain the same. They embody transformation without movement. The enemies are encapsulated in the same topology all the time—they are transforming themselves, but they remain in the same place. The history presents itself as a protean movement incapable of changing place, incapable of producing a real difference.

In "The Evolution of Life: Mechanism and Teleology," Henri Bergson says that there are two kinds of movement. One is a movement of a body in space, and the other might be described as the dissolution of sugar in a glass of water.[9] Something has happened to the water; it became sweet water. But this change is invisible. Gilles Deleuze gives two similar examples in his book on cinema: movement in space as opposed to a freer, transformative flow.[10] For Schütte, the movement of history is more like the dissolution of sugar in water than it is the progress of a car in the street.

Thomas Schütte's overall artistic strategy presents itself as subtle, protean movement undermining the classificatory art-historical, art-critical discourse, by the wish to escape external categorization and historical judgment, to make it difficult to define his work. For me, this wish to escape the classification and art-historical judgment is the most interesting aspect of Schütte's work. It does not result in a particularly hermetic imagery that has to be hermeneutically revealed by an interpreter. Rather, every attempt to theoretically interpret the work inevitably confronts the artist's conscious intention to avoid the very possibility of theoretical interpretation, because he creates a permanent situation in which every definition and conceptualization seems to be irrelevant and pointless. In fact, the only adequate way to address Schütte's work, to recognize and to take seriously the will of the artist, seems to be to stay silent. Schütte seems joyful when he senses his success in resisting interpretive critical discourse. The art critic is confronted, then, with a hopeless situation: every attempt to identify and categorize Schütte's work demonstrates a misunderstanding of the artist's main idea. But how can a critic say anything at all without using categorizations and identifications? Of course, I didn't remain silent and I will continue. It's my job as a critic to find a way to speak, even if

an artist tries time and again to prevent me from doing so.

One obvious critical strategy might be to say that Schütte has not fully achieved his goal, and that his art retains a certain recognizable, identifiable style, but such a solution is not especially interesting and, in fact, employs a line of false presuppositions. The wish itself to avoid critical appreciation is a strategy that by no means characterizes only Schütte's art or even, more generally, German art after World War II. At first glance, this wish contradicts the classic modernist strategy to rely on theoretical manifestos, rigid programs, strong commitments, clearly defined and explicitly formulated aesthetic principles, and clearly drawn demarcation lines.

But, in fact, from its beginnings, the artistic avant-garde was driven by two contradictory desires: to be absolutely modern and, simultaneously, to elude confinement in its own time, to avoid being superseded by the next step in a historical progression. Modernist artists and theoreticians strove to be free from the burden of history, from the necessity to take the next step, from the obligation to conform to historical laws and the requirements of the new. In their struggle against the dominance of the spectator, the avant-garde artist used the device of aesthetic provocation, the "shock of the new," which was calculated to disconcert and to disarm the viewer. The avant-garde wanted to be new to avoid judgment by the spectator on the basis of established criteria of taste, mastery, and traditional classifications of art production. But it was precisely this desire that paradoxically subjected the avant-garde artist to the art-historical narrative, which is, of course, inherently based on differentiating between the old and the new, on the premise that new art can emerge only

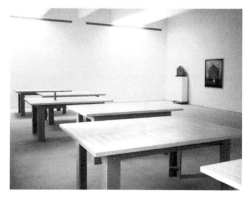

Thomas Schütte, "Gloria in Memoria," at Dia in 1999, installation view of *Wo ist Hitlers Grab?* (*Where Is Hitler's Grave?*), 1991, and *Mein Grab* (*My Grave*), 1981

through a comparison to old, already known, already collected art. Avant-garde artists' writings consistently protest against this predicament and argue that any neutrality controlling art-historical progression is spurious.

Wassily Kandinsky asserts in "On the Spiritual in Art" (1911)—one of the earliest and most radical manifestos outlining avant-garde strategy and practice in Germany—that specific forms and colors exert a magical, unconscious influence on the viewer if the soul of the viewer is finely tuned, reactive, and receptive enough for such an influence.[11] Only a few souls, the true artists who are gifted with special sensibilities and powers of self-analysis, are able to capture, to generate, and to manipulate consciously these unconscious effects according to a principle, which Kandinsky defines as "principle of inner necessity." Modern art, in Kandinsky's view, requires the artist to understand this inner necessity, to explore it, and to master it technically. The artist who can master the unconscious influence of images has the ability to command the viewer's psyche and to manipulate and educate him or her to become a better human being. This ability to control marks the artist as an elite member of society. On this deeper level of inner necessity, as Kandinsky states, there is no difference between old and new, between abstract and figurative, between original and trivial, and, thus, all art-historical descriptions and classifications become useless. The spectator therefore loses the capability to judge a work of art. Quite on the contrary, the work of art begins to judge the spectator. According to Kandinsky, the spectator's soul participates in a cosmic drama, in a battle between opposing spiritual principles; specific artworks, by stimulating reactions, assign the role of the spectator's soul in this inner drama. Kandinsky's reference to the soul or the unconscious serves here to bridge the aesthetic distance that intervenes between the spectator and the work of art. The illusion of that distance serves only to conceal the unconscious effect of the image—and thus reinforces it. The viewer no longer has control of the image, and the artist, like a magician, manipulator, and educator, wields power over the viewer's unconscious.

Many other twentieth-century artists tried, in differing ways, to seize control from the spectator, from the critic. Artists from Duchamp to Andy Warhol and beyond refer to the collective unconscious by embracing or alluding to contemporary technology in their work. Joseph Beuys appealed to cosmic processes and energies to escape critical and art-historical control. Schütte's art is not so aggressive, and he does not present his work as a revelation of the unconscious. The images that Schütte uses are too well defined, too clear, to be misunderstood as eruptive and expressive.

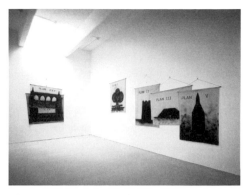

Thomas Schütte, "Scenewright," at Dia in 1998–99, installation view of *Pläne I–XXX* (*Plans I–XXX*), 1981

But Schütte's work demonstrates a similar will to break loose from historicity by appealing to a temporal dimension of *uchronia*, or the state of disruption. He tries to do that by referring to the infinite flow of images and signs that cannot be controlled, described, and categorized by a finite vocabulary of standard art-historical discourse. This seemingly limitless, virtual flow of images should give the artist the opportunity to find at any time an image that can deconstruct known oppositions. Such an image would be neither old nor new, neither traditional nor immediately expressive. Such an image should also be able to navigate through all historical categorizations into an atemporal, uchronic sea, where it could somehow survive historical dangers and changes.

The work of Schütte evokes such an image flow. The individual work groups look like sequences, like fragments of the infinity of virtual transformations, modifications, and variations that flow beyond the museum, beyond personal or collective memory, beyond any art-historical control. Schütte stages his work as a ceremony in which individual authorship is sacrificed; the reward for this sacrifice is access to the uchronic eternal stream of virtual images.

Undeniably, there are, however, no purely virtual signs. Schütte himself demonstrates that artworks need a material support—they must be made, produced. And hence they are always finite. By producing his work using traditional techniques of craftmanship, Schütte makes clear, at the same time, the gap that separates his romantic aspirations from the reality of a private or museum collection as a final destination of a contemporary artwork. In the end, Schütte cannot escape history: Rather, he ultimately joins a history of attempts on the part of modern artists to evade art history. Under the conditions of modernity, the art critic is a spectator of a historical competition to escape art criticism; and the role of the art critic is to record the best results in this competition. In this respect, to follow Schütte's artistic strategy is promising and rewarding.

March 2, 2000

Notes

1. See Søren Kierkegaard, "Diary of a Seducer," in *Either/Or: A Fragment of Life*, trans. David F. Swenson and Lillian Marvin Swenson (1959: Princeton, N.J.: Princeton University Press, 1987).

2. See Marcel Mauss, *The Gift: The Form and Reason of Exchange in Archaic Societies,* trans. W. D. Halls (New York: Routledge, 1990).

3. See Georges Bataille, *The Accursed Share: Consumption,* trans. Robert Hurley (New York: Zone Books, 1988).

4. Kazimir Malevich, "On the Museum" (1919), in *Essays on Art, 1915–1933*, vol. 1, ed. Troels Andersen, trans. Xenia Glowacki-Prus and Arnold McMillin (London: Rapp & Whiting, 1971), p. 70.

5. Ibid.

6. Thomas Schütte, in conversation with James Lingwood, in *Thomas Schütte* (London: Phaidon Press, 1998), pp. 20, 37. "Somehow the idea came from the Russian productivist movement after Constructivism, when artists worked with real life objects for mass production, like in the Bauhaus. . . . The Bauhaus got all the credit and made all the mistakes. I mean their disciplines made a lot of cities ugly; nobody wants to live in them."

7. Ibid., p. 29.

8. See Ernst Jünger, *The Storm of Steel: From the Diary of a German Storm-Troop Officer on the Western Front* (1920), trans. Basil Creighton (New York: H. Fertig, 1975).

9. See Henri Bergson, "The Evolution of Life: Mechanism and Teleology," *Creative Evolution,* trans. Arthur Mitchell (New York: Henry Holt and Co., 1911), pp. 1–97.

10. See Gilles Deleuze, *Cinema: Movement—Image*, vol. 1, trans. Hugh Tomlinson and Barbara Habberjam (Minneapolis: University of Minnesota Press, 1986).

11. See Wassily Kandinsky, "On the Spiritual in Art" (1911), in *Complete Writings on Art*, ed. Kenneth C. Lindsay and Peter Vergo (New York: Da Capo Press, 1994), pp. 114–20.

Rodney Graham's Black Box Treatment

JAN TUMLIR

I.

> The more closely you look at a word the more distantly it looks back.
>
> —Karl Kraus

Literary artists like Rodney Graham inspire suspicion among critics; the transgression of categorical boundaries is applauded until the moment the territory of language has been encroached. The word is jealously guarded, maybe more than any other tool, by those who have made it their business. Accordingly, only the most dyslexic and tongue-tied artists receive a unanimous thumbs-up. This border patrol is not entirely misguided: language, particularly literary language, has endured considerable mistreatment at the hands of artists (and critics alike). Artworks pale beside books, with their structural complexity and emotive wealth, just as they pale before the cerebral power of music and film. Competition at this level will tend to cast art in the role of the "cultural retard," as Jorge Pardo likes to say—that is, to adopting a strategy of open failure, the sole purpose of which is to point out the secret failure of everything else in the world. A no-win

Emile Berliner gramophone, 1895

Rodney Graham, *Alice's Adventures in Wonderland,*
1989

situation, apparently; art plays dumb, eviscerating the artifact, the masterpiece, and reducing every sparkling passage down to the dull material truth of its component parts.

This, on the face of it, is what Graham does: suck dry a cultural legacy of devastating richness and beauty, leaving behind only withered husks, empty wrappers, for our own intellectual amusement. The Brothers Grimm, Lewis Carroll, Edgar Allan Poe, Herman Melville, Georg Büchner, Søren Kierkegaard, and Sigmund Freud—these are just a few of the literary giants that Graham submits to this stunting treatment. All are in some sense reduced, but to what, and to what end? Moreover, it is worth asking at the outset just what, apart from a certain canonical status, the above personalities hold in common. If one of the under-lying aims of Graham's plunder is simply to leave his mark, his signature, or better still his tag upon the edifice of this established, accumulated culture, to claim it and thereby render it same as opposed to other, then it would seem that Graham has reversed the whole process. Collecting is a matter of life and death, Walter Benjamin reminds us, but in this case the magic circle always remains partly—fatally?—open.[1] One after another, these authors and texts are waylaid from a concentric, public archive into an eccentric, private one, and in the process something of their original strangeness is restored.

Books are just a part—albeit a representative part—of the work overall. Graham also makes photographs, films, videos, and sound and music recordings, each form entailing its own appropriate constellation of reference. This multimedia expansiveness might be off-putting at first, suggesting a brash and unseemly dilettantism, until one recalls that all these forms are basically reproducible

information. Graham makes art about information, the medium as well as the message, as that other communications-savvy Canadian Marshall McLuhan famously put it. My choice to begin here with a discussion of books is for this obvious reason: the book marks the dawning of the information age.

2.

> Printing changed learning and marketing processes alike. The book was the first teaching machine and also the first mass-produced commodity.
>
> —Marshall McLuhan, *Understanding Media*

For such a bookish artist, Rodney Graham remains remarkably unsystematic in his methods. Beyond a generic tendency to quote, his work seems to have been scrupulously purged of all signature traits or any sort of epistemological or aesthetic bias. Graham takes as much from the sciences as the humanities, from the "high" as the "common" cultures, from the academy as the avant-garde. So what does it all add up, or boil down, to? First, one may note a recurring optical thematic. Many or most of the texts that he chooses to work with devolve upon instances of seeing and/or picturing that somehow exceed the usual parameters of literary description. These passages all relay the interface of viewer and view as an emphatic kind of production, one that resounds suggestively within the fine-art context that houses it. These productions are emphatic because they are flawed, because the medium of visualization, whatever it might be, has turned opaque and reflective. The author in this way appears at either end of the pictorial funnel, wavering at the point of origin and vanishing, and the reader follows suit.

If a single category can be made to contain all these various expressions, it is the Fantastic, a flexible designation that originates in the imagination of the Gothic and runs right through to such proto- and postmodernists as Franz Kafka, Jorge Luis Borges, Alain Robbe-Grillet, and beyond. The Fantastic emerges as the irrational flipside of the Enlightenment, or as "the return of the Enlightenment's repressed."[2] According to Michel Foucault, the Age of Reason—

what he terms "the Classical period"—had repressed "not only an abstract unreason but also an enormous reservoir of the Fantastic. . . . One might say that the fortresses of confinement added to their social role of segregation and purification a quite opposite cultural function . . . as a great, long silent memory."[3] For Foucault, then, the Fantastic is concretely housed; he is describing the first modern prisons and insane asylums, but, as storehouses or archives of forms and concepts from an earlier era, these would become the models as well for such seminal works of Gothic horror as Horace Walpole's *Castle of Otranto* (1764), Mary Shelley's *Frankenstein, or the Modern Prometheus* (1818), and Poe's "The Fall of the House of Usher" (1839). Here begins the concern for problems of perception and representation as subject matter. The unreliable narrator is only the symptomatic tip of the iceberg of a much larger "crisis of the real," ultimately forcing readers to acknowledge the subjective basis of experience.

For literature and art, this revelation would lead to the wholesale relocation of "the real" within the work itself, a negativist variant of the autonomy concept emerging through the holes and tears of an increasingly worn-out representational order. If, as theorist Tzvetan Todorov points out, literary language is essentially tautological— that is, unlike the language of journalists and critics, for instance, it has no real object outside itself—then the Fantastic is the most literary form of all. It is "the quintessence of literature,"[4] owing to its openly made-up character, as well as this self-reflexive streak.

Problems of vision and perception generally, exaggerations, distortions, hallucinations, and psychosis are all characteristic of the form. The "sleep of reason"[5] would open a fantastic portal to an earlier age, regressing all our newfound knowledge to its root causes in superstition, magic, and the occult. One by one, the representative figures of this archaic order are pulled into the blinding light of a new day: a proliferation of compound creatures, doubles, and partial selves, running the gamut between the marvelous and the uncanny. Ultimately, however, they are neither wholly one nor the other. There is a hesitation at the heart of the Fantastic narrative between natural and supernatural explanations, and this hesitation

is key to the modernist density of the text, the medium, the delivery mechanism of the image and the idea.[6]

Graham's references turn consistently on this moment of textual foregrounding, the rendering opaque of the medium in an experience of anxious uncertainty. It is not quite an alternative to the dominant form of modernism that he seeks, nor is it the sort of counter-tradition that once stoked the critical furnace of postmodernism, since Graham appears to have little faith in the claims of this discourse to stand authentically apart from its chosen *doxa*. Instead, if we can make out one line of modernism extending from Foucault's Classical period toward an evermore assertive positivism—essentially, a progressive succession of solutions to the problems of representation—then an "other" line, which Graham has chosen to follow, would run right alongside it, doubling it, in a sense, since both wind up at the same point. The difference between them is only a question of attitude, ambience, or subjective coloring, although, as anyone who has experienced even the faintest tweaking of the tints and hues will attest, these variations might land you in whole other worlds. While outwardly the lines would appear to run parallel, inwardly they diverge, and it is at this point where the alignment between outside and in, objective and subjective, matter and mind, become skewed, that Graham's work takes shape.

Rodney Graham, *Camera Obscura Mobile*, 1996, installed on Dia's rooftop in 1999–2000

The camera obscura keeps cropping up in this context; it is after all the start, the first agent, of just this sort of transference. Externalizing consciousness as a black box with a single staring eye, it has allowed us to perceive the act of perception at the most rudimentary level. From the Renaissance to the modern era, the camera obscura has overseen the entire succession of epistemological shifts that would reorient the phenomena of observation from a

Rodney Graham, *Reading Machine for Lenz*, 1993

place outside the subject to a place within.

The dark room is never far off. Graham no doubt elected to work on Georg Büchner's unfinished novel, or novella, *Lenz* (1835) because of the extremism of its expressionist tendencies, its restless conflation of internal and external landscapes by way of a steadily unraveling protagonist—the eponymous Lenz. But just as significant as these matters of style and sensibility is the name of the book and its central figure. Lenz is an actual person, apparently a friend to Goethe who begins his own book on color theory with the example of a camera obscura whose aperture is suddenly shut tight. Goethe goes on to describe the various afterimages that greet his eyes in response to no outside signal or prompting, as though internally generated.

Jonathan Crary places this passage on the fulcrum of a momentous turnover in our theories of knowledge and understanding, as phenomena that once were objectively determined now seem to issue straight from the body and mind.[7] Accordingly, we might place Lenz among the early casualties of this dawning relativism, his vision increasingly blurred by the gray fog of synaptic misfiring—"die Trübe"—from which Goethe himself seems largely immune. Lenz truly is one of the original moderns in this sense; his escalating schizophrenia reduces him inwardly to a state of nature, abandoned to the flux of one thing after another, no two things ever the same, while outwardly he appears to others as some sort of broken-down machine. His conflicted condition comes to a head, in the original, during a walk in the woods. In the "remake," this becomes a voyage of no return. Graham loops Büchner's text, so that following the opening section it seems to get stuck, repeating the same five pages

over and over until the book ends. The repetition thus both negates and overdetermines the text's underlying logic.

3.

> A mechanism is made of a group of mobile parts that work together in such a way that their movement does not threaten the integrity of the unit as a whole. A mechanism therefore consists of movable parts that work together and periodically return to a set relation with respect to each other.
>
> —Georges Canguilhem, "Machine and Organism*"*

Here is how Rodney Graham describes his own *Lenz* (1983):

> In the first 1434 words of the C. R. Mueller translation of Georg Büchner's novella *Lenz* there are two occurrences of the phrase *through the forest* in mutually compatible grammatical contexts. It is possible to typeset the first 1434 words of the text so that they fall on precisely 5 justified pages, with the last word (the second occurrence of the word *through*) falling flush right at the end of the last line on page 5. It is further possible to set this same text so that the first occurrence of the word *through* (word 242) falls exactly at the end of the last line of page 1, flush right, and so that *the forest* (words 243 and 244) falls at the top of page 2. In this way the original narrative is short-circuited before the second *the forest* is attained and a 5 page text loop is created in which page 5 may be (endlessly) joined back to page 2.[8]

Foregoing textual analysis or explication in favor of a kind of writing exercise—one every bit as daunting as that perennial favorite: "describe, in detail, the act of tying your shoes"—the above passage is remarkable mainly for its mathematical concision and accuracy. Beside the hothouse subjectivism of the literary source material, it comes off all the more bracingly cool and detached; there is no mistaking Graham's objective relation to the literary text as a storage medium for text, pure and simple. He puts it in terms not of "this is what I did" but of "this is what can be done." The art-making process is systematically deindividualized in this way: Büchner

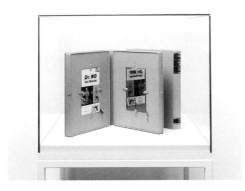

Rodney Graham, *Dr. No**, 1991

poured himself into his prose, and now this same self must be forcibly expunged. Graham offers up instructions for producing emptied-out artworks. His *Lenz* is not simply a book that repeats but a machine that reproduces itself.

This machinic aspect is rendered even more explicit in subsequent book works, such as *The System of Landor's Cottage* (1987) after Poe and *Die Gattung Cyclamen* (1987) after Freud, as well as the Ian Fleming–derived *Casino Royale* (1990) and *Dr. No** (1991). All of these involve reconfiguring the conventional structure of the book by various means that allude to the workings of other, more "advanced" information technologies. All share an optical fixation, moreover, that pushes the camera to the fore as the most appropriate analogue for Graham's mode of literary customization. Indeed, the apparatus is almost a leitmotif in this artist's practice, resumed time and again, as both a metaphorical figure and a functional machine. A crude camera obscura fabricated for *Rome Ruins* (1978) basically inaugurated Graham's public career. As he tells it, this foundational gesture was improvised on the spot to compensate for the loss of his original camera while traveling abroad. Regardless, the simple device set the mold, establishing the thematic parameters of his project, as well as the scope of its subsequent variations. The large-scale *Camera Obscura* (1979), installed in a park in Abbotsford, British Columbia, and the model for *Millennial Project for an Urban Plaza* (1986) both evidence this same photomechanical consciousness, with all its built-in constraints, acceding to an "expanded field" of operations as sculpture, installation, Land Art, and so on. By the time of *Camera Obscura Mobile* (1996), which is modeled on a nineteenth-century mail-delivery vehicle, the link between the technologies of imaging and those of literacy is resumed as though from the other end of the

metaphorical spectrum. Graham concurrently produces amended, mechanized books with these various optical devices, and both are subjected to a process of liberal cross-pollination. All sorts of internal echoes and reverberations are registered between them: the machine books can be seen as the reversed reflections of his postal camera on wheels and vice versa.

The ambiguous status of photography certainly appeals to Graham, for it is both an externalized figure for the interior—the camera as mind; its product, thoughts—and the express antagonist of the interior. Over and above even the printing press, the camera is seen as a usurper of interiority, and repetition is its primary tactic. Graham's pointed selection of the camera obscura, in this respect, is motivated by a perception of self-sufficiency: its (re)production of images is almost authorless—that is, once it has been brought into being, the apparatus appears to operate itself. And this same characteristic can be extended to Graham's process in its totality: a means of deindividuation, it loosens the word and image from the grip of human intentionality.

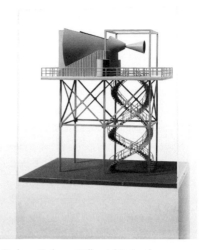

Rodney Graham, *Millennial Project for an Urban Plaza*, 1986

In itself, this ongoing conflation of reading and seeing already constitutes a slap in the face of orthodox modernist aesthetics, but clearly Graham wants to go further. After all, the point here is not to reduce but to increase exponentially the causal menu. To proceed in like fashion, then, calls for adding yet another apparatus, another information-storage technology to complete Graham's three-tiered system of cultural excavation: phonography. It is not until we have factored in the faculty of hearing that the resulting equation will take on a truly mind-boggling, synaesthetic dimension. The works involving musical scores, such as *School of Velocity* (1978) after

Austrian composer Karl Czerny, serve as switching stations since they are concerned with sound and music as writing, a printed and published thing. Also, these works deploy the principle of mathematical repetition to ends that verge on the sublime. For instance, Graham's *Parsifal* (1989) extends the already-long running time of Richard Wagner's original 1882 composition to a literally astronomical thirty-nine billion years. At the level of practical operations, however, these works continue to conform to the model of *Lenz*—a section of the score, like the text, turns back on itself, over and over, but in a way that now recalls the skipping of the stylus on a vinyl LP.

4.

> I am electrical by nature. Music is the electric soil in which the spirit lives, thinks, and invents.
>
> —Ludwig van Beethoven

"There has never been any gramophone-specific music," claims Theodor W. Adorno in "The Form of the Phonograph Record"[9]— at least not in 1934, the time of his writing. "According to every standard of artistic self-esteem," he goes on to suggest, "the form of the phonograph record was virtually its nonform. The phonograph record is not good for much more than reproducing and storing a music deprived of its best dimension, a music, namely, that was already in existence before the phonograph record and is not significantly altered by it."[10] In an earlier essay, however, Adorno offers this startling insight as to what form such a "gramophone-specific" music might in fact take: "There is only one point at which the gramophone interferes with both the work and the interpretation. This occurs when the mechanical spring wears out. At this point the sound droops in chromatic weakness and the music bleakly plays itself out. Only when gramophonic reproduction breaks down are its objects transformed."[11] The critic's underlying demand for medium specificity is implicitly modernist, but what is not—what effectively undermines the very foundations of modernism—is the suggestion that specificity will be attained, in this instance, by way of dysfunction, by the misuse of the apparatus. Whereas photography

serves to remove the hand of the artist from the production of the work, phonography reintroduces it, as it were, by default. Increasingly, art making becomes tied to the exercise of an open technological incompetence.

The "skip" that determines the form of Graham's *Lenz*, and many other works besides, is itself an irritating technical malfunction at first. In time, it is rendered intentional and emphatic, first through the device of the locked groove popular among some of the "trippier" exponents of 1960s and 1970s rock, and then much more ubiquitously through current practices of sampling, the piecemeal assemblage of found sound segments, or, again, loops. The search for precedents will take us even further back to such proto-Minimalist/proto-Ambient works as Erik Satie's *Vieux Sequins et Vieilles Cuirasses* (*Old Sequins, Old Waders*), 1913, which contains an instruction to its pianist to repeat the final passage 380 times. Or the more notorious *Vexations*, composed two decades earlier (1893), which is to be played in its entirety 840 times in a row.

Satie's musical practice is germane to our subject, if only because it was developed contemporaneously with the means of its own "mechanical reproduction," or "technical reproducibility." The invention of Emile Berliner's flat-disk recording technology was announced in 1887, the playback apparatus becoming available four years later through the Washington Gramophone Company. Radio followed close behind (1899), as did magnetic tape (1900)—in fact, the years on the cusp of the twentieth century were literally backed up with electrical breakthroughs. The whole range of sound, as well as moving-image technologies, which all continue to dominate the mass-media landscape, were conceived right then, as though in a single burst. Their implementation—production, distribution, and consumption on an authentically popular, or mass, level—took time, however. In this sense, Satie was responding to a vague technical incentive, a still-gathering Zeitgeist, and he did so in much the same manner as Büchner himself was responding to forces latent in his own moment. *Lenz*, for its part, was written in 1835, four years before the invention of photography was made public. The author's relation to a changing optics, registered in the deep, perhaps

subconscious, structure of his text, demands emphasis, elaboration—which is exactly what Rodney Graham proceeds to furnish. He draws this submerged content up and out in a way that forcefully anticipates the next round of technical revolutions.

Such moves point to an intuitive grasp of the structural symmetry that links all information technologies: a recording device is always also suited to playback. Human perception provides the ultimate model, in this regard, since its capacity for multitasking is virtually limitless. By studying the workings of the inner ear, for example, Alexander Graham Bell develops the idea of the telephone: "At once the conception of a membrane speaking telephone became complete in my mind; for I saw that a similar instrument to that used as a transmitter could also be employed as a receiver."[12] This rudimentary insight enables the whole series of historical shifts that transform a camera into the cinema, for instance, or a phonograph into a gramophone. The progressive account of the evolution of media toward an evermore accurate and objective depiction of the natural world depends on this relation, but so does the account of both the machines and their operators retreating from the world in shell-shocked stupor. This latter account is the one that Graham seems generally to favor, which allows him to move both forward and back, as well as up, down, and across, the modernist time line.

Each individual technology takes shape around a control booth, a mediating way station, a black box that determines its given mode of disassembling the continuous fabric of reality into discrete fragments. For Graham, this interzone is less scientific laboratory than dungeon keep; its products do not so much improve human perception as lop it off at the root. It gives us, instead of documents or objects of inquiry, doubles—double vision; double hearing; a doppelgänger; a skipping, repeating consciousness—threatening our sanity and more.

In this regard, the story of Lenz, told and retold, is exemplary. Here, as with Satie, the loop replaces duration, the "organic" unfolding of narrative time and its progressive sequencing of events from beginning to end. The loop preempts any sense of development or conclusion; any sense of expectation, suspense, surprise, delight,

or disgust; any strong emotion at all; and thereby also empathy and identification—especially the latter since it is above all the "human element" that is drained from this systemic structure. Graham's *Lenz* is a paradox: by bending the almost excessively subjectivist tenor of the original text toward its machinic "other," it also calls up the machine that was there all along as a kind of repressed content. Filtering in and out of the overindividuated voices of Lenz and Büchner is a mechanical drone, one that belongs partly to them and partly to what were once called the "black teeth" of the printing press.

In a very short time, then, we have traveled from "the first teaching machine and mass-produced commodity" to the last one. The intermediate conjunction of a photomechanical optic with the looping capabilities of phonography lands us squarely in the realm of the digital. Drawing together the beginning and end of this technological narrative seals it shut as a separate world, holding its contents captive. Inside, this figure, this Lenz, is precisely a common medium: the site of mutual projection from either end of the text, whether produced or received, and comprising, overlaying, aspects of both the author(s) and the reader. Ultimately, though, he and, by extension, them and us, will be dissolved into the same substance as everything else there—that is to say, words storing words, pure and simple. In a way, the loop restores the density or opacity of the original book. The tale of Lenz's unhappy wanderings through the forest, repeated ad infinitum as though he were *really* lost, appears to fold back on itself until it is in effect the book that is regarding the trees all around as its material source and, simultaneously, recalling the spinning chain saws and factory conveyor belts as its means of production.

5.

> I would like to draw your attention to a curious crisis which I underwent when I was nineteen, just after I had written *La Doublure* [*The Doubling*]. For several months I was filled with an extraordinary intense sensation of universal glory.
>
> —Raymond Roussel,
> *How I Wrote Certain of My Books, and Other Writings*

This enthusiasm and these feelings lasted, with fluctuations, the entire time he was composing his verses, a period of five or six months; they diminished greatly during the printing of the book. When the volume appeared, as the young man, with great emotion, went out into the street and realized that no one was turning to stare at him as he passed, the sensations of glory and luminosity were rapidly extinguished. There then began a real crisis of melancholic depression, taking the strange guise of persecution mania in the form of an obsession with, and a delirious conception of, the universal denigration of men by each other. This depression lasted for a long time and healed very slowly, its traces remain even today.

—Dr. Pierre Janet, "The Psychological Characteristics of Ecstacy"

Graham often cites the influence of Raymond Roussel on his methodology. Between the Surrealist poets and such practitioners of the French nouveau roman as Robbe-Grillet and Michel Butor, this eccentric author occupies a prominent role on the front line of modernism's great "hollowing out" of literary language. His mathematically structured wordplay provides a glaring antithesis to the torrential stream of consciousness that characterizes Büchner's own prose, yet when these distinct practices merge, the outcome is not nearly as absurd or incompatible as one might assume. Repetition cruelly serves to extend Lenz's psychic torments (almost) to infinity, but at the same time it points the way out of subjectivity altogether.

Roussel, a renowned neurasthenic himself, is said to have chosen his machine consciousness as a coping mechanism, to relieve the stresses and strains of modern life. "Everything that is new disturbs me," he is quoted as saying by Michel Leiris, who goes on to furnish this diagnosis: "So profound was his horror of change that, having once performed a certain act, he would perform it again and again because the precedent thus formed had the force of an obligation."[13]

Along with symptoms of fatigue, irritability, and depression, this morbid anxiety in the face of "the New" would characterize almost all the so-called diseases of the will—hysteria, synchraesthenia, melancholia, abulia, and the like—that were the by-products of modernity's relentless march forward. Under the generic term

misoneisme, it became the focus of much psychophysiological research in the late nineteenth century, having by then attained the proportions of a minor epidemic. To historians and critics of modernism, this affliction is of particular interest owing to its highly paradoxical—some would say allegorical—character. As historian Anson Rabinbach has pointed out, neurasthenia and its various derivatives can be understood simultaneously as a profound resistance to progress (basically a form of regression) and as an essential condition of the success of progress.[14] As the afflicted subject's will is worn down, s/he is effectively taken out of the running, no longer to provide any impediment to the wheels of change. In this way, some of the most conservative, opinionated, and self-righteous opponents of modernism would be reduced to a machinelike state of alienation themselves, recycling their own critical gestures until they had lost any trace of their original potency or purpose.

Graham's cast of characters includes many more of these melancholy figures, crushed by the wheels of industry and progress, than the modernist pioneers—the *budetlyane* (people of the future), as the Soviets dubbed the new breed of man-machine that was to emerge from the revolutionary experiment. After all, this is largely a historical project, tracing the origins of an idea of art as an insoluble problem: a counterempirical, nonprogressive, antipositivist art of anxious subjects and objects.

Freud, another key figure in Graham's intellectual cosmology, would provide a fairly comprehensive listing of these in his paper "The Uncanny." "Waxwork figures, ingeniously constructed dolls, and automata,"[15] as he puts it, are all representative of a newly industrialized order of the Fantastic. The archaic fear of the double assumes a contemporaneous mechanized aspect here, for if we remain afraid of dead bodies springing suddenly to life, or conversely of live bodies revealed to be dead, it is because, thanks to the "wonder" of technology, such things are continually reentering the realm of possibility. In fact, artificial intelligence is right around the corner as Freud begins fretting about "the impression of automatic, mechanical processes at work behind the ordinary appearance of mental activity."[16]

Rodney Graham, *Vexation Island*, 1997

The uncanny occurs at the juncture of the past and the future, some event in the present partly confirming an ancient suspicion or dread. The forward course of history is derailed at such times; the beginning is synched with the end, constructing a loop. Freud's schema is also essentially one of repetition, although here what returns is not only not the same, it is other, or more accurately it is somewhere between the same-as-other and the other-as-same. It is thereby not distance but proximity that disturbs most. A loop will always appear to be closing, drawing in its estranged elements, until one can no longer even recognize one's own reflection in the mirror.

This experience of self-estrangement, the periodic reversal of the "mirror stage," is a paradigm instance of the uncanny and functions as the key structural principle of Rodney Graham's work using the industrial medium par excellence, film. *Vexation Island* (1997), *How I Became a Ramblin' Man* (1999), and *City Self/Country Self* (2000) all involve archetypal characters, played by Graham, that seem to have been incubated within the substance of cinema itself. They are germane to the medium, in other words, and thereby offer the artist, who is not, a sort of cover. Appropriately attired—as a pirate-figure for *Vexation Island*, as a cowboy for *Ramblin' Man*, and as a nineteenth-century rural bourgeois for *City Self/Country Self*— Graham gains access to these various make-believe worlds, and yet it is ultimately his being there that, in part, "breaks the spell" for us, the audience. One is reminded, perhaps, of the intrusive presence of Alfred Hitchcock, always somewhat stiff or mechanical, within the

space of his films. Graham, who is uneasily situated between a leading man and a character actor in the looks department, may likewise strike us as an emissary from another world, one who has effectively "crossed over" but is now stuck.

The loop tightens, as mentioned; once one has made out the seam around which it turns, one can only wait for it to come around again. Meanwhile, the one caught inside—pirate, cowboy, transplanted farmer—is submitted to a range of repetitive tortures. He is knocked unconscious by a falling coconut on *Vexation Island*, only to awaken and have it happen again, and again, and again. For his part, the cowboy in *Ramblin' Man* is doomed to travel back and forth between the on-screen "here" and the off-screen "there." He can never really leave because, as filmaker, critic, and composer Michel Chion puts it, "what is specific to film is that it has just one place for images."[17] The "country self," meanwhile, is repeatedly kicked in the ass by the "city self." This repetition has the long-term effect of reigning in the protagonist. This fish out of water gradually becomes acclimatized, integrated; the loop draws these artificial worlds tightly around him until every trace of organic humanity is squeezed out. Graham's obvious gifts as an entertainer only serve to accelerate the transformation process: soon enough he will be rendered machinelike himself, and not in the manner of the *budetlyane* so much as an animatronic robot in a fairground ride.

Repetition brought to bear upon this unproductive labor of slapstick pratfalls and personal loss recalls the origins of cinema in sheer fun-fair spectacle. After all, what are these various figures that Graham has chosen to enact if not Freud's "waxwork figures, ingeniously constructed dolls, and automata"? They are precisely the spectacular counterparts of Graham's neurasthenic moderns, the phantasmagorical backwash of an urban industrial mass culture.

6.

> Sensibility immensely more irritable; . . . the abundance of disparate impressions greater than ever: cosmopolitanism in foods, literatures, newspapers, forms, tastes, even landscapes.
>
> —Friedrich Nietzsche, *The Will to Power*

The impact of photography and phonography has already been noted, but the anxiety that attends Rodney Graham's *Lenz* is also partly borrowed from film. As with *How I Became a Ramblin' Man*, for instance, it has less to do with getting lost in the world than in a work or a word. The individual trajectories of Lenz and the cowboy could be seen to cross; or, maybe these two protagonists inhabit the same wilderness and are simply chasing each other's tails. To one who is just lacking direction, repetition might provide welcome relief, but for them it is a warning sign. Repetition marks the limits of the world as an emphatically constructed, unreal thing.

This far and no further, then. The cowboy seems to be touching the bases, the edges of the frame; the loop always yanks him right back. An emblem of rugged individualism, personifying the frontier spirit, he remains at the same time absolutely dependent upon an audience, that "someone" to "watch over" him. Ultimately, he must always reappear before us to sing his little song: "City life just got me down / Seems I was an encumbrance on that god-forsaken town / Figured it was time to start just wanderin' around . . ." Lenz, on the other hand, is kept running in circles by the voice of God; although in the Graham version, this theological dimension can only intrude by default. The deity that Lenz cajoles and curses is ultimately revealed to be a cruel joker, himself a victim of a limited imagination.

If Lenz, as a product of language, has any advantage, it is of arriving first to this dismal conclusion. The word is there at the beginning: it is the point of origin, or script, for the world, but precisely as such it cannot provide a viable means of transcendence. As text storing text, pure and simple, it can only describe the edges of knowledge and understanding; it can only describe the "life of the mind" as enclosed, imprisoned. An artist that treats the word as a thing may have a more distanced view on the matter, and yet, maybe because it is romantically doomed from the get-go, the attempt to turn the very instrument of our confinement into a missile, seeking a way out, remains enormously attractive. In effect, this quixotic experience of repeatedly knocking up against the limits of consciousness—and sometimes, even often, knocking oneself

Rodney Graham, *How I Became a Ramblin' Man*, 1999

unconscious in the process—is integral to Graham's process, as well
as his work overall.

Above all, Graham approaches literature as a psychic index
of historical change, and the various passages he appropriates are
always in some sense transitional—devolving on moments of
heightened flux in the (actual, as well as imagined) landscape.
Büchner's story testifies to the point where nature no longer
provides the alienated subject any sort of consolation; Poe speaks,
rather, to its spectacular mechanization; Freud's image of nature
appears in a book in a dream; and Ian Fleming, author of the James
Bond novels, reverses the standard relation of observer and observed
altogether in a scene of torture where we experience Bond's own
body as an expansive wilderness through the eyes of a marauding
centipede. All of these landscapes are fantastic, products of such
mind-altering agents as madness, opium, sleep, and adrenaline.
All, moreover, are convulsive in the original Surrealist sense,
describing the breakdown of boundaries between figure and
ground, subject and object, self and other. And, finally, all repeat.

The cyclical course of a journey that winds up, unintentionally,
at the point of departure is yet another cause of the uncanny,
according to Freud. He illustrates this point with an anecdote about

losing his way in Italy, continually passing by the same haunting landmarks and the dreamlike sense of helplessness that this evinced—an experience of pervasive low-key dread not at all unlike the one given off by many of Graham's works. The dialectical tension between the idea of individual autonomy and the worst sort of fate that subtends it is occasionally brought to a head, and, again, as a collision, not of same and other but of same-as-other and other-as-same. It is this proximity within distance—the process of recognition and remembering what should have been forgotten—that is traumatic. The repetition of certain key elements suggests that one might be not just lost but, essentially, lost inside the machine. The sovereign self gives way at this point, renouncing any hope for future progress to a hellish eternity of turning in place.

For Graham and Freud both, these mechanistic anxieties all devolve upon the subject of work, technically defined as no more or less than a movement and calculated in terms of force exerted upon an inert object and the subsequent distance covered. Of course, man has always "worked" in this sense by projecting his will onto objects outside himself. With the advent of mechanization, though, the basic game plan is partly reversed; perhaps for the first time, it is the outlying object projecting its will onto one's body. One must now adapt to a wholly alien work rhythm, one that is by definition repetitious and cyclical, a sequence of regular movements that always return one right back to the starting point. Just like a cog or a wheel, the worker must conform entirely to the system.

Karl Marx specifies that the wheel (both the fundamental component and the symbolic leitmotif of any given mechanism), in the specific guise of the clock and the mill, was the prime mover of the changing nineteenth-century economy, as it enabled the momentous turnover from an artisanal system of handicrafts to full-scale industrialism. The wheel drives forward the conveyor belt as well as the locomotive. It describes not only the pathway of the finished product as it travels through the factory and the marketplace but also the course of the copy that ceaselessly refers back to the model, the prototype, the original, from which it has become nearly indistinguishable. Driving the industrial machinery, the

wheel converts everything and everyone it touches to its repetitive scheme. Accordingly, the industrial workers would not be alone in feeling like "waxwork figures, ingeniously constructed dolls, and automata." After all, fears of being replaced by or annexed to the machine visited the massive labor force of the factories—those, that is, who mass-produced—and, increasingly, those who consumed en masse their commodities, as well as their industrial culture of kitsch, spectacle, and information. The deep structure of industrial capitalism is circuitous: recording begets playback, and "production is also immediately consumption," just as "consumption is also immediately production," as Marx suggests in "The Grundrisse: Foundations of the Critique of Political Economy."[18]

7.

> It is as clear as noon-day, that man, by his industry, changes the forms of the materials furnished by Nature, in such a way as to make them useful to him. The form of wood, for instance, is altered by making a table out of it. Yet, for all that, the table continues to be that common, every-day thing, wood. But, so soon as it steps forth as a commodity, it is changed into something transcendent. It not only stands with its feet on the ground, but, in relation to all other commodities, it stands on its head, and evolves out of its wooden brain grotesque ideas, far more wonderful than "table-turning" ever was.
>
> —Karl Marx, *Capital*

It is tempting to link these forms of mechanized labor with Fantastic narrative, its exploitation of the uncanny potential of repetition, the never-ending story that continually cycles the reader back to page one. It is when two incompatible modes of being, sovereign and machinic, collide that the modern subject is effectively turned inside out and upside down. In what is certainly the oddest passage in Rodney Graham's *Lenz*, the wandering protagonist—rendered "loopy" from the first moment, it would seem, by his predicament—expresses irritation at not being able to walk on his hands. But what if he could? At this point, one has to imagine that he would be seeing the very same

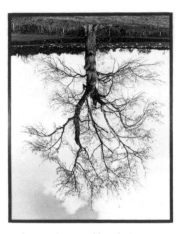

Rodney Graham, *Welsh Oaks (4)*, 1998

vistas that grace Graham's famous upside-down photographs of trees.

Clearly, there is more than one way to turn things around. Either the machinery does it for you, smoothly, in line with its given program, or else it is the outcome of "technical difficulties," possibly assisted—the proverbial "wrench" thrown into the "works." As the emblem of age-old solidity and uprightness, the tree does not ask to be upended; the act of doing so suggests an aggressive intentionality. Just as Lenz responds to his own sense of helplessness with his desire to not only stand on his hands but flip the world on its head, the act of overturning bespeaks the exercise of human autonomy at the most basic level. By the same token, though, it immediately implies the opposite as well: the lack of autonomy that is here being compensated. The tree has the last laugh, in this sense: initially a figure of male virility, it can only turn flaccid upon capture.

Upside-down, Lenz would foresee the natural destruction that enables the cultural production of the book that holds him captive. Rodney Graham, likewise: as an artist raised in Vancouver, surrounded by forest as well as a logging economy, he is conscious of his implication in the rape of the surrounding landscape and is therefore uniquely well suited to envision the tree with a certain ambivalence and complexity. According to him, these photographs began with the search for an isolated specimen, one proud "type" that might stand for the rest, like the subject of a portrait by August Sander. But the singular tree also promotes a certain ecological anxiety, as though it were the only one to survive an orgy of clear-cutting.

Outwardly simple, solid, and true, the lone tree can also be seen, therefore, as the pivot around which all media circulate. Heroically scaled, printed in antique black and white, it beckons like the tree of knowledge, but upended what does it have to tell us? It depicts either literally a world in motion, a world seen through

the eyes of an overturned ob-
server, or figuratively a world
gone topsy-turvy. Or else, it
is a literalized figure of the
Fantastic—that is, a metaphori-
cal conceit realized through an
overt artifice. These distinctions
are admittedly slight, yet it is
only the last possibility that
allows for the frank considera-
tion of form and medium that
is implicit in Graham's work.

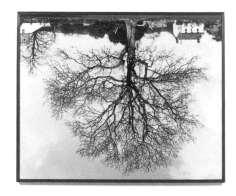

Rodney Graham, *Welsh Oaks (2)*, 1998

The upside-down photograph is one that has been stalled midway
between production and reception. It remains resolutely "of the
apparatus," as though not yet fully released back into the world.
The author has ceded some part of his will to the camera, the black
box; this is also what this picture shows. Pointing back as much
as forward, it is merely the souvenir of a process, a still, but also a
moment of substance, a literal inscription or encoding of time that
has been rendered eternally "now."

There are good and bad infinities, G. W. F. Hegel tells us.
Kierkegaard, meanwhile, contemplates two opposed strains of repe-
tition, the ethical (repetition through duty) and the aesthetic. For
Benjamin, these take shape on earth in the form of commodities,
which partake both of the "New" and the "eternal return of the
same"—a concept he came to equate directly with hell. No doubt
Graham's black box has a stake in the hellish as well, but then, just
like the dark enclosure of Gormenghast in Mervyn Peake's *nouveau
gothic* trilogy, it is subject to change. "The walls of Gormenghast
were like the walls of paradise or the walls of an inferno. The colors
were devilish or angelical according to the color of the mind that
watched them."[19] Here, also, we are watching the walls—two of
which are dead black, while the third is brightened only by a small
hole through which streams the image that alights, upside down,
on the fourth. The image is generated almost spontaneously at the
point of contact of this interior space and its given exterior. This is

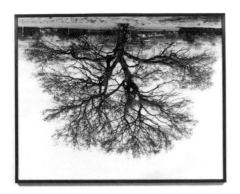

Rodney Graham, *Welsh Oaks (5)*, 1998

a rudimentary form of information technology, one of the earliest machines of reproduction, and it has been trained on the very symbol of organic wholesomeness and singularity. The lone tree stands to model individuality in its most exalted form: Genius.

Here is the purifying source from which the first-generation moderns were led to drink by Immanuel Kant and Friedrich Schiller to cleanse their souls of an industrial culture polluted by mass-produced commodities and spectacle, the noxious culture that had already taken shape behind this seemingly innocent image of nature. Already, that is, Graham's proud tree nestled in its bucolic landscape is a cliché of a cliché, automatically compelling the kind of metareading that largely overlooks the phenomenal event of the thing-in-itself in favor of its various symbolic and metaphorical connotations. Although the image is sharply rendered and just about inundated with "sense of place," so much of this specificity and detail just gets worn away, leaving behind precisely the sort of degraded emblem that the earliest photo avant-gardes militated against in their quest for "making strange." Graham, by overturning the image, might nod in this direction, but in such a blunt and exaggerated manner that one could easily mistake it for parody. Ultimately, though, the gesture emphatically claims nature for information. The original tree is pulped into the paper that its image is printed on. As a sign for a sign, precisely, the image-tree announces the enfolding presence of the black box, even in its de facto absence. In Graham's work, these two components form a dialectical pair, never the one without the other.

The viewer stepping into Graham's black-box treatment will come right between them: the real and the represented, the organic and the artificial. Here we have the process of reproduction arrested

in space as an equation, and as soon as we enter this space we must count ourselves among its givens and variables, all of which are at once present and open to scrutiny.

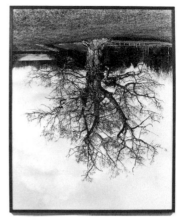

Rodney Graham, *Welsh Oaks (3)*, 1998

The philosophical chestnut about the tree falling in the forest without a witness—did it happen if there was no one to see it?—is here resumed in reverse. It is the sort of question that a reproduction cannot really ask, not even a reproduction of a fallen or upside-down tree, since it is always already a product of a given point of view. And here one can assume that the viewing process began long before we got there and will continue long after we are gone. That is, even in the brief flash of our presence, we are bound to feel somewhat excluded.

8.

> He seems to be completely unreceptive. / The tests I gave him show no sense at all. / His eyes react to light the dials detect it. / He hears but cannot answer to your call. / . . . His eyes can hear / his ears can see his lips speak / All the time the needles flick and rock. / No machine can give the kind of stimulation, / Needed to remove his inner block. / . . . / What is happening in his head / Oooh, I wish I knew, I wish I knew.
> —Pete Townshend, "Go to the Mirror, Boy"

The image is flat; the black box, by definition, three-dimensional. The image represents an object, a moment; the black box represents nothing, at least not explicitly, it just is. The black box is an object in itself, and at the same time it is a container for objects, for images and for those of us who like to look at them. If we can conceive the image as a cut into the fabric of space and time, then the black box is rather a duration, one that synchs up with our own

duration, that is, for the length of our looking, our being there. The image exists to be looked at; the black box likewise, but it is also a viewing mechanism, a vision machine, and by the same token it is a machine that impedes vision, an inner block. In the end, they really cannot be compared, not only because of their differences in temporality and scale but because the one actively enfolds and subsumes the other. The black box is information and apparatus, object and context at once—just like the gallery, here reproduced for emphasis. A box within a box, then; each set of walls further separates the viewer from the view as a worldly phenomenon, replacing it with an insubstantial reproduction, information, a real- or delayed-time construct.

Rodney Graham has fabricated numerous large-scale camera obscuras that double as small-scale movie theaters. He has sealed both photographs (*75 Polaroids*, 1976) and film (*Coruscating Cinnamon Granules*, 1996) in these dark enclosures, which are reminiscent, again, of a camera's interior or a screening room. Sometimes this same structure will be alluded to within the space of the image, as in the upside-down tree photographs or the video *Halcyon Sleep* (1994), which features the artist crashed out in the back of a car that travels from a motel in the suburbs of Vancouver to his studio in the city center. Unraveling in one long take, as Alexander Alberro points out, the voyage is framed in such a way that "the back seat of the car increasingly comes to double as the inside of a movie theater—the seat upon which Graham actively dreams distorts into a theater seat, while the glimmering headlights that stream through the rear window come to resemble the light beam projected from behind the spectator's head in a cinema."[20]

Halcyon Sleep is a silent film, inviting viewers to dream up their own private sound tracks, whereas the work *The King's Part* (1999) submits sound alone to the black-box treatment. Here it is a recording of a flute being played minus its musical output, that is to say "pure" musical process, that prompts a sort of listening that Chion has dubbed "causal"—"listening to a sound in order to gather information about its cause (or source)."[21] Causal listening tends to

promote visualization, another instance of the synaesthetic dimension that we have already attributed to Graham's work, but here especially it will be seen to originate as much from a lack as a surplus of means. This is a synaesthesia that remains firmly tethered

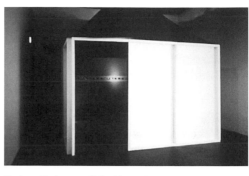

Rodney Graham, *75 Polaroids*, 1976

to the materialist practice of montage. In the end, what is being made visible, audible, and subject to our aesthetic scrutiny in all the above examples are the framing conditions of spectacular perception itself.

This hardly qualifies as a revelation. Art continues to doggedly propose itself as the genuine article by lying so obviously that it appears to be telling the truth. The climax of the whole process still consists in this ritual "laying bare of the apparatus," the technical base and support structure of simulated experience and further, hopefully, a dawning enlightenment on the part of the audience. However, it is worth asking at this late stage in the game if this outcome can really be expected any longer, and at what point it might instead begin to backfire, compelling the exact opposite effect—a redoubled sense of alienation? Now that the term *deconstruction* has for several years already found a much more vital purpose in the world of fashion design than it ever did in art, it is maybe time to reconsider the ostensibly emancipatory potential of the exposed seam. Conversely, however, it could also be argued that it is exactly at this juncture, where a once-crucial critical paradigm appears to falter, that it might again start to yield some surprising results. This, at least, is what Rodney Graham would have us believe. Bypassing the heroic Brechtian mode of *Umfunktionierung* (functional transformation), he embraces the political potentials of gaming and parody, a fantastic, *mise-en-abyme* criticality arising on the vague borders of so-called reality and illusion, and he is not afraid of getting lost there from time to time.

Rodney Graham, *Coruscating Cinnamon Granules*, 1996

Remember that the artist whose gaze we are sharing likes to picture himself with his eyes closed: deeply sedated, as in *Halcyon Sleep*, or KO'd by a coconut on *Vexation Island*. Similarly, the play of the coruscating cinnamon granules in the 1996 film of that name is described by Graham in terms both traumatic and spaced out: "By simply spreading granules of the common household spice over the spiral element of an electric stove and then turning the element on in darkness, one is able to contemplate a spectacle resembling the shifting spiral nebulae of stars such as those that appear on the surface of the retina after a mild blow to the head."[22] Within the context of Conceptual art, the category that comes closest to circumscribing the heterogeneous totality of Graham's output, this "mild blow" is highly pointed. Clearly, he submits his head to such mistreatment not just to enlighten, or even to illuminate, the audience: Time and again, the lights dim, the eyes shut, and when they are again opened, as in *75 Polaroids*, for instance, it is to complete darkness.

Graham has suggested that much of his work springs from a sense of deep-seated animosity toward the media, especially film. Regarding his cinematic debut, *Two Generators* (1984), he says, "My intention was to create a spectacle that would inspire negative thoughts about cinema, which I neurotically hated at the time."[23] Accordingly, we can assume that he shuts his eyes partly in protest. Welcoming this "mild blow to the head," the artist is obviously mimicking the perpetually dazed and confused disposition of the spectator within a society of spectacle; a mean parody, no doubt, but one that is underwritten by genuine social concern. For a visual artist to close his eyes might seem like some sort of authorial suicide,

even if the act is largely symbolic, and yet the view, the image, or the work is never wholly eclipsed in the process. Graham cedes some part of his will to the apparatus, as mentioned, but by extension he cedes it to the audience as well. The artist renounces some part of the status that is due a producer in order to side, for a moment at least, with the recipients: the viewers, listeners, readers. He tries on the audience's perspective right along with that of the apparatus, and finally even that of the surroundings, the landscape, the tree.

Discussing *How I Became a Ramblin' Man* in a recent interview, Rodney Graham puts it this way: "I wanted to perform in it myself. I was interested in taking that position, rather than a directorial one, because I'm not so much interested in directing." The aim, he suggests, is to "just create a situation where someone else can actually have a kind of vision."[24] This vision is one that belongs, at least partly, to "someone else"; it is not given but consciously prompted by the artist who exempts himself in this way. In his semiabsence, the relation between viewer and view, as well as the medium of their exchange, becomes oddly charged. Once more, these three points of the perceptual equation regard each other as strangers, with all the fear and expectation of a first encounter, or a collision. One is per-haps reminded of the dream that accompanied every new medium to the point of emergence, but no further: the dream of stopping life in time and reproducing it into eternity. Sublime visions, occult connections, transcendent revelations: all this and more will be gleaned by the lax witness, passed out at the controls both the artist and his audience, in this case, a moment before impact.

May 18, 2000

Notes

1 See Walter Benjamin, "Unpacking My Library," in *Illuminations*, ed. and trans. Hannah Arendt (New York: Harcourt Brace, 1968).

2 Noël Carroll, *The Philosophy of Horror, or, Paradoxes of the Heart* (New York: Routledge, 1990), p. 56. On a related note, Tzvetan Todorov has written that the Fantastic is "nothing more than the uneasy conscience of the positivist nineteenth century" (Tzvetan Todorov, *The Fantastic: A Structural Approach to a Literary Genre*, trans. Richard Howard [Ithaca, N.Y.: Cornell University Press, 1975], p. 169).

3 Michel Foucault, *Madness and Civilization: A History of Insanity in the Age of Reason*, trans. Richard Howard (New York: Vintage Books, 1988), p. 209.

4 Todorov, p. 168.

5 Francisco de Goya, *The Sleep of Reason Produces Monsters* (1797–98), from the series *Los Caprichos*.

6 Todorov writes that the Fantastic "seems to be located on the frontier of two genres, the marvelous and the uncanny, rather than to be an autonomous genre." He goes on to define the marvelous as "the supernatural accepted," while the uncanny is "the supernatural explained" (Todorov, p. 41).

7 Jonathan Crary, *Techniques of the Observer: On Vision and Modernity in the Nineteenth Century* (Cambridge, Mass.: MIT Press, 1995), pp. 67ff.

8 Rodney Graham, quoted in *Rodney Graham: Works from 1976 to 1994* (Toronto: Art Gallery of York University, in association with the Renaissance Society at the University of Chicago, and Yves Gevaert, Brussels, 1994), p. 81.

9 Theodor W. Adorno, "The Form of the Phonograph Record" (1934), in *Essays on Music*, ed. Richard Leppert, trans. Susan H. Gillespie (Los Angeles: University of California Press, 2002), p. 277.

10 Ibid., p. 278.

11 Adorno, "The Curves of the Needle" (1927/1965), in *Essays on Music*, p. 275.

12 Alexander Graham Bell, quoted in Friedrich A. Kittler, *Gramophone, Film, Typewriter*, trans. Geoffrey Winthrop-Young and Michael Wutz (Palo Alto, Calif.: Stanford University Press, 1999), p. 75.

13 Michel Leiris, "Conception and Reality in the Work of Raymond Roussel," in *Raymond Roussel: Life, Death and Works, Essays and Stories by Various Hands*, ed. Alastair Brotchie and Andrew Thompson (London: Atlas Press, 1987), p. 75.

14 Anson Rabinbach, "Neurasthenia and Modernity," in *Incorporations*, ed. Jonathan Crary and Sanford Kwinter (New York: Zone, 1992), pp. 178–89.

15 Sigmund Freud, "The Uncanny" ("Das Unheimliche," 1919), in *Psychological Writings and Letters*, vol. 59, ed. Sander L. Gilman (New York: Continuum, 1995), pp. 201–02.

16 Ibid.

17 Michel Chion, *Audio-Vision: Sound and Screen*, ed. and trans. Claudia Gorbman (New York: Columbia University Press, 1994), p. 67.

18 Karl Marx, "The Grundrisse" (1857–58), in *The Marx-Engels Reader*, 2nd ed., ed. Robert C. Tucker, trans. Martin Nicolaus (New York: W.W. Norton, 1978), p. 228.

19 Mervyn Peake, *Gormenghast*, quoted in Rosemarie Jackson, *Fantasy and the Literature of Subversion* (New York: Routledge, 1998), p. 163.

20 Alexander Alberro, "Demystifying the Image: The Film and Video Work of Rodney Graham," in *Cinema Music Video* (Vienna: Kunsthalle Wien, in association with Yves Gevaert, Brussels, 1999), p. 80.

21 Chion, p. 25.

22 Rodney Graham, "Project," *Art/Text*, no. 59 (November 1997–January 1998), p. 54.

23 Ibid.

24 Rodney Graham, interview by Ulrike Groos (2000), quoted in *Retake*, ed. Ulrike Groos and Suzanne Titz (Aachen: Neuer Aachener Kunstverein, 2001), p. 88.

The Myth of the West

PETER WOLLEN

I want to begin, unexpectedly perhaps, with Mabel Dodge. Up until 1912, Mabel Dodge had been living with her wealthy husband in Florence, Italy, but that year she returned home to New York, partly because her son was now old enough to enter prep school, partly because she was finding Florence "aesthetically and emotionally bankrupt." In his book *New York 1913*, Martin Burgess Green has described in detail the artistic and political salon that Mabel Dodge masterminded after her return,[1] a salon whose habitués played crucial roles not only in the 1913 Armory Show but also in the Paterson Strike Pageant, a demonstration of support for the silk millworkers of Paterson, New Jersey, under the leadership of the IWW (Industrial Workers of the World)—whose members were better known as the Wobblies. The Wobblies had originated out

Bruce Nauman, *Green Horses*, 1988, installed in Dia's exhibition " . . . the nearest faraway place . . . ," 2000–2001

West, where they had organized, as best they could, a largely nomadic workforce of sailors, harvesters, loggers, and miners who drifted from job to job and from town to town, a kind of hobo proletariat, who self-consciously lived the "myth of the West," although they are largely absent from its mediated representation in literature, cinema, and art.

Ralph Chaplin, the composer of "Solidarity Forever" and bard of the IWW, used to recall the stories his father told him as a boy— tales of wild horses, Indian raids, and the frontier characters of Kansas. The world of the Wobblies was fundamentally a man's world—more precisely a *young* man's world—a world in which thousands of young men had traveled out West and thrown themselves into living out the political ideals of Karl Marx and Thomas Paine, into reading Jack London's *Iron Heel* but also Frederick Jackson Turner's histories of the West and the frontier—in Green's words, "a love of the West was as dominant a passion in the IWW as a hatred of capitalism."[2] Turner's ideas about the frontier were important to the Wobblies for a number of reasons. First and foremost, as Green notes, "they were empowered by the myth of moving west whenever city life became oppressive, of starting again in the infinite spaces where a man had to deal with nature, not with society."[3] In other words, nature was socialist rather than capitalist in its essence.

In fact, for every factory hand who had turned farmer between 1860 and 1890, there were twenty farmers who had gone into the factory, according to Patrick Renshaw.[4] The Wobblies, however, were mostly itinerants, attracted by a vision of freedom—freedom to move on, to look for a new opportunity, however transient it might turn out to be. They saw themselves in the words of Fred Thompson, editor of the Wobbly newspaper, as fundamentally footloose: "I think they shunned stereotype in all things. Their frontier was a psychological fact—a rather deliberate avoidance of certain conventions, a break with the bondage of the past. Yet . . . individuality and solidarity or sense of community flourished here together, and with a radical social philosophy."[5] William "Big Bill" Haywood, the Wobbly leader, was unusual as he was actually born in the West,

in Salt Lake City. He wore a Stetson and spoke with a Western drawl and loved cowboy stories. In his autobiography, Haywood told the tale of a faro table in Tuscalora, with eight men and one woman, each of whom had killed at least one man. He himself was a quick hand with a gun. As Green notes, "Haywood's west was the site of mining, not ranching, but he tried his hand at being both a cowboy and a homesteader."[6] Haywood even organized a "Bronco Busters and Range Riders" union, although apparently it didn't last very long.

Bill Haywood's father was a Pony Express rider, his mother an immigrant from South Africa. After their marriage broke up, Bill went with his mother to Ophir, Utah, a mining camp where the mines produced copper, gold, lead, and zinc. He took his first job at the age of nine, going down the mine in Ophir. By that time the mines were more or less worked out—shrinking from 2,500 workings to 150. In one of the two or three streets remaining in Ophir, Haywood witnessed the shoot-out in which Slippery Dick killed Marny Mills and walked away. Soon afterward, Big Bill went down to Nevada and took a job in the mines there. But Haywood was not a typical miner. His stepfather had introduced him to the classics—Voltaire and Byron, Burns and Milton. He played chess and, like Doc Holliday in the film *My Darling Clementine* (1946), he liked to recite Shakespeare. He took the Indians' side, remarking that the massacre of Indians "began when the earliest settlers stole Manhattan Island [right here]. It continued across the continent. The ruling class with glass beads, bad whisky, Bibles, and rifles continue the massacre from Astor Place to Astoria."[7]

By 1913 Haywood himself was in New York, where he met the journalist Hutchins Hapgood, who brought him to Mabel Dodge's salon. Martin Green describes the scene at 23 Fifth Avenue in vivid terms:

> Her bedroom was draped in white Chinese silk and embroidered Chinese shawls, bought from smugglers on the beach at Biarritz during her second honeymoon. In the front room there was a bearskin rug in front of a white marble fireplace; there was old

gray French furniture and chaises longues, old colored glass, and a Venetian chandelier in pastel shades. When at midnight food was served, that too seems to have been often white or pastel: turkey, ham, white Gorgonzola, with hundreds of cigarettes and bottles of Kümmel in the shape of Russian bears.[8]

In Carl Van Vechten's novel *Peter Whiffle: His Life and Works* (1922), there is a description of Bill Haywood's effect on Mrs. Dodge's salon—Edith Dale's in the fiction—"the tremendous presence of the one-eyed giant filled the room. . . . Débutantes kneeled on the floor beside him."[9] To be taken with a pinch of salt, perhaps, but indicative of the power that radiated from the miner, gambler, and Wobbly leader, who had seen the inside of at least three jails, surrounded now by artists and intellectuals. There, in Mabel Dodge's salon, they talked about both revolution and art.

Big Bill Haywood's companions at the salon included many artists: Andrew Dasburg, Marsden Hartley, Max Weber. An old friend of Gertrude Stein's, Mabel Dodge was committed to modernism. (Stein had even written a portrait of her—*Mabel Dodge at the Villa Curonia*.) It was from the circles of Stein and Dodge that the impetus behind the Armory Show first came, though the task of organization fell to the Association of American Painters and Sculptors, who then named Dodge as one of the show's two vice presidents and as writer of an introductory essay to the catalogue. Not long after the conclusion of the show—and the conclusion of the pageant produced by the IWW in support of the Paterson strike—Dodge decided to leave New York. In 1916, she moved out of her Fifth Avenue house and relocated to the Hudson Valley—to Croton-on-Hudson, where she had found a temporary home for Isadora Duncan's dance company. Among her many houseguests was the painter Maurice Sterne, who had been part of Stein's circle in Paris and whom, despite the failure of her two previous marriages and her Freud-based theories of feminism, Dodge decided to marry in August 1917.

Immediately after the marriage, in a typical gesture, Dodge sent her new husband off to Wyoming to paint the landscape. A few weeks later, he left Wyoming and moved down to Taos in

New Mexico, where he was finally joined by his wife. Artists were already painting in Taos—in fact, the area had been "discovered" for painters, as Green points out, as long ago as 1898, by Bert Geer Phillips and Ernest Leonard Blumenschein, although, as Green also notes, "they were traditionalists in art. It was Mabel Dodge who brought the modernists there."[10] Soon, Dodge and Sterne were joined by other protégés—Andrew Dasburg and Robert Edmond Jones, who became famous as a stage designer. Later came John Marin, Stuart Davis (whose stay didn't last very long), Georgia O'Keeffe, and Paul Strand, as well as writers such as D. H. Lawrence and Robinson Jeffers. For Dodge, Taos was essentially an "Indian place"—as Green notes, "its connections with Kit Carson, for instance, were of no interest to her."[11] The relevant myth for her was that of the Indian and a primeval American culture, a native and non-Cartesian culture, based on community and a reverence for nature and the earth. John Sloan summed this up when he wrote that the paintings of Native Americans were "evidently inspired by a consciousness of life, plus a thing we have not got— a great tradition."[12]

This tradition was essentially a landscape tradition, as interpreted by the Taos group of painters. As John Marin put it, "the artist must from time to time renew his acquaintance with the elemental big forms which 'have everything': sky, sea, mountain, plain."[13] This group of modernists continued, in effect, the landscape tradition that had long inspired Western painters, transposing ideas of the sublime into a more abstract or even, as in the work of O'Keeffe, erotic register. Later, when Max Ernst arrived as a refugee from World War II and moved to Sedona, Arizona, he brought a Surrealist vision with him—the Surrealists had long been interested in Native American culture, as demonstrated by André Breton's collection of Native American masks and by Wolfgang Paalen's expedition to the totem poles of British Columbia's Skeena Valley. In fact, Native American art was to resurface as a key influence in the 1940s—on the Gallery Neuf group, on Indian Space painters such as Steve Wheeler and Peter Busa, but also on Busa's friend Jackson Pollock.

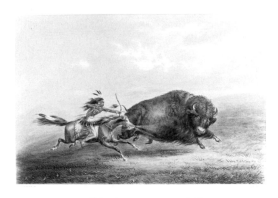

George Catlin, *Buffalo Chase over Prairie Bluffs*, 1844

Western art had traditionally been landscape oriented. Its roots were in early nineteenth-century paintings of Indian life—exemplified by George Catlin's portraits and his quasi-ethnographic scenes of village life, as well as paintings of buffalo hunting, bronco riding, and throwing the lasso—soon to be followed by paintings of human figures set in a vast landscape—Native Americans and trappers, riding on horseback or in canoes, set in scenes of natural beauty, with luxuriant forests or craggy mountains. In time, the human figures were left out, and artists such as Albert Bierstadt and James Madison Alden painted pure landscapes, often scenes of grandeur—mountains viewed across a glistening lake or the giant waterfalls of Yosemite. Then, energetic foreground action within the landscape began to return, as in William Tylee Ranney's *Hunting Wild Horses* of 1846, Alfred Jacob Miller's *Buffalo Hunt* of about 1850 or James Walker's painting *Cattle Roundup* (circa 1878). The buffalo hunt painting became almost a genre in its own right, although it was not until the end of the century, in Charles Marian Russell's paintings, that the Indian war party became a subject, and we see buffalo being shot rather than speared. Finally, in Frederic Remington's work we see Native Americans attacking a wagon train and scenes of urban slaughter, as in *The Misdeal, Barroom Scene* (circa 1897), with its dead and dying sprawled across the floor amid toppled chairs, dislodged hats, and fallen guns.

By Remington's time, the Wild West Show had already established an image of the West as a site of danger, brutality, and vigorous action. As Paul Reddin has noted, the roots of the Wild West Show can be traced back to Catlin's exhibitions of his paintings in 1836—for which, of course, he charged entrance fees—

as well as his lectures, for which he used the paintings as illustrative materials.[14] It was not long before he brought live Indians along, in ethnographic displays, playing their musical instruments and performing dances for the audience. Soon afterward, he assembled an entire troupe of Ojibway dancers, who would then be replaced

Rodney Graham, *How I Became a Ramblin' Man*, 1999, installation view at Dia's exhibition " . . . the nearest faraway place . . . ," 2000–2001

by an Iowa troupe who erected wigwams, demonstrated the game of lacrosse, and performed scalp dances, complete with tomahawks and "real and genuine scalps." On tour in England, Catlin eventually introduced horses and feats of horsemanship into his show—the first of these outdoor performances took place in 1844 at Lord's Cricket Ground, then as now the headquarters of England's national sport.

Just two years later, Catlin ended his career as a showman and returned to his painting, after six of the Iowa contracted smallpox and died in Brussels, a city to which Catlin had been invited by the king of Belgium following his success with the king of France. Catlin was shattered by the deaths and, to his credit, made every effort to protect Indians from any further danger, campaigning against the prospect of sending any future shows to Europe. Nonetheless, Catlin had set in motion a process that was by then unstoppable. As it happened, William Frederick "Buffalo Bill" Cody was born near Leclair, Iowa, in February 1846. It was Cody who would develop Catlin's concept of the Wild West Show, but featuring the Indians as the enemy rather than as the stars of the show. As Reddin put it, "For Catlin, Native Americans became heroic, and the Westward expansion of the United States was 'a headlong stampede of half-crazy adventurers.' For his part Cody would identify

with frontiersmen who fought against Indians and cleared the way for settlement."[15] Catlin exploited his Indian employees but did so somehow out of a wish to educate the world about Native American culture. Cody simply exploited them and despised them.

The scalping in Cody's Wild West Show was carried out by Cody himself, dressed in vaquero costume while killing and scalping Yellow Hand, a coup de theatre based on Cody's actual scalping of an Indian soon after General Custer's 1876 defeat at Little Big Horn. Encountering a group of Cheyenne, Cody shot their leader and then, according to his own account, stabbed him in the heart, pulled his warbonnet off, and scalped him, all within five seconds. He then brandished the scalp in the air, shouting, "The first scalp for Custer!" Cody began his career exhibiting this scalp. Then he moved on to theatrical performance, reenacting the event in a play he had written himself, *The Red Right Hand*, finally using the reenactment to launch his first Wild West Show, which opened at the fairgrounds in Omaha on May 17, 1883. After exhibitions of riding, shooting, and roping came the reenactment "A Startling and Soul-Stirring Attack upon the Deadwood Mail Coach." Cody's formula mingled spectacle with melodrama, combined to provide the public with a patriotic and triumphant celebration of America's violent westward expansion. As Reddin put it, "the show wrote frontier history in blood."[16] Cody presented his audience with an amalgam of horsemanship, marksmanship, animal exhibitions, variety acts, and acts that depicted this one-sided conflict between frontiersmen and Plains Indians—encounters from which the white frontiersmen, of course, always emerged victorious. Eventually the Wild West Show faded away, to be replaced by the rodeo, a development of one aspect of the show—feats of horsemanship, with titles like "Bucking Bronco," "Bucking Steer," "Steer Riding," and "Bucking Mustang"—as rodeo developed into a competitive sporting contest rather than a dramatized demonstration. The real impact of the Wild West Show, however, was to be found in its effect on the new art of cinema, which continued this celebration of westward expansion. Buffalo Bill's last show took place in 1913, after the aging Cody had been bamboozled into signing his property rights away. After

the intervention of law enforcement officers, Cody was forced to appear in a rival circus until it too collapsed, whereupon its effects were auctioned off to the Miller Brothers' 101 Ranch Wild West Show. Cody worked for the 101 Ranch show for less than a year, finally dying at his daughter's home in Denver, January 1917.

Miller Brothers' 101 Ranch Wild West Show

By then the baton had already been passed to the film industry. The key figure was Tom Mix, born in Driftwood, Pennsylvania, in 1880. As a youngster, he was carried away by the Wild West Show, inspired by Buffalo Bill to practice bareback riding on the horses his father used for hauling logs to the family sawmills. Eventually, after a spell in the military, he left home to seek his fortune in the Wild West. Settled in Oklahoma, Mix hung out at the 101 Ranch, swaggering and spinning yarns, eventually finding work in the Miller Brothers' show as the rustler who is dragged to his death behind a galloping horse. Mix was proud of what he did, asserting that "these ranch shows are just as important as cleaning up a band of rustlers. The old ways are going fast. We've got to keep on showing people what they were."[17] He appointed himself keeper of the memory of the Old West's heroic past, finally quitting the 101 Ranch to start a show of his own, with all the standard features of the genre—a battle with Indians, an attack on a stagecoach, bulldogging, jousting—until his big break came and the Selig-Polyscope Studios hired him as a stock handler for a film they were shooting, *Ranch Life in the Great Southwest* (1910). Mix wheedled his way into performing for them as a broncobuster and soon became a regular, moving on to Hollywood in 1911.

Mix was able to exploit his Wild West skills in the new world of movies—marksmanship, athleticism, being dragged by a horse

Gilbert M. "Bronco Billy" Anderson in *The Great Train Robbery*, directed by Edwin S. Porter, 1903

with his foot caught in the stirrup. He soon overtook such stars as Bronco Billy Anderson, who had gotten an early start in Edwin S. Porter's *The Great Train Robbery* (1903). In 1917 Mix joined the Fox Film studio and began his spectacular rise to fame. In the 1920s, when postwar disenchantment coincided with the shock of the "jazz age," Mix saw the appeal the Western might have as a vehicle for reassurance and nostalgia. Moreover, he was "a wonderfully malleable man," as Reddin phrases it, equipped with a stock of tall tales and a crew of press agents.[18] He refashioned his life story, acquiring a new birthplace (El Paso, Texas, instead of Driftwood, Pennsylvania), a father who had served in the United States Cavalry, and, of course, Cherokee blood. He claimed that his childhood was spent growing up with cowboys, that he attended a military academy, fought in a series of wars—Mexico, the Philippines, China, South Africa—and served as a Rough Rider in Cuba with Teddy Roosevelt. He said he had been a Texas Ranger, a cowboy, a deputy U.S. marshal, and a fearless sheriff who arrested 113 ne'er-do-wells in one fell swoop.

Mix's movies followed a simple formula—"I ride into a place owning my horse, saddle, and bridle. It isn't my quarrel, but I get into trouble doing the right thing for somebody else. When it's all ironed out, I never get any money reward. I may be made foreman of the ranch, and I get the girl, but there is never a fervid love scene." Or, as his new Hollywood wife put it, somewhat sardonically— "[His films] consisted of plenty of action, a simple plot, a very white hero, an impossibly incorrigible villain, a number of dangerous schemes to be foiled, and a helpless heroine to be rescued at the last moment."[19] While these two versions are not exactly the same, they fit within the same general scheme, one in which Mix

single-handedly righted wrongs, yet never got any reward, becoming involved simply because of an innate sense of justice. He did the right thing because, after all, he knew it was the right thing to do. He also had a winning manner, a sense of humor, and a glamorous repertoire of cowboy skills. Indians were still seen as savages, but they were not

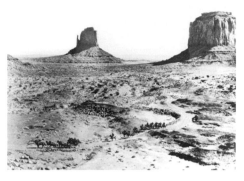

Stagecoach, directed by John Ford, 1939, scene shot in Monument Valley

central to Mix's view of the West. After a century of harassment and genocide, the relatively few Indians who remained were no longer considered threatening and were replaced as villains by local bullies, corrupt bosses, and bloodsucking creditors.

Another type of Western film, however, was soon to appear, one that eventually replaced the old Tom Mix formula. The new epoch began with a trilogy of films that showed much greater ambition—James Cruze's *The Covered Wagon* (1923), John Ford's *The Iron Horse* (1924), and Raoul Walsh's *The Big Trail* (1930). Though *The Big Trail* was John Wayne's first major film, his career as a whole was dominated by work for John Ford, in a sequence of films that began with the classic *Stagecoach*, released in 1939. Ford had been in the film industry since before World War I, starting out as an extra and a stuntman in films made by his brother Frank, mostly Westerns. It wasn't until 1917 that he got director credit. In the 1920s, he made a series of formula Westerns as his brother had done, including some Tom Mix vehicles, but none of these films was taken seriously. His reputation before *Stagecoach* depended on the dramatic films he had made earlier in the 1930s, films like *The Informer* (1935) and *The Plow and the Stars* (1936). As Garry Wills points out, the reputation of *Stagecoach* as a seminal Western was constructed retrospectively in light of Ford's subsequent postwar career as a specialist in Westerns.[20] Only then was *Stagecoach* seen

as the first true Ford Western, the first to feature not only John Wayne but also the sweeping landscape of Monument Valley, at the Arizona-Utah border.

When Ford first approached him to play the Ringo Kid in *Stagecoach*, Wayne saw it as a minor role. The leads were the talkative characters in the stagecoach, not the Kid, who was a stock Western character with little dialogue. Ford, however, had much higher ambitions—basically he wanted to remake Guy de Maupassant's "Boule de Suif" as a Western, bringing together the workaday genre in which he began his career with the respected drama that had crowned it, mixing Hollywood saddle tramps with seasoned character actors. Wayne, it goes without saying, was a saddle tramp. Wills compares the film to Alfred Hitchcock's *The Lady Vanishes* (1938), Edmund Goulding's *Grand Hotel* (1932), and Jean Renoir's *Rules of the Game* (1939), films whose characters are isolated as passengers on a train or guests in a hotel or country house. *Stagecoach* is a film about class and how the wealthiest member of the group—the banker—is arrested and comes out worst, while Wayne as the Kid, a wronged young man bent on revenge, comes out best and then leaves with the other outcast, the prostitute. Thus the social scale within the Western is turned upside down. Elitism is trashed, egalitarianism is rewarded.

The western setting—the landscape of Monument Valley, which subsequently became the signature landscape of a John Ford Western—functions both as a stupendous backdrop to the foreground action, as in so many nineteenth-century paintings, but also as a zone of danger, a device for isolating the characters in the stagecoach and then submitting them to a series of tests, both moral and physical. The Western becomes the site of allegory—an allegory that reveals the discrepancy between the social and the ethical hierarchy, ethics perceived in terms of depth of character rather than the observation of a conventional code. In this context, the Ringo Kid, like the Indians, is almost a part of the landscape, as well as acting within it. He belongs in the landscape rather than in the town—in fact the town of Lordsburg, to which the coach is traveling, is a threat to the Kid rather than a refuge, a haven of civilization. The

landscape stands for "nature" rather than "culture," for values that are somehow innate rather than acquired, for a deeply felt sense of the right course of action, which is dependent on an inner light, a natural gift, rather than on a superficial surface respect for the law as a social artifact. The little microcosm in the stagecoach is saved not by its law-abiding members but by its outcasts.

A few words about Monument Valley. Edward Buscombe, in his essay "Inventing Monument Valley: Nineteenth-Century Landscape Photography and the Western Film," notes that the first film to feature the landscape of the West was Selig-Polyscope's *Western Justice*, made in Colorado in 1907 and advertised in the press as set "in the wildest and most beautiful scenery of the Western country."[21] He goes on to point out that genuine Western scenery rapidly became a sine qua non of the Western, and was a principal factor in preventing other countries from making Westerns, until the belated appearance of the Italian Western, shot on location in the south of Spain. Buscombe also notes that Albert Bierstadt, perhaps the most successful of the nineteenth-century Western landscape painters, actually regarded the mountainous scenes in which he specialized as similar to the Swiss Alps, and therefore suitable for a style of painting derived from German Romanticism. Bierstadt painted Yosemite, which was declared a preserve by President Abraham Lincoln as early as 1864. Shortly after this, the photographers arrived, and following them the filmmakers.

Yet as Buscombe points out, "Today when we think of the West and Westerns, it's not mountains, trees, and lakes that first come to mind, but more often the deserts and canyon lands of Arizona and Utah. Since the 1860s the center of gravity of the Western landscape has moved to the Southwest"—although, as Buscombe also points out, the director Anthony Mann went against the trend, saying, "I have never understood why people make almost all Westerns in desert country. John Ford, for example, adores Monument Valley, but Monument Valley, which I know well, is not the whole of the West. In fact, the desert represents only a part of the American West."[22] In a French study, *Géographies du Western*, a detailed map shows how the vast majority of Westerns are

Fig n°4 Lieux de tournages (191 lieux recensés) et localisations diégétiques (411 recensées). Écrase de domination de Hollywood (Californie) et de Kanab (Utah). Par contre la fiction induite un trophème occupant du Texas (19 %), du Far sud (Californie Arizona New Mexico Texas, soit 47 % des diégésies), des Rocheuses-Hautes Plaines (23 %) et le bloc des embrayes (Colorado-New Mexico-Kansas-Oklahoma-Arizona) tardivement admis dans l'Union (37 %) indiquent les deux lo ts les majeures de l'iconicité imposée par le western: le Far West c'est l'aride où la montagne et, si possible, les deux.

Maps showing where majority of
Westerns took place and were filmed,
from *Géographies du Western*

set in the Southwest (principally Texas, Arizona, and New Mexico), although most of them were actually shot in just three states—Utah, Arizona, and California—even when they represented Montana, Wyoming, or Kentucky. Buscombe argues that the principal reason for this preference was the preeminence given to the Grand Canyon as a symbolic site. By 1899 Baedeker's guide to the United States included a map and instructions on how to get to the canyon by stagecoach. A few years later, the Santa Fe railroad built a spur to provide access by train.

Buscombe suggests that the stories of Zane Grey, by far the most successful Western author in the first part of the century, were instrumental in privileging landscapes of mesas and deserts above those of mountains and forests.[23] (Grey's first best-seller was actually *The Heritage of the Desert*, written after a trip to Arizona and the Grand Canyon.) In 1913 Grey visited Monument Valley and then wrote about it in *Tales of Lonely Trails*. As Buscombe points out, these stories, set in the desert, privilege stoicism in the face of the wilderness over the comfort and "softness" of civilization, a preference clearly shared by John Ford's *Stagecoach*.[24] The appeal of the Southwest was based not simply on a preference for nature over culture but also, more specifically, on the distance it provided from urban life and even from the farm community—it was attractive precisely because of its inhumanity, which automatically conferred a heroic quality on those who ventured into it and survived. The desert is also, as Michael Budd has noted, a zone of extreme contrast between light and shadow.[25] Garry Wills notes that in *Stagecoach* "shadows and sources of light [actually] reconfigure human relationships."[26]

In his classic study of the Western film, *The Six-Gun Mystique*,

John G. Cawelti stresses the role played by geography in the Western.[27] Primarily, he considers the role played conceptually by the frontier, traditionally the geographical meeting point of civilization with savagery and lawlessness. Most Westerns, however, seem to be set in the latter part of the nineteenth century, at a time when the battle over the doomed Indians had been more or less won and the United States had completed its triumphant and murderous march to the Pacific (and indeed beyond). Lawlessness was already in decline—the Indian as nomad was vanishing, the forces of social order had gained the upper hand. It is precisely for this reason, Cawelti suggests, that the landscape itself became such a central feature of the genre, a landscape whose principal characteristics are those of "its openness, its aridity, and general inhospitability to human life, its great extremes of light and climate, and, paradoxically, its grandeur and beauty."[28] These visual images of landscape themselves, he explains, exemplify the grand thematic conflict between civilization and savagery and its final resolution. The Western—as in *Stagecoach*—presents a world in which an isolated town, ranch, or fort is surrounded by prairie or desert, linked to the rest of the civilized world only by train, stagecoach, or a simple trail. While we can see the town as the advance guard of an oncoming civilization, we also sense that it could be swept back into the desert. While inhospitable, the desert's expanse and grandeur suggest that it is not simply the site of lawlessness but also a source of natural power, the "sublime."

The people in this landscape, Cawelti proposes, can be divided into three categories: the townspeople, who are static and defensive in their settlement; the outlaws or Indians, who are mobile and potentially aggressive; and the hero—a sheriff in the town or a cavalry officer in the desert, perhaps—as mobile as the outlaws, with much the same skills, yet differentiated from them by moral character.[29] The landscape, in its grandeur, helps us to characterize him as an epic hero. Monument Valley, for instance, embodies its own complex mixture of magnificence and savage hostility, which serve as metaphors for the encounter between the values of hero and outlaw. Yet, in *Stagecoach*, it paradoxically is the heroism of the two

Jackson Pollock, *Going West*, c. 1934

outcasts, an outlaw and a prostitute, that is contrasted with the shameful conduct of "respectable" townsfolk, overeager to reach safety in the next town.

Artists have often identified with the figure of the outcast who is redeemed as a hero, in the face of rejection by respectable people. In this context, with the myth of the Western in mind, it is worth making a detour in order to look at the life of Jackson Pollock, whose family moved to California when he was a teenager. Pollock was born in Cody, Wyoming, in 1912 in the Big Horn Basin. In the center of town stood the Irma Hotel, an impressive sandstone structure erected by Buffalo Bill Cody himself. The carved cherrywood bar, it seems, had been sent by Queen Victoria as a gift to her favorite cowboy. The year Pollock was born, *The Great Train Robbery* played in the local movie house, as Steven Naifeh and Gregory White Smith reveal in their exhaustive biography of the artist.[30] Pollock's father became a sheep ranch foreman, working up in the Big Horn Mountains. This was where Pollock's elder brothers heard Rattlesnake Pete tell stories of life on the range, stories Pollock himself would later echo as he spun his own tales of the West, put on his Western boots and painted Western scenes with covered wagons and cowboys. Not long afterward, the Pollock family left the ranch and set off for Arizona, where they stayed five years, farming. Next, in 1917, came Chico, California—a gold rush town—followed by Janesville in the foothills of the Sierra Nevada, where the teenage Jackson hung out at the Diamond Mountain Inn, built in 1782 as a stagecoach stop on the road between Susanville and Reno. There Pollock followed the Wadatkut Indians out to their burial grounds and listened to their chants. After a series of other moves, including more time spent in Phoenix, Pollock ended

up living on the Carr Ranch in southeastern Arizona, on the slopes of Aztec Peak, where his mother ran the kitchen in the big boarding-house, where the fiddlers played for the cowboys on Saturday nights, and where young Apache girls from the reservation waited on tables.

It was in 1926, sometime after the family had moved to Riverside, near Los Angeles, that Pollock set out with his brother Sande and their friend, Roy Cooter, on a trip back to Arizona, where they chanced upon a "cowboy-turned-roadworker" called Red, who took them mustang hunting. Naifeh and Smith describe the sequence of events as follows:

> With "Red" as guide, the boys drove back across the plateau, out of the forest and into the hot sagebrush flats around Fredonia. Around noon at Cain Springs, they turned off the road and headed west across the dry, rough ground. . . . By sundown they found a suitable campsite at a watering hole, where they built a fire and slept round it on the ground. . . . At first light, before the horses arrived, [they moved] to the narrow draw that served as a gateway to the watering hole. From there, Red figured, the shooting would be best. Before they could reach their positions, however, they heard the rustle of horses' hooves echoing from deep within the canyon. "We were just a little late getting there," Cooter recalled, "so Red says to get down and be real quiet or the horses might see us and get scared away." On their knees, they crawled the final few feet into position as the tight knot of horses appeared in the draw and moved nervously toward the watering hole, just a few dozen yards away. "They had long manes hanging way down," Cooter remembered, "and tails that hit the ground. They were beautiful animals and they shook their long manes." Then the shooting began. At the first thunderlike vol-ley, the herd exploded. A few horses fell almost immediately, the rest were in full gallop within seconds, stampeding through the draw. . . . They could hear the rumble of hooves for a long time after the last horse disappeared, leaving a thick haze of dust and three or four dark shapes on the canyon floor. "They were beautiful horses," Cooter recalled, "and I can't believe we could just shoot them and walk off. But we did. And I'm ashamed of it to this day."[31]

Seventeen years later, in 1943, Pollock was in New York where his patron, Peggy Guggenheim, commissioned him to paint a mural on canvas. Pollock was unsure how to approach the project, and the day before the final deadline he had hardly even begun work on it. Then, Pollock told a friend, "I had a vision. It was a stampede." In fact, he was back there in the canyon in Arizona. "Cows and horses and antelopes and buffalo. Everything is charging across that goddam surface . . . every animal in the American West."[32] Fifteen hours later, at nine the next morning, the mural was finished, the black outlines filled in with white and then splattered over with colors, and Pollock was on his way to becoming America's most famous painter. Pollock, I might add, had already painted works that were influenced by the viewing of Navaho sand paintings, Tlingit and Tsimshian paintings on hide, and Haida totem poles. The slaughter of the mustangs must surely have recalled to him the slaughter of the Indians, so central to the history of the West.

Pollock was well aware of the celebration of Native American art and culture in the work of the Mexican muralists—especially David Alfaro Siqueiros. In fact, like Siqueiros, Pollock, we might say, tried to combine the gun-slinging cowboy and the noble Indian in his own self-image as an artist. On the one hand, his biography contains no less than eighteen entries under "Cowboy, image of." On the other hand, Pollock was one of a group of American artists of his generation influenced by Native Americans, both for political and artistic reasons and impressed by the Surrealists' fascination with Native American art as well as by the analogies that were made at the time between Northwest Coast art and certain aspects of Cubism. In 1946, Howard Daum organized an exhibition in New York including the work of Steve Wheeler, Robert Barrell, and Pollock's old friend Peter Busa, under the guise of the Indian Space movement, titled "8 and a Totem Pole." Barrell actually carved a totem pole for the exhibition, entitled *Bird Feeding Young*. The whole group was influenced by the collection of Native American art on display in the American Museum of Natural History in New York, and Barrell was an enthusiastic student of work illustrated in the annual reports of the Bureau of American Ethnology (copies of

which Pollock also owned and treasured, keeping them under his bed). Busa had studied Franz Boas's book *Primitive Art* (1927), and many of the Indian Space painters used the flowing black line typical of Northwest Coast art in paintings otherwise influenced by the flat space of Cubism.

As for cowboys in art, we can find them again in the work of Manny Farber, an artist best known as a film critic—one who was especially fond of Westerns. Perhaps this is because he was born in Douglas, Arizona, a township he evoked in his 1947 work *Birthplace*, a painting dominated by railroad tracks and a broken line of eight cowboys and a mule. Later Farber celebrated, in paintings, the Westerns of Anthony Mann, Budd Boetticher, Sam Peckinpah, and, indirectly, Howard Hawks. Ronald B. Kitaj has paid a moving tribute to John Ford, in a painting that shows the great director on his deathbed, saluted by an obstreperous but humble character from his Westerns, Sergeant Quincannon of the U.S. Cavalry. Nonetheless, it is Pollock who most comes to mind when I think of the myth of the West in the context of painting. In 1949 Pollock even told the architect Tony Smith that collectors out West would better appreciate the scale of the murals he wanted to paint.

Whitney Darrow has recalled taking a trip out across the deserts of Arizona and New Mexico with Pollock, back in 1932, through landscapes in which, as Darrow put it, "you could tell Jackson was in his element." After a night spent sleeping out in the desert, he would lean back in the car, his cowboy boots up on the dashboard, and play his mouth harp "until the coyotes complained."[33] (Pollock had begun to play the mouth harp at the Benton's musicales back in New York, which featured a medley of hillbilly ballads and country blues.) Back in 1910, folklorist John Avery Lomax had published his collection *Cowboy Songs*, writing in the introduction that "they loved roaming; they loved freedom; they were pioneers by instinct; an impulse set their faces from the east, put a tang for roaming in their veins and sent them ever westward."[34] By the 1920s, singing cowboys were performing on stage and radio. In the 1930s, Tex Ritter and John White, the "Lonesome Cowboy," became national stars singing cowboy numbers on the radio. Soon

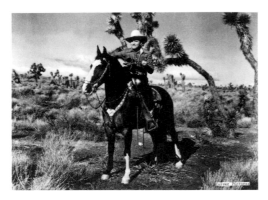

Gene Autry in the HBO special *The Singing Cowboys Ride Again*, 1982

cowboys (or pseudo cowboys) were singing on screen. One of the first was none other than John Wayne, who made a series of eight films for Monogram's Lone Star Productions, in which he played the cowboy part of Singin' Sandy, singing as many as four songs per picture.

Wayne, however, was unhappy in the role of singer, and in 1935 he confronted the head of the studio (Monogram had now merged with Republic) and told him he was refusing to sing anymore, explaining, supposedly, "I've had it. I'm a goddamned action star, you son of a bitch. I'm not a singer. Get yourself another cowboy singer."[35] That is just what Republic did. After a lengthy search, they chose Gene Autry, the one candidate who could both sing and ride. Autry was brought up in West Texas and began singing to while away the lonely hours while he was a railroad telegrapher. "Discovered" by Will Rogers, he quickly became a radio star and successful recording artist. When he replaced Wayne, Autry was cast in *In Old Santa Fe* (1934) and *Tumbling Tumbleweeds* (1935). Aimed at the juvenile market, these films nonetheless launched his career and made him into a film star, too. Soon he was selling Gene Autry songbooks by the million and marketing Gene Autry Roundup guitars through the Sears Roebuck mail catalogue. In 1938, however, he finally asked the studio for too much money and was replaced by Roy Rogers. That didn't stop him from selling no less than two million Gene Autry cap pistols in 1939.

The success of Western singers on film led to an attempt by other musicians to get on the Western bandwagon. Hillbilly singers started to put on cowboy boots and Stetson hats. It turned out that it was Western "style" and imagery that were popular with the

public, rather than Western music as such. This trend, apparently, accelerated after 1928 when Harry Stone took over the task of auditioning and booking artists. Richard A. Peterson, in his book *Creating Country Music: Fabricating Authenticity*, describes how Stone "was more concerned with producing a popular show than adhering to tradition," and, in practice, that meant hiring bands, many of whom were dressed in "the newly fashionable Western outfits," whatever their actual origins.[36] The main contribution of the singing cowboy was not so much the music but, in Bill Malone's words, "the fabric of usable symbols which surrounded him."[37] That is to say, as Peterson has explained, "the ten-gallon hat, the silver-studded leatherwear, the distinctive cut and decoration of clothes and boots, the six-shooter, the horse in Western saddle, the impassive look, and the imperious, legs-spread-wide stance."[38] First, the myth of the West was a spur to America's imperial expansion, then it became a dramatization of the conflicts that ensued; finally, it was transmuted into a repertoire of styles and images. The West had become a style commodity.

Pollock, at least, had a claim to authenticity. His brothers remembered questioning their father about the letters *IWW*, which they had seen scrawled on walls, and hearing a sympathetic account of the Wobblies and their struggles against exploitation. The Wobblies were a key part of Pollock's Western inheritance, actors in a drama of the West who played their mythic role alongside the cowboys and the Indians. In his memoir *The Living Spirit of the Wobblies*, Len De Caux describes a

Rodney Graham, *How I Became a Ramblin' Man*, 1999, installation view at Dia's exhibition " . . . the nearest faraway place . . . ," 2000–2001

movement of "footloose rebels," hobos who rode the rails in box-cars, migrant laborers looking for work in the mines, in the lumber camps, in the farms at harvest time, an itinerant way of life that came to an end with the combine harvester and the barbed wire.[39] In the 1930s, long before Jack Kerouac, Pollock hitchhiked from the East Coast to the West Coast and back. In a letter to his brothers, he wrote: "My trip was a peach. I got a number of kicks in the butt and put in jail twice with days of hunger—but what a worthwhile experience. . . . The country began getting interesting in Kansas—the wheat was just beginning to turn and the farmers were just making preparation for harvest."[40]

At the same time, Indians were important to Pollock, because of his fascination with the West, his childhood, because of his Jungian therapy—hence paintings like *The Moon-Woman Cuts the Circle* (1943) and *Totem Lesson* (1944). This was the side of Pollock that was close to Mabel Dodge—the Mabel Dodge who married a Pueblo Indian, Tony Luhan, but also fought politically for Indian rights in New Mexico and beyond. Luhan, coincidentally, had actually performed in a Wild West Show, even appearing at Coney Island. He also worked closely with the Indian rights activist John Collier, accompanying him to every pueblo in New Mexico to translate Collier's explanations of the Bursum Bill of 1922 and the effect it would have if it became law, making it possible to deprive the pueblo of 60,000 acres of land, much of it irrigated and culti-vated. Mabel Dodge herself worked hard to build a coalition of Indian rights supporters, opposing the Bursum Bill and calling for recognition of Indian civil rights, conservation of their lands through cooperative enterprise, preservation of their communal societies, and agricultural and industrial assistance programs spon-sored by the federal government. So the spirit of her Fifth Avenue salon survived to the end, bringing together, in spirit, both the Wobblies and the Indians—as Jackson Pollock did, too, in his own confused way. One day, perhaps, the art world might build upon their example—on the tradition of Mabel Dodge.

December 14, 2000

Mabel Dodge and her husband Tony Luhan, 1918

Notes

1 Martin Burgess Green, *New York 1913: The Armory Show and the Paterson Strike Pageant* (New York: Scribner, 1988), pp. 49–61.

2 Ibid., p. 75.

3 Ibid., pp. 158–59.

4 See Patrick Renshaw, *The Wobblies: The Story of Syndicalism in the United States* (Garden City, N.Y.: Doubleday, 1967).

5 Green, p. 31.

6 Ibid.

7 Ibid., p. 113.

8 Ibid., p. 53.

9 Carl Van Vechten, *Peter Whiffle: His Life and Works* (1922; Whitefish, Mont.: R. A. Kessinger Publishing, 2003), p. 125.

10 Green, p. 236.

11 Ibid., pp. 258–59.

12 John Sloan, quoted in ibid., p. 260.

13 John Marin, quoted in ibid., p. 260.

14 Paul Reddin, *Wild West Shows* (Urbana: University of Illinois Press, 1999).

15 Ibid., p. 53.

16 Ibid., p. 62.

17 Tom Mix, quoted in ibid., p. 191.

18 Reddin, p. 197.

19 Mix and his wife, quoted in ibid., p. 199.

20 Garry Wills, *John Wayne's America: The Politics of Celebrity* (New York: Simon & Schuster, 1998), p. 65.

21 Edward Buscombe, "Inventing Monument Valley: Nineteenth-Century Landscape Photography and the Western Film," in *Fugitive Images: From Photography to Video*, ed. Patrice Petro (Bloomington: Indiana University Press, 1995), p. 87.

22 Anthony Mann, quoted in ibid., p. 91.

23 Buscombe, p. 105.

24 Ibid.

25 Michael Budd, "A Home in the Wilderness: Visual Imagery in John Ford's Western," in *My Darling Clementine: John Ford, Director*, ed. Robert Lyons (New Brunswick, N.J.: Rutgers University Press, 1984), pp. 163–67.

26 Wills, p. 255.

27 John G. Cawelti, *The Six-Gun Mystique* (Madison: University of Wisconsin Press, 1984), pp. 62ff.

28 Ibid., p. 67.

29 Ibid.

30 Steven Naifeh and Gregory White Smith, *Jackson Pollock: An American Saga* (New York: C. N. Potter, 1998), p. 36.

31 Ibid., pp. 112–13.

32 Jackson Pollock, quoted in ibid., p. 468.

33 Whitney Darrow, quoted in ibid., p. 220.

34 John Avery Lomax, *Cowboy Songs and Other Frontier Ballads* (New York: Sturgis & Walton, 1910), p. xxi.

35 John Wayne, quoted in Richard A. Peterson, *Creating Country Music: Fabricating Authenticity* (Chicago: University of Chicago Press, 1997), p. 84.

36 Peterson, p. 103.

37 Bill Malone, quoted in ibid., p. 83.

38 Ibid.

39 Len De Caux, *The Living Spirit of the Wobblies* (New York: International Publishers Co., 1978), pp. 4–5.

40 Pollock, quoted in Naifeh and Smith, p. 200.

Contributors

JONATHAN CRARY has been a professor in the Department of Art
History and Archaeology at Columbia University since 1989. He has
written widely on contemporary art and has published articles in
Art in America, *Artforum*, *Grey Room*, *October*, *Domus*, *Arts*, *Village
Voice*, and other periodicals. He is a cofounder and a coeditor of
Zone Books, a press that has become internationally noted for its
publications in intellectual history, art theory, politics, anthropology,
and philosophy, including texts by Michel Foucault, Guy Debord,
Gilles Deleuze, Georges Bataille, Caroline Bynum, and many others.
Crary was coeditor of *Incorporations* (Zone Books, 1992), which
assembled a broad range of reflections on the problem of the body
in modern technological culture. He is the author of *Techniques of
the Observer: On Vision and Modernity in the Nineteenth Century*
(MIT Press, 1990), where he began his extended study on the ori-
gins of modern visual culture. His book *Suspensions of Perception:
Attention, Spectacle and Modern Culture* (MIT Press, 1999) was the
winner of the 2001 Lionel Trilling Book Award. Crary has been the
recipient of Guggenheim, Mellon, Getty, and National Endowment
for the Arts fellowships, and he has been a member of the Institute
for Advanced Study in Princeton, New Jersey.

BORIS GROYS is professor for philosophy and media theory at the
Hochschule für Gestaltung in Karlsruhe, Germany, since 1994 and
is currently a visiting professor at New York University. Between his
study of philosophy and mathematics at the University of Leningrad
and his emigration from the Soviet Union to the Federal Republic
of Germany in 1981, he held various academic positions in Russia.
He has subsequently held appointments as a visiting professor at the
University of Pennsylvania and the University of Southern California.

Groys's research interests are centered on the Russian avant-garde, the art of Stalinism, and the aesthetic and intellectual concepts of post-Communism. He is the editor with Max Hollein of *Dream Factory Communism: The Visual Culture of the Stalin Period* (Hatje Cantz, 2003) and the author of many books, including *Total Art of Stalinism: Avant-Garde, Aesthetic Dictatorship, and Beyond* (Princeton University Press, 1992), and *Über das Neue. Versuch einer Kulturökonomie* (Hanser, 1992). His recently published book *Topologie der Kunst* (Hanser, 2004) proposes a new approach to looking at contemporary art in the contexts of both the museum and the everyday.

PAMELA KORT is an independent curator and writer based in Berlin. Among the numerous exhibitions she has organized are "Paul Klee: 1933" (Lenbachhaus Munich, 2003) and "Comic Grotesque: Wit and Mockery in German Art" (Neue Galerie, New York, 2004), which originated as "Grotesk! 130 Jahre Kunst der Frechheit" at the Schirn Kunsthalle in Frankfurt. She has written extensively on twentieth-century art in German-speaking Europe, including essays on Jörg Immendorf, Sigmar Polke, Joseph Beuys, and others. She is currently curating "Rodin—Beuys," which will open at the Schirn Kunsthalle in fall 2005.

BÉRÉNICE REYNAUD is a film critic and theorist and a film and video curator. She is currently on the faculties of the School of Film and Video and the School of Critical Studies at the California Institute of the Arts in Valencia. Author of *Nouvelles Chines, nouveaux cinemas* (Cahiers du cinéma, 1999) and *Hou Hsiao-hsien's "A City of Sadness"* (BFI, 2002), she has also coedited a collection of

texts on feminist film criticism, *Vingt ans de théories féministes sur le cinéma—Grande-Bretagne et États-Unis* (CinemAction, 1993). She has published articles in *Cahiers du cinéma, Libération, Film Comment, Afterimage, The Independent, Senses of Cinema, Cinema Scope, Sight & Sound, Screen, Meteor, Springerin, Nosferatu,* and *Cinemaya, the Asian Film Quarterly,* among others. As a curator, she has organized film and video exhibitions for Artists Space, New York; the Collective for Living Cinema, New York; the Museum of Modern Art, New York; the UCLA Film and Television Archive; the Festival d'Automne, Paris; the Galerie Nationale du Jeu de Paume, Paris. Reynaud is currently cocurator of Film at REDCAT, a new polyvalent space opened by CalArts in the Frank Gehry building in downtown Los Angeles, where she has, among other series, organized a Chantal Akerman retrospective in collaboration with the UCLA Film and Television Archive.

ELAINE SHOWALTER is the author of many books, including *Literature of Their Own: British Novelists from Brontë to Lessing* (Princeton University Press, 1977), *The Female Malady: Women, Madness, and English Culture, 1830–1980* (Knopf, 1985), and *Hystories: Hysterical Epidemics and Modern Media* (Columbia University Press, 1998). She is a frequent contributor to the *Times Literary Supplement* and the *London Review of Books,* among many other periodicals and journals. From 1984 to 2003, Showalter taught at Princeton University as a distinguished professor of English and the humanities.

VICTOR I. STOICHITA is a professor of the history of art in the Department of Art History and Musicology at the University of Fribourg, Switzerland. He is the author of many books and essays, including *Visionary Experience in the Golden Age of Spanish Art* (Reaktion, 1995), *The Self-Aware Image: An Insight in Early Modern Metapainting* (Cambridge University Press, 1997), and, with Anna Maria Coderch, *Goya: The Last Carnival* (Reaktion, 2000). His book *A Short History of the Shadow* (Reaktion, 1997) is an investigation into the meaning and symbolism of the shadow, drawing on painting, literature, photography, and film, from Plato to Andy Warhol.

JAN TUMLIR is a writer who lives in Los Angeles. He teaches critical theory at Art Center College of Design and the University of Southern California and is on the editorial board of the Los Angeles art journal *X-tra*. His articles appear regularly in *Artforum*, *Frieze*, and *Flash Art*. In addition, he has written essays on the work of many artists, including Uta Barth, Jeroen De Rijke and Willem De Rooij, Jorge Pardo, Jeff Wall, and Jennifer Pastor. Tumlir's latest book project, *The Magic Circle: On the Beatles, Sgt. Pepper, and the Invention of Art Rock*, is being serialized in *X-tra*. His most recent curatorial projects include "An Arc, Another, and So On," at Cal State L.A. Fine Arts Gallery in 2004, and "Morbid Curiosity," presented at ACME gallery in 2001 and at I-20 gallery in New York in April 2002. "The Lateral Slip," a multimedia exhibition dealing with movement and the urban topography of Los Angeles, will be mounted in the art gallery at the University of California, Riverside.

PETER WOLLEN is a professor in the Department of Film, Television, and Digital Media at the University of California, Los Angeles. He has organized numerous exhibitions, including those of the work of Frida Kahlo and Tina Modotti at the Whitechapel Gallery in London and the work of Komar and Melamid at the Fruitmarket Gallery in Edinburgh. He also organized the Situationist International at the Centre Pompidou in Paris (1989) and "Addressing the Century: Art and Fashion" at the Hayward Gallery in London (1999). His previous books include *Raiding the Icebox: Reflections on Twentieth-Century Culture* (Indiana University Press, 1993), *Paris Hollywood: Writings on Film* (Verso, 2002), and *Paris Manhattan: Writings on Art* (Verso, 2004), among others. He is coeditor, with Lynne Cooke, of *Visual Display: Culture Beyond Appearances* (Bay Press, 1995).

Photo Credits

Works by Joseph Beuys
© 2004 Artists Rights Society (ARS), New York/VG-Bildkunst

Works by Robert Irwin
© 2004 Artists Rights Society (ARS), New York

Works by Andy Warhol
© 2004 Andy Warhol Foundation for the Visual Arts/ARS, New York

Works by Douglas Gordon
courtesy Gagosian Gallery, New York, and Douglas Gordon

Works by Stan Douglas
courtesy David Zwirner Gallery, New York, and Stan Douglas

Works by Thomas Schütte
© 2004 Artists Rights Society (ARS), New York/VG Bildkunst

Works by Rodney Graham
courtesy 303 Gallery/Donald Young and Rodney Graham

Works by Bruce Nauman
© 2004 Artists Rights Society (ARS), New York

Page 10 Collection of the artist, photo Cathy Carver; page 11 Collection of the artist, photo Richard Barnes; pages 18, 19, 22, 23 Collection Dia Art Foundation, photo Cathy Carver; pages 20, 21, 65, 66, 70, 75, 78, 83 photo Thibault Jeanson; pages 24, 25, 32, 110, 111, 113, 118, 125, 136 photo Stuart Tyson; page 28 Collection Ydessa Hendeles, photo Cathy Carver; page 29 Collection Museo Cantonale d'Arte Lugano, photo Cathy Carver; pages 30, 148 Collection of the artist, photo Nic Tenwiggenhorn; pages 31, 141 photo Nic Tenwiggenhorn; pages 33, 34, 143, 153 photo Cathy Carver; page 35 Collection of the Museum for Contemporary Art, Chicago, photo Cathy Carver; pages 37, 39, 40, 55 Collection Dia Art Foundation; page 42 Collection Stiftung Museum Schloss Moyland, Collection van der Grinten, Bedburg-Hau, photo Walter Klein, Düsseldorf; page 44 photo Eva Beuys-Wurmbach; page 46 photo Ugo Mulas © Ugo Mulas Estate; page 47 photo Heinrich Riebesehl, Hannover; page 50 photo Philipp Schönborn, Munich; page 73 photo David Robinson; page 74 Réunion des Musées Nationaux, Paris/Art Resource, NY; page 81 Collection of Rijksmuseum, Amsterdam; pages 95, 116 top and bottom, 128, 129, 130, 135, 200, 201, 210 © Photofest, New York; page 96, 101 top Collection of The Andy Warhol Foundation for the Visual Arts/Art Resource, NY; page 97 Collection of The Andy Warhol Museum, Pittsburgh/Art Resource, NY; page 98 photo Arthur Tress; page 99 private collection, courtesy Philadelphia Museum of Art/ARS, New York/ADAGP, Paris/Succession Marcel Duchamp; page 100 top © Collection National Gallery, London; page 100 bottom Founding Collection The Andy Warhol Museum, Pittsburgh, photo Richard Stoner; page 101 bottom Art Resource, NY, courtesy Ronald Feldman Fine Arts Inc., New York; pages 102, 103 ARS, New York/ADAGP, Paris/Succession Marcel Duchamp; page 105 photo Paige Powell; page 115 courtesy D. M. Bourneville and P. Regnard, *Iconographie Photographique de la Salpêtrière*, vol 1, 1878; page 117 bottom courtesy Patrick Painter Editions, Vancouver/Honkong; page 139 courtesy Gallery Nelson, Paris, photo Cathy Carver; pages 145, 150, 151 courtesy Marian Goodman Gallery, New York; page 146 photo Thomas Schütte; page 149 top, middle, bottom photo Candida Höfer, Cologne; page 155 Collection Fischer, courtesy IFA, Stuttgart, photo

Cathy Carver; pages 160, 164, 166, 174, 183, 186 courtesy 303 Gallery, New York; page 163 Collection of FRAC Haute Scotteville-lès Rouen, photo Michael Govan; page 167 Collection Vancouver Art Gallery, photo Cathy Carver; pages 177, 197, 211 courtesy Donald Young Gallery, Chicago, photo Ron Gordon; pages 181, 183 courtesy Donald Young Gallery, Chicago; pages 180, 182 private collection, photo Stuart Tyson; page 206 courtesy Smithsonian American Art Museum, Washington, D.C./Art Resource, NY.